GVSTAV KLIMT

AT HOME

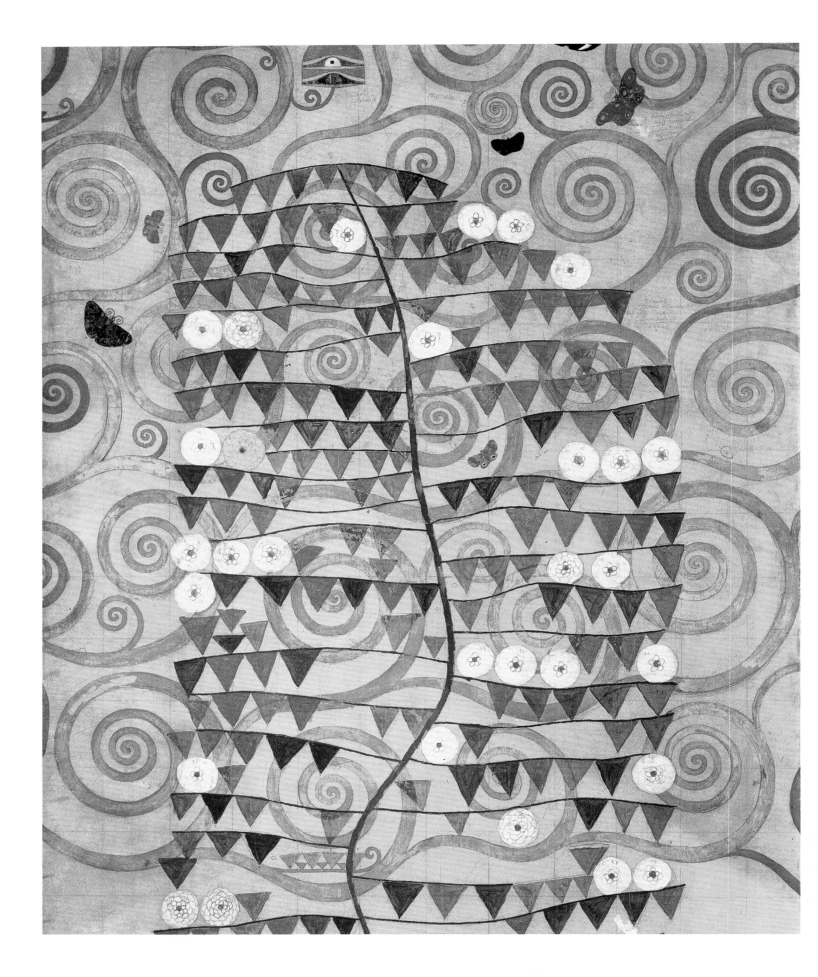

GUSTAV KLIMT
AT HOME

PATRICK BADE

FRANCES
LINCOLN

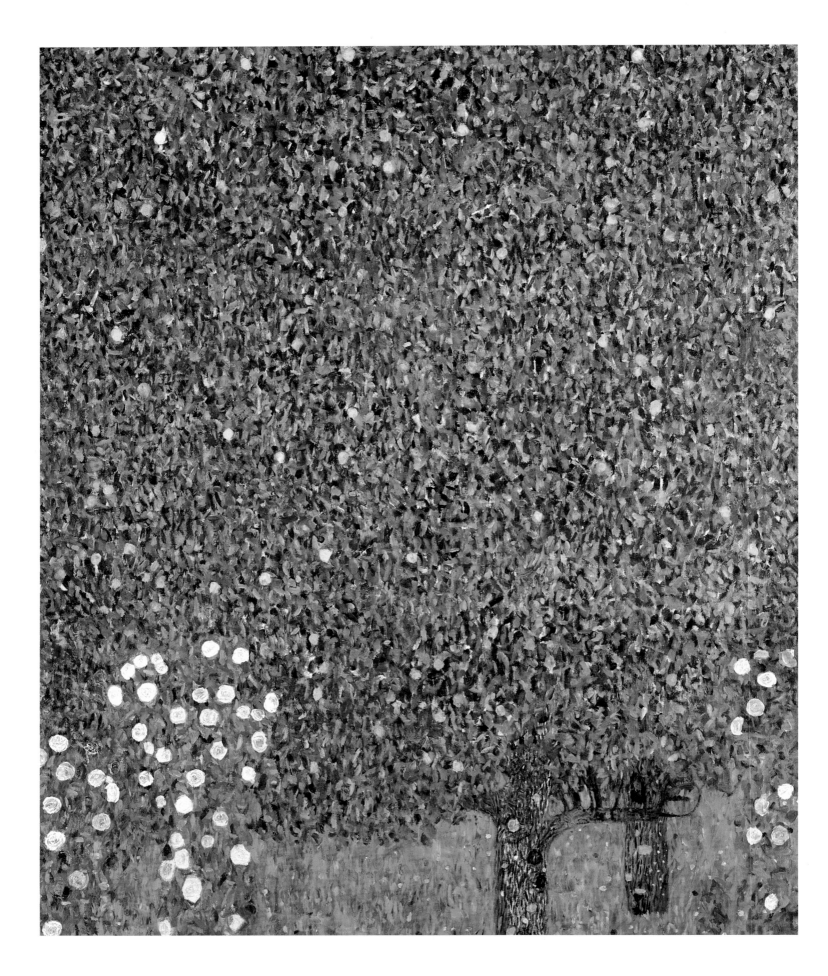

TITLE PAGE *Tree of Life*, detail from the *Stoclet Frieze*, c.1905–09, tempera and watercolour, MAK (Austrian Museum of Applied Arts), Vienna

OPPOSITE *Roses under the Trees*, c.1905, oil on canvas, 110 × 110 cm, Musée d'Orsay, Paris

BELOW Gustav Klimt and Emilie Flöge in Klimt's studio garden, c.1905

CONTENTS

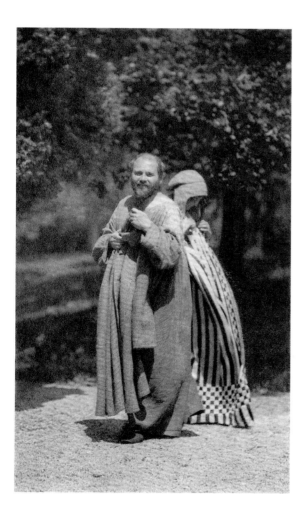

TIMELINE

1857
Construction of Vienna's Ringstrasse begins

1862
Gustav Klimt born in Baumgarten, Vienna

1876
Klimt enrolls at the Kunstgewerbeschule

1886
Commission to paint staircases and interior at Vienna's Burgtheater

1848
Revolution in Austrian Empire, Franz Josef I declared Emperor

1861
Morris, Marshall, Faulkner & Co. founded by William Morris in London

1873
Financial crash in Vienna

1883
Klimt, his brother Ernst and Franz Matsch form the Künstlercompagnie

1888
Awarded Golden Order of Merit for work at Burgtheater

1899
Son Gustav born in July to Maria Ucicka
Son Gustav born in September to Maria Zimmermann
Publication of The Interpretation of Dreams by Sigmund Freud

1901
Scandal and protest over Faculty painting, Medicine
Klimt completes Judith I

1903
Wiener Werkstätte founded
Klimt Collective at the Secession
Klimt travels to Italy, including Ravenna and Rome
First German-language edition of Reigen by Arthur Schnitzler published in Vienna

1905
Klimt leaves Vienna Secession
Premier performance of The Merry Widow at the Theater an der Wien
Premier performance of Strauss's Salome in Dresden
Height of the Dreyfus Affair scandal in France

1898
Vienna Secession first exhibition, Ver Sacrum founded
Berlin Secession
Summer holiday in Salzkammergut, first landscapes painted
Second Secession exhibition at new Secession building

1900
Scandal surrounding Faculty painting Philosophy, wins gold medal at Paris World Fair

1902
Klimt creates Beethoven Frieze for Fourteenth Secession exhibition
Mahler brings members of Vienna Philharmonic Orchestra to perform Ode to Joy from Beethoven's Ninth Symphony at opening
Son, Otto, born to Maria Zimmermann, dies the same year

1904
Commission for Stoclet Frieze
Emilie Flöge opens fashion salon with her sister

Construction of Eiffel Tower
 completed for Paris World Fair
Adolf Hitler born in
 Braunau am Inn, Austria

1889

Ernst Klimt marries
 Helene Flöge
Klimt meets Emilie Flöge

1891

Awarded Faculty
 painting commission for
 University of Vienna
Dreyfus Affair scandal
 begins in France

1894

Publication of *Der Judenstaat*
 by Theodor Herzl

1896

1890

Commission for paintings at
 Vienna's Kunsthistorisches
 Museum
Künstlercompagnie moves into
 studio on Josefstädterstrasse
Klimt moves to apartment on
 Westbahnstrasse

1892

Death of Klimt's father and
 brother
Dissolution of the
 Künstlercompagnie
Munich Secession
Symbolist salon Rose+Croix
 launched by Joséphin Péladan

1895

Commission for music
 room, Palais Dumba in
 Vienna

1897

Klimt co-founds and is first
 President of Vienna Secession
Summer with Emilie Flöge and
 her sisters in Tyrol
Gustav Mahler appointed
 Director of Vienna Court
 Opera

Klimt meets Egon Schiele
*Portrait of Adele Bloch-
 Bauer I* completed
Mahler resigns from
 Court Opera, leaves
 Vienna for New York

1907

Klimt travels to Paris

1909

Stoclet Frieze completed,
 mounted in Brussels
Klimt moves to studio on
 Feldmühlgasse

1911

Outbreak of
 First World War

1914

Klimt exhibits at
 Berlin Secession

1916

1906

Klimt becomes president
 of Künstlerbund
Travels to Brussels,
 London, Germany
 and Italy

1908

Opening of Kunstschau
 exhibition including
 first display of *The Kiss*

1910

Klimt participates
 in 9th Venice
 Biennale

1912

Klimt made
 President of Bund
 österreichischer
 Künstler

1915

Death of Klimt's
 mother

1918

Klimt suffers stroke
 on 11 January and
 dies on 6 February
 in Vienna

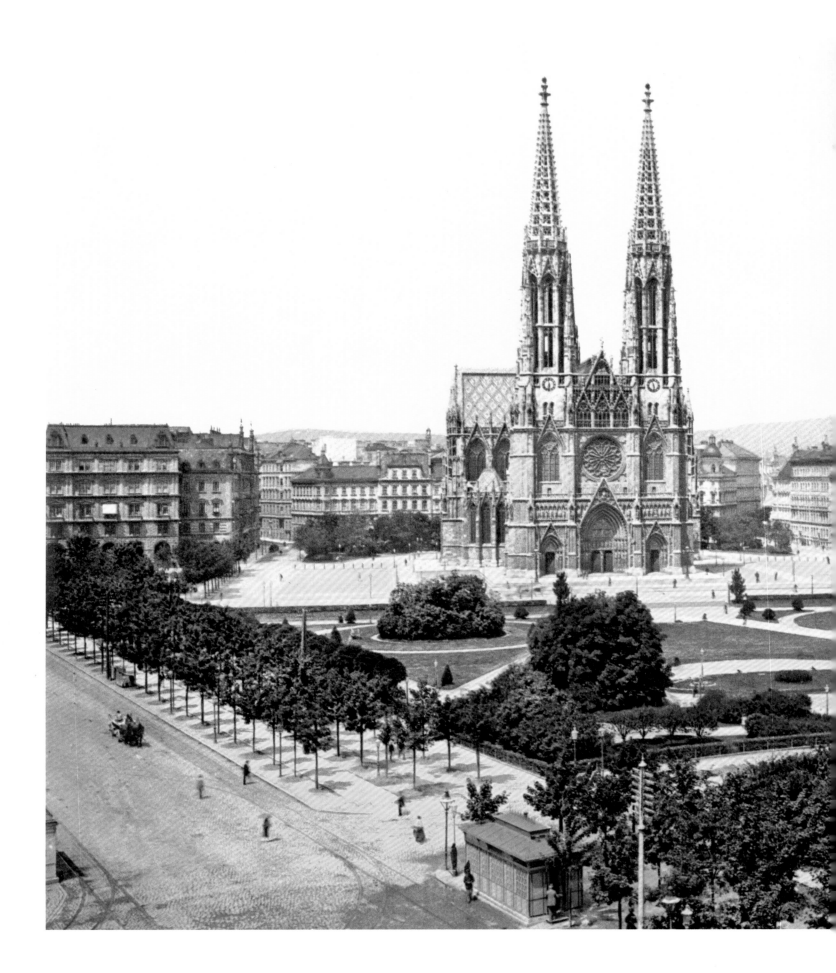

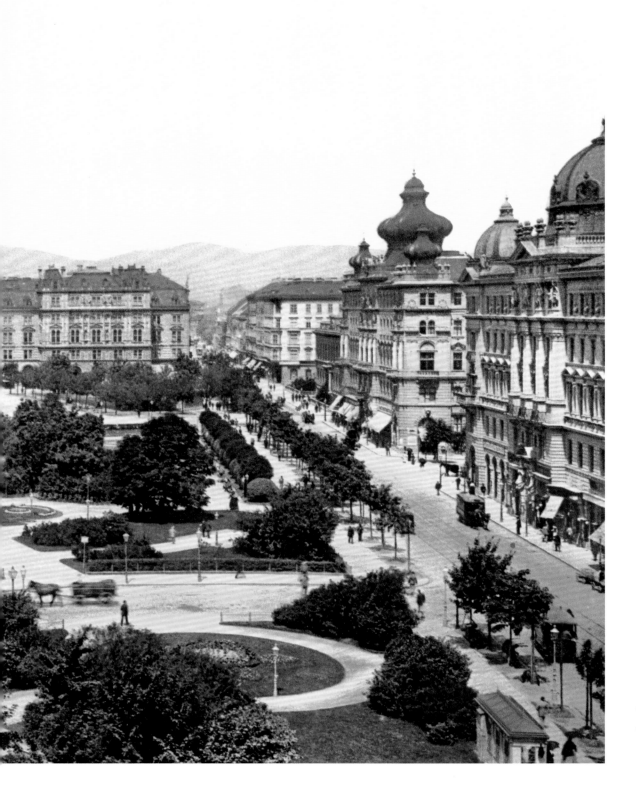

View of the Votivkirche, Vienna,
c.1890–1900

KLIMT'S VIENNA

..

Hymn to Joy, detail from the
Beethoven Frieze, 1902, casein
colour, gold leaf, semi-precious
stones, mother of pearl, plaster,
pencil and pastel on stucco
primer, 215 x 3414 cm (long
walls 1392 cm each, short
wall 630 cm), Österreichische
Galerie Belvedere, Vienna

The enduring and ever-increasing appeal of the art of Gustav Klimt stems not only
from its seductive beauty but also from its association with the Vienna of 1900.
Klimt's Vienna was the Vienna of Sigmund Freud, Gustav Mahler, Arthur Schnitzler,
Karl Kraus, Arnold Schönberg, Theodor Herzl and the young Adolf Hitler. Paris
may have prided itself on being the cultural capital of the western world, but with
hindsight we can see that Vienna proved to be the cradle of much that was the best
and worst in the twentieth century.

In strictest truth Gustav Klimt could have declared in the words of a popular
Viennese song, '*Mei Muatterl war a Wienerin*' (My mother was a Viennese girl).
Friends who later recalled his somewhat terse utterings usually did so in the
broadest Viennese dialect. His mother, Anna Finster, was born in a suburb of Vienna
in 1836. His father, Ernst Klimt, was of Bohemian ancestry. This mixed heritage
was typical of much of the population of Vienna in the late nineteenth century.
In 1900 Vienna was Europe's fourth most populous capital (after London, Paris
and Berlin) but by far its most diverse ethnically, linguistically and culturally. Writer
Stefan Zweig rejoiced in the cosmopolitanism of turn-of-the-century Vienna: '…all
the currents of European culture had merged in this place. At court and among
the nobility and the common people alike, German elements were linked with the
Slavonic, Hungarian, Spanish, Italian, French and Flemish. It was the peculiar genius of
Vienna, the city of music, to resolve all these contrasts harmoniously in something

new and unique, specifically Austrian and Viennese. Open-minded and particularly receptive, the city attracted the most disparate of forces, relaxed their tensions, eased and placated them. It was pleasant to live in this atmosphere of intellectual tolerance, and unconsciously every citizen of Vienna also became a supranational, cosmopolitan, citizen of the world.'[1]

This diversity was the source of Vienna's creativity but also contained the seeds of future disaster and tragedy. According to the 1912 edition of *Encyclopaedia Britannica*, the 1900 population numbering 1,662,269 consisted of '1,386,115 persons of German nationality, 102,974 Czechs and Slovaks, 4346 Poles, 805 Ruthenians, 1329 Slovenes, 271 Serbo-Croatians and 1368 Italians, all Austrian subjects. To these should be added 133,144 Hungarians, 21,733 natives of Germany, 2506 natives of Italy, 1703 Russians, 1176 French, 1643 Swiss etc.' Of this heterogeneous population 1,461,891 were Roman Catholics, the Jews coming next in order with 146,926. Protestants of the Augsburg and Helvetic confessions numbered 54,364; members of the Church of England, 490; Old Catholics, 975; members of the Greek Orthodox Church, 3674; Greek Catholics, 2521; and Mahommedans, 889. Only 45.5% of Vienna's population was estimated to have been born in the city.

The encyclopaedia goes on to tell us that 'As a general rule, the Viennese are gay, pleasure-loving and genial.' Stefan Zweig concurred with this view of the Viennese as refined and cheerful hedonists. 'The people of Vienna were gourmets who appreciated good food and good wine, fresh and astringent beer, lavish deserts and tortes, but they also demanded subtler pleasures. To make music, dance, produce plays, converse well, behave pleasingly and show good taste were arts much cultivated here ... You were not truly Viennese without a love for culture, a bent for enjoying and assessing the prodigality of life as something sacred.'[2]

Cakes and conversation were to be found in the famous Viennese cafés. As Stefan Zweig opined, 'the Viennese coffee house is an institution of a peculiar kind, not comparable to any other in the world. It is really a sort of democratic club, and anyone can join it for the price of a cheap cup of coffee. Every guest, in return for that small expenditure, can sit there for hours on end, talking, writing, playing cards, receiving post, and above all reading an unlimited number of newspapers and journals. A Viennese coffee house of the better sort took all the Viennese newspapers available, and not only those but the newspapers of the entire German

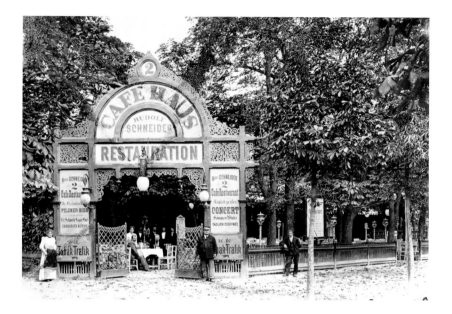

ABOVE Coffee house in Prater, Vienna, c.1900

BELOW Gustav Klimt having breakfast in a
tavern garden, turn-of-the-century Vienna

Reich, as well as the French, British, Italian and American papers, and all the major literary and artistic international magazines, the *Mercure de France* as well as the *Neue Rundschau,* the *Studio,* and the *Burlington Magazine* … Perhaps nothing contributed so much to the intellectual mobility and international orientation of the Austrians as the fact they could inform themselves so extensively at the coffee house of all that was going on in the world, and at the same time could discuss with a circle of friends.'[3]

Memoirs of those who lived in Vienna, often written after the catastrophe of the First World War, evoke life in the city through a haze of rosy nostalgia. Dagmar Godowsky, the silent film star and daughter of the celebrated piano virtuoso Leopold Godowsky who was a professor at the Vienna Academy of Music, remembered her Vienna childhood in idyllic terms: 'Ah, Vienna! I think of the gardens, the garlands of flowers on the lamppost, the Stadtpark, the Ringstrasse. The Gothic beauty of Vienna. The Stephanskirche, the Schoenbrunn. The statues – tragic, beautiful Empress Elizabeth standing before that little pool in the corner of the Volksgarten. The cosy winters with the giant porcelain stoves. The exquisite springs. And music everywhere. Everyone was a musician in Vienna. On New Year's Eve, each of a thousand cafés would boast a large orchestra, and careful inspection would reveal your letter carrier, your street cleaner, your chimney sweep, your lamplighter, all of them versed in Mozart and Beethoven. Safe Vienna, where all houses were locked at ten in the evening, and entrance to your own home had to be bought for a token from the porter who had the key. *Alt Wien!* – music and flowers, flowers and music.'[4] The Godowsky household, while hardly characteristic of the average Viennese, was certainly typical of the cultural elite of the city. Dagmar

described the succession of distinguished visitors, including Arthur Schnitzler, Niggar Haim, Edib Bey, Dr Wilhelm Stekel, Gustav Mahler, Franz Werfel, Felix Salten, Jacob Wassermann, Gerhart Hauptmann, Hermann Sudermann and Thomas Mann.

Stefan Zweig's recollections of the Vienna of his youth, while expressed with greater sophistication, are hardly less rosy: 'If I try to find some useful phrase to sum up the time of my childhood and youth before the First World War, I hope I can put it most succinctly by calling it the Golden Age of Security. Everything in our Austrian Monarchy, then almost a thousand years old, seemed built to last, and the state itself was the ultimate guarantor of durability. The rights it gave its citizens were affirmed by our parliament, a freely elected assembly representing the people, and every duty was precisely defined. Our currency, the Austrian crown, circulated in the form of shiny gold coins, thus vouching for its immutability. Everyone knew how much he owned and what his income was, what was allowed and was not. Everything had its norm, its correct measurement and weight. If you had wealth, you could work out precisely how much interest it would it would bring you every year, while civil servants and officers were reliably able to consult the calendar and see the year when they would be promoted and the year when they would retire. Every family had its own budget and knew how much could be spent on food and lodging, summer holidays and social functions, and of course you had to put a small sum aside for unforeseen contingencies such as illness and the doctor . . . Everything in this wide domain was firmly established, immovably in its place, with the old Emperor at the top of the pyramid, and if he were to die the Austrians all knew (or thought they knew) that another emperor would take his place, and nothing in the well-calculated order of things would change. Anything radical or violent seemed impossible in such an age of reason.'[5]

So it seemed to an intelligent child brought up in a prosperous, assimilated and cultivated Jewish household in late nineteenth-century Vienna. But fin-de-siècle Vienna did not feel so cheerful, nor so reassuringly immutable to everyone. Underlying the conviviality and the hedonism, there was a strain of melancholy in the Viennese, to be heard in the sighing nostalgia of the popular songs of the day. Smiling through tears was a peculiarly Viennese attitude. According to Zweig, funerals were particularly festive occasions – 'A genuine Viennese turned even his death into a fine show for others to enjoy.' There was also a deep vein of pessimism and apprehension. Many voices were warning against or even calling for an end to

this rigidly hierarchical system, and burgeoning nationalism throughout the great multi-ethnic Habsburg Empire threatened to bring down the whole edifice.

The cynical author and journalist Karl Kraus took on the role of Cassandra, prophesying that turn-of-the-century Vienna was an experimental station on the road to the end of mankind: 'Everyone is stopped, waiting, maitre d's, hansom cab drivers and governments. Everyone is waiting for the end. Let's hope the apocalypse will be pleasant, Your Majesty.'[6]

For the critic and playwright Hermann Bahr, writing in 1891, it was precisely the rigid continuity and traditionalism of the Habsburg Empire which was the problem: 'The future is blooming all around us; but we are still rooted in the past. For this reason, there can be no peace, but only hatred and schism, enmity and violence ... It is truth we desire. We must pay heed to that commandment which comes from without, and to our own inner yearnings. We must become as our environment. We must shake off the mould of past centuries – that same past which, long since faded, chokes our souls with its decaying foliage. We must be as the present ... We must open the windows and let in the sun, the radiant sun of early May. We must open up our senses, and greedily listen and perceive. And with joy and reverence we shall greet that light which breaks triumphant into rooms emptied of the litter of the past.'[7] In 1898, seven years later, Klimt and his fellow Secessionists headed Bahr's call, embracing the modern in the spaces of the new Secession building, 'emptied of the litter of the past'.

In the words of Stefan Zweig: 'The truly great experience of our youthful years was the realisation that something new in art was on the way – something more impassioned, difficult and alluring than the art that had satisfied our parents and the world around us. But fascinated as we were by this one aspect of life, we did not notice that these aesthetic changes were only the forerunners of the much more far-reaching changes that were to shake and finally destroy the world of our fathers, the world of security.'[8]

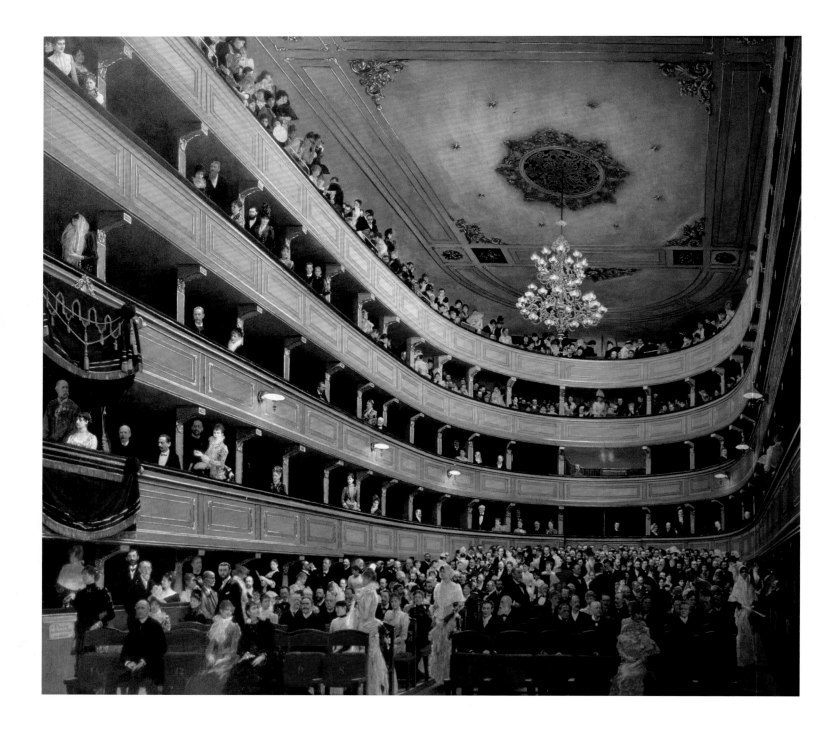

Auditorium of the Old Burgtheater, Vienna, 1888,
oil on canvas, 82 × 92 cm, Wien Museum, Vienna

REVOLUTION &
RINGSTRASSE

· ·

Between 1813 and 1815 at the end of the Napoleonic Wars, Vienna hosted a
conference in which representatives of the victorious nations, Austria, Russia, Prussia
and Great Britain, manipulated by the devilishly clever Charles Maurice de Talleyrand
representing the defeated France, redrew the map of Europe and attempted
to force the genie of revolution back into the bottle. The Congress of Vienna
confirmed the city's reputation as the capital of gaiety and good living. In the words
of the 1912 *Encyclopaedia Britannica*, 'From the first the social side of the congress
impressed observers with its wealth and variety, nor did the statesmen disdain to
use the dining-table or the ballroom as the instruments of diplomacy.'

Vienna had not changed substantially since its appearance was recorded so
meticulously in the 1750s by the Venetian artist Bernardo Bellotto. The cramped
old city still nestled behind the medieval walls and the inner suburbs that had begun
to spread out beyond them were protected by an outer girdle of fortifications. The
population had yet to explode and remained well under half a million until the 1848
Revolution. During the so-called Biedermeier period that followed the Congress
of Vienna, Beethoven and Schubert created some of the greatest masterpieces in
Western music against a background of stultifying political repression and petit-
bourgeois mediocrity. Their smaller-scale works, including the songs so loved by
Klimt, were composed to be performed in the comfort of private drawing rooms.
The cosy domesticity of the Biedermeier found its most characteristic expression

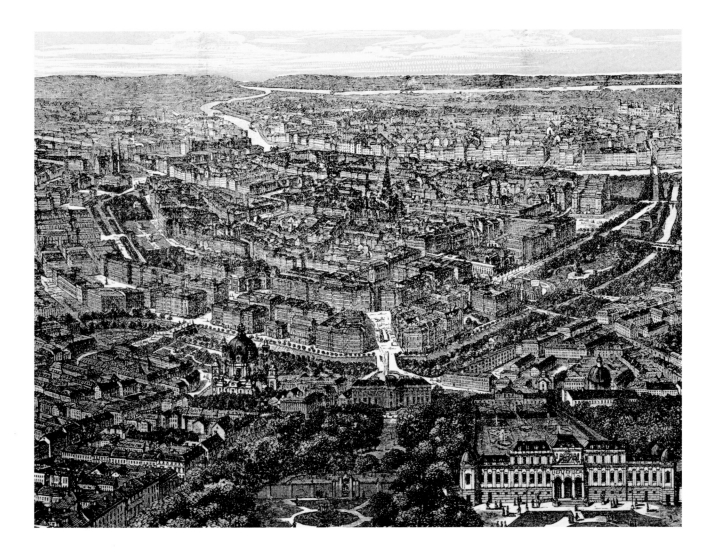

in the decorative arts and in particular in furniture made from pale local woods and boldly simplified neo-classical forms.

The seething discontents that built up under the placid surface of the Biedermeier finally erupted in the abortive revolutions of 1848. Once these had been put down and the new authoritarian emperor Franz Joseph installed, Vienna continued on its rigidly reactionary way as capital of the increasingly fractious Habsburg Empire.

ABOVE View of Vienna, 1873

OPPOSITE The first plan for the development of the Ringstrasse in Vienna, 1859

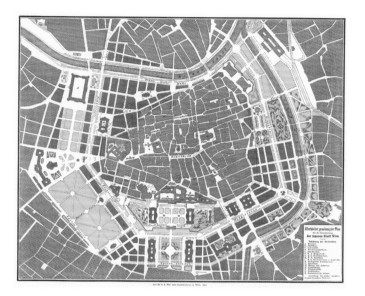

Franz Joseph had already been on the throne for fourteen years when Klimt was born in 1862 and he continued to reign for all but the last 18 months of Klimt's life. Bowed with grief after the suicide of his son, the Crown Prince Rudolf in 1889, and the assassination of his wife, the Empress Elisabeth in 1898, he must have seemed immortal to many of his subjects by the early 1900s. In his record-breaking 68-year reign, Franz Joseph morphed from stern reactionary into a benign liberal, gently and wisely attempting to guide his sclerotic empire into the modern age.

The trigger of this transformation was Austria's humiliating defeat by Prussia at the Battle of Königgrätz in 1866. The following year Franz Joseph enacted the reforms that created Dual Monarchy of Austria-Hungary and introduced a large measure of parliamentary democracy. Partly through the obstruction of the Hungarians, who had been the chief beneficiaries of the 1867 reforms, Franz Joseph failed to pacify other ethnic groups in the Habsburg domains, notably the Czechs and the Southern Slavs who clamoured for similar rights leading to the tensions that eventually caused the outbreak of the First World War.

The modernisation of the Habsburg Empire found its most spectacular expression in the construction of the Ringstrasse on the site of the venerable city walls that had been built in the thirteenth century with money paid in ransom for the feckless English King Richard the Lion Heart, captured by the Austrians on his return from the crusades. These walls had twice withstood siege by the Turks in 1529 and 1683 but had failed to stop Napoleon from taking the city in 1809 and were deemed militarily useless in modern warfare. In 1857 Franz Joseph issued the decree 'Es ist meine Wille' (It is my will) for the demolition of the wall and work began the following year, continuing into the 1880s. The Ringstrasse provided one of the two most influential models for the modernisation of cities in the nineteenth century, the other being Haussmann's Paris which involved the ruthless cutting of wide straight boulevards through the old city — something never contemplated in Vienna. The magnificent boulevard

encircling the old city was to be lined with handsome public buildings, apartment blocks and palaces of the new rich such as that of the Ephrussi family.

Between 1830 and 1890 most public buildings in Europe were built in a variety of historical styles. Each building on the Ringstrasse was designed in what was believed to be the appropriate style for its purpose – the Town Hall and the Votivkirche were Gothic, the Parliament building was Greek, and the Burgtheater, Opera House and the Kunsthistorisches Museum were all Neo-Renaissance. The result was the most magnificent architectural fancy dress ball in history.

Not surprisingly, considering the importance of opera in Viennese cultural life, the Imperial Opera House was the first of these buildings to be completed. The architects Eduard van der Null and August Sicard von Sicardsburg apparently failed to take note of the eventual level of the street resulting in the curiously squat proportions of the building. The Emperor commented that it looked like someone had sat on it. Mortified by the criticisms, van der Null hanged himself. Von Sicardsburg died of natural causes a few weeks later. Shocked by the impact of his comment the Emperor rarely offered an opinion in aesthetic matters thereafter, confining himself to the diplomatic, 'Es war sehr schön. Es hat mir gut gefallen.' (It was very nice. It pleased me.) He even consented to make a visit to the Secession in 1898, though he was not generally in sympathy with new tendencies in art and design.

In the early stages of his career Klimt was involved in the decoration of two of these buildings – the Burgtheater and the Kunsthistoriches Museum – and was rewarded in 1888 by the Emperor for his work on the Burgtheater with the Golden Order of Merit. In the same year he was commissioned to record the appearance of the interior of the old Burgtheater and its audience before the demolition of the building to make way for the construction of the new wing of the Hofburg. Containing nearly two hundred miniature portraits, it is a collective portrait of the Viennese cultural elite at a moment of transition.

Stefan Zweig described the emotional significance of the occasion for the Viennese: 'When the old Burgtheater, where the first performance of Mozart's *The Marriage of Figaro* had been given, was to be demolished, Viennese high society gathered there in a mood of solemn emotion, and no sooner had the curtain fallen than everyone raced on stage to take home at least a splinter from the boards that had been trodden by their favourite artists as a relic. Even decades later, these plain wooden splinters were kept in precious caskets in many bourgeois households, just as splinters of the Holy Cross are preserved in churches.'[1]

Vienna at the turn of the century:

ABOVE The Opernring and State Opera House

BELOW A view of the Ringstrasse, with Parliament, City Hall, the new University and the Burgtheater

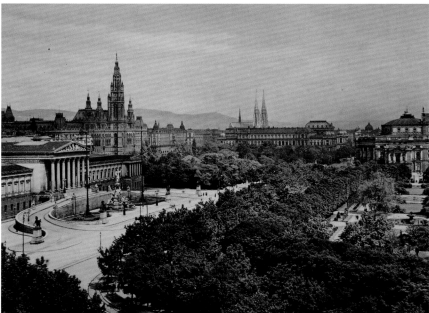

The birthplace of Gustav Klimt: Linzerstrasse 247, Vienna
(torn down in 1967)

BEGINNINGS

· ·

Just as the great project of the Ringstrasse was getting underway, Gustav Klimt was born on 14 July 1862 in the tiny village of Baumgarten to the west of Vienna and soon to be incorporated into the city. His father Ernst was a metal engraver with the status of a humble craftsman. A portrait of him in the manner of Frans Hals and dressed in seventeenth-century Dutch costume gives him a rather pugnacious expression and he was apparently of choleric temperament. His wife Anna, by contrast, possessed a sunny nature, though with some mental fragility and she suffered a severe breakdown after the death of her penultimate daughter Anna at the age of five in 1874. Anna enjoyed singing and going to the opera and it was perhaps from her that Gustav Klimt inherited his love of music.

Klimt was the second of seven children. His elder sibling Klara (1860–1937) suffered from severe melancholia, suggesting an inherited strain of instability in the family. Ernst junior (1864–92) was perhaps the sibling closest to Gustav. Gustav and Ernst trained and worked together alongside their friend Franz Matsch in the early years of their careers and it is not always possible to distinguish the hand of one from another. Ernst was married to Helene Flöge, sister of Gustav's life-long companion Emilie Flöge. When Ernst junior died at the age of 28 in 1892, the same year as Ernst senior, it provoked a profound crisis and change of direction in Gustav's work.

Hermine (1865–1938), like her elder sister, never married and followed the artistic bent of the family with needlework, something in which Klimt himself would

Ernst Klimt, *Ernst Klimt Senior,*
oil on canvas, 1892

later take a great interest. Georg Klimt (1867–1931) followed in the footsteps of his older brothers to study at the Kunstgewerbeschule and became a successful metal worker, creating some of the frames designed and used by Gustav.

The third daughter Anna who had been sickly since birth died at the age of five. The last daughter Johanna (1873–1951) married an accountant but passed on the artistic tradition of the Klimt family to her son Julius Zimpel (1896–1925) who became artistic director of the Wiener Werkstätte before his untimely death.

Anna's death marked the low point of Klimt's childhood and coincided with a period of great economic hardship for the Klimt family. The construction of the Ringstrasse and its palatial buildings and the modernisation of Vienna had generated frantic economic speculation and a mood of unfounded optimism. In hindsight the decision to stage a World Exposition in Vienna in 1873 in a spirit of rivalry with London and Paris looks like hubris. Housed in a huge metal and glass rotunda by the Scottish engineer John Scott Russell, the exhibition was regarded as a success with over seven million visitors. But it was no coincidence that eight days after the opening of the exhibition on 9 May 1873, the Vienna stock market crashed, triggering a worldwide recession lasting several years. The impact in Vienna was especially dire with multiple insolvencies of banks and other business. Klimt's father's business was hard hit and he struggled to support his family, who were forced to move into poorer accommodation.

With seven children to feed, times were often dire for the Klimt family following the financial crash. Their poverty and eventual escape from it can be traced through their numerous changes of address between 1860 and 1890. Though Klimt's birth house was demolished in the 1960s, surviving photographs show that it was extremely modest and rural in appearance and very much the residence of a peasant. After several changes of address matters improved in the early 1880s when both Gustav and Ernst junior began to earn money and the family were able to descend from the attic floor of their building in the Mariahilferstrasse in the 3rd district to an apartment on the garden

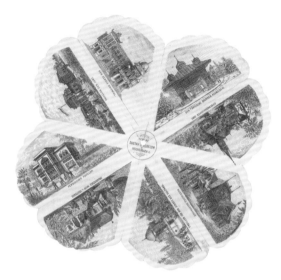

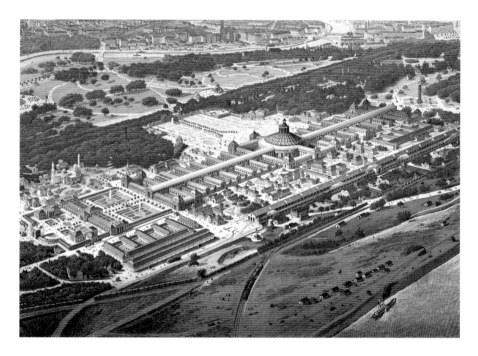

LEFT A so-called *Städteblume* for the World Exhibition in Vienna, unfolded, with sights and pavilions of the exhibition, 1873

RIGHT Aerial view of the World Exhibition in Vienna, c.1873

level. Moving down a floor in the nineteenth century was generally a sign of going up in the world. In 1890 the family moved to a handsome and very bourgeois modern apartment block on the Westbahnstrasse, where they occupied a third floor apartment which Klimt continued to share with his unmarried sisters Klara and Hermine until his death in 1918.

Klimt's schooling was restricted to that of any working class boy of his period. At the age of 14, he enrolled at the Kunstgewerbeschule, where his father had also studied his trade. The wide ranging literary culture that Klimt later possessed was self-acquired. He liked to declaim from Dante and Petrarch when painting portraits and was never without copies of the *Divine Comedy* and Goethe's *Faust* in his pockets.

Klimt made sensitive portrait drawings of his family circle, and before he was well-enough established to afford professional models they frequently modelled for him. His sister-in-law Helene Flöge and her father Hermann Flöge can be recognised dressed up in sixteenth-century costume on the staircase of the Kunsthistorisches Museum and several members of the family can be identified in his painting of the interior of the old Burgtheater.

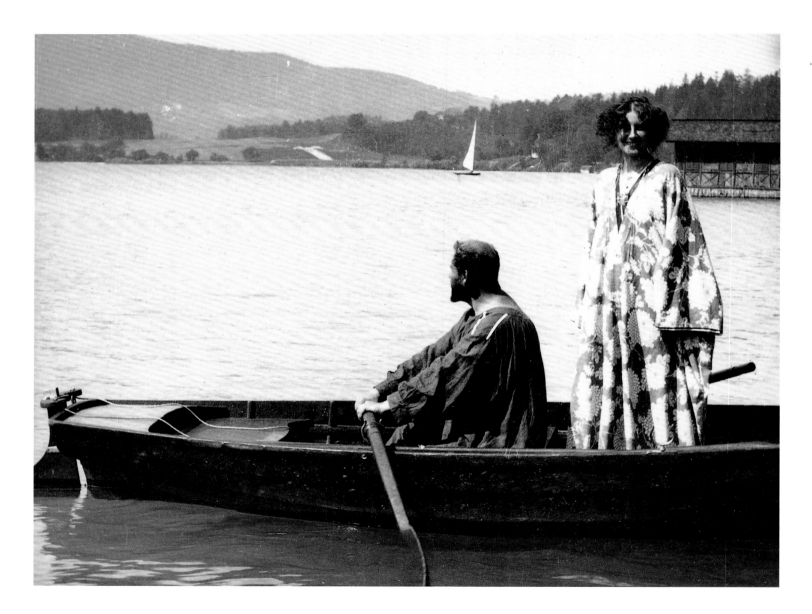

Gustav Klimt and Emilie Flöge in a rowing boat
on the Attersee Lake, c.1909–10

CHARACTER &
PERSONAL LIFE

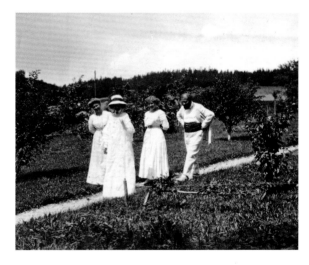

Gustav Klimt and friends walking
at the Attersee Lake, 1907

Klimt was a man of few words. In appearance he was muscular, hirsute and handsome in an earthy way hardly to be expected from the creator of such exquisitely refined and even decadent images. In his private life he was neither a dandy nor an aesthete and though he painted the wealthy and was welcomed into their houses, he was not a socialite. He was, however, what the Germans would call 'gesellschaftfähig' – presentable in society. He could maintain conversation with intellectual friends and flirt with Alma Mahler. Many photographs show him well-groomed, wearing expensive well-cut suits and sporting a cummerbund. He enjoyed physical exercise including wrestling, rowing and fencing and above all loved nature. There were frequent walks in the environs of Vienna and holidays (in as far as there can be such a thing for an artist as dedicated as Klimt) were taken over many years en famille with the Flöge sisters at the Attersee, amongst some of Europe's loveliest scenery.

For a man who remained intensely private throughout his life and who was apparently without great personal vanity we know about at least some aspects of his personal life in remarkable detail. This is down to Klimt's love of photography and the many informal photographs taken by Klimt himself or by his friends of Klimt in his everyday surroundings and amongst friends. These are exactly the kind of images that in our more narcissistic and exhibitionistic times would be posted on social media – Klimt in his garden, Klimt on holiday, boating on the Attersee, Klimt at a

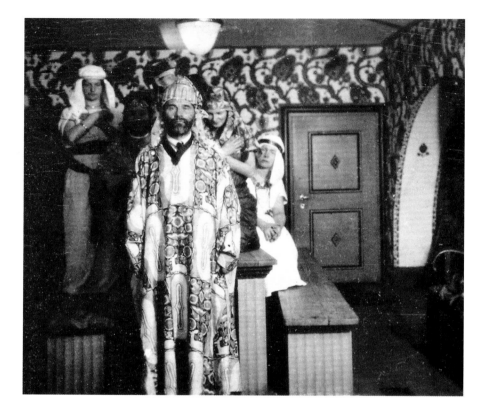

Gustav Klimt at an artists' gathering at Primavesi House in Winkelsdorf, wearing robes made from the Wiener Werkstätte fabric 'Waldidyll', 1916

picnic or a fancy dress party, Klimt on a trip to London in 1906, Klimt with his mother on her seventieth birthday.

Klimt was very much a woman's man. According to Alma Mahler, 'He was tied down a hundredfold, to women, children, sisters, who turned into enemies for love of him.'[1] He was clearly very attractive to women, including the beautiful Alma. We can trace the progress of their abortive affair in the pages of her diary, and through the distorting prism of her narcissism she affords us rare glimpses of Klimt the man along the way. She first mentions him on 9 February 1898, when she was in a state of exaltation after she had attended a performance of Fidelio at the Court Opera with the great dramatic soprano Lilli Lehmann. 'Nothing pleases me more than to be told that I am exceptional. Klimt for instance, said: "You're a rare unusual kind of girl, but why do *you* do this, that and the other, just like anyone else?"' By 10 March, when they were invited out by mutual friends, Alma's interest has gone up a notch.

Photograph of Klimt by Karl
Schuster, 1892, taken from a
sketchbook for Sonja Knips

'Klimt is such a dear man . . . Mama said: "The Zierers are bound to make remarks,
because Klimt sat with you (Alma) all evening and spoke to you so much." But he was
delightful, talked about his painting etc., then we talked about *Faust*, a work which he
loves as much as I do – No, he's really a delightful fellow. So natural, so modest – a
true artist!'

On 27 March she says: 'I was actually a little annoyed with him, because he said
I was spoilt by too much attention, conceited and superficial.' Evidently she had
forgiven him by 31 March: 'Walked very quickly as is my wont. Suddenly I heard hasty
steps behind me, *guessed* that it was Klimt, but just kept walking, and hid behind my
umbrella – So it went on, but then he took few strides and ended up beside me: "You
can hide behind your umbrella and walk as fast as you like, but you still can't escape
me," he said. "Will you get into trouble if I walk beside you?" I said not, although I was
inwardly uncertain. So he walked with me and was delightful company. He said he
wanted to escort me home, but I declined . . . Why didn't I walk home with him? It
would have been such fun!'

For a young lady of her period and respectable background Alma seems to
have been remarkably well-informed about Klimt's love life and there are spiteful
references in the diaries to Klimt's 'sister-in-law' (presumably Emilie rather than
Helene Flöge). In the Spring of 1898 Alma was also conducting a somewhat more
decorous flirtation with the visiting Belgian artist Fernand Khnopff. On 13 April
she recorded Khnopff's playful compliments and noted, 'I did not exchange a word
with Klimt.' And so Klimt and Alma's cat and mouse games continued until Klimt
overstepped the bounds of decorum and gave Alma her first passionate adult kiss on
an evening stroll through the Piazza San Marco in Venice.

It was an event that seems inevitable in the light of Alma's increasingly passionate
diary entries. 'I just saw the picture that Klimt is also in, and I want to put it in here
[the diary] . . . And indeed as I looked at that picture again today, I sensed, my struggle
is futile. I drown, and sink incessantly deeper, and suffer indescribably.' A little later she
wrote of another photograph of Klimt amongst friends, 'Most of all I would like to cut
out his lovely, lovely image, so that only he can be seen, but it is not necessary. Next to
him I see no other man anyway.' When the budding affair was discovered and nipped
in the bud by Alma's mother and her husband, Klimt's colleague and close friend
Carl Moll, Klimt wrote Moll a grovelling letter of apology and exculpation. This is the
longest letter written by Klimt that survives and is worth quoting at some length for

what it reveals about the character of this normally rather buttoned-up man:

'Alma has often sat next to me, and we talked together without any harm ... I have never courted her in any real sense – and even if I had, I would never have expected any success, there [are] many gentlemen coming to the house paying their addresses to her – I have had false suspicions of her and laboured under misapprehensions ... It was only very recently – the trip to Florence had already been decided on – that I noticed various things, the young lady must have heard a few things about my affairs, a lot of it true, much of it false. I don't know everything about my affairs myself and don't want to – but there is one thing I'm sure of – that I am a poor fool – to cut a long story short, from suggestive questions and remarks it seemed to me that the young lady was not entirely indifferent to these matters, as I had thought at first. This rather scared me, as I have nothing but awe and respect for true love, and I came rather into conflict with myself, in conflict with my true feelings of friendship for you, but I consoled myself with the thought that it was just a little game on her part, a mood. Alma is beautiful, intelligent, and witty, she has everything a discriminating man could require of a female .. . but even as a game it seemed disastrous to me, and it would have been my job to be sensible, as I have more experience, and this is where my weakness begins ...

Then that evening in Venice came. I am an embittered person, and this sometimes expresses itself in malice that is not without its dangers, which I deeply regret afterwards. So it was here as well. I had been drinking rather more quickly than was wise, I am not trying to excuse myself here – what I said was rather more careless than it usually is, and this is probably what you heard, and from what you drew your own conclusions, which are certainly too wicked, too black ... Dear Moll, forgive me and Miss Alma, I don't think it will be difficult for her to forget about it.'[1]

In fact Alma remembered the ecstasy of her first kiss in St Mark's Square for the rest of her life.

Alma Schindler, later Mahler, 1900

Klimt's claim that he had not courted Alma was disingenuous and for a man of Klimt's age and experience to lay the blame on a girl young enough to be his daughter for leading him on, seems ignominious, not to say ungentlemanly. Nevertheless, if we are to believe the knowing and manipulative portrait that Alma painted of herself in her dairy, Klimt's account was probably truthful.

After the first years of his career, Klimt focused entirely upon women for his subject matter. This was not so unusual in the period 1870–1914. Degas, Renoir, Félicien Rops, Helleu, Gustave Mossa and Giovanni Boldini were all artists who fixated on the female sex, though none perhaps to the same extent as Klimt.

Klimt's sexual appetites were legendary. Rumours abounded of his affairs with the elegant society women who commissioned portraits from him. Whether such rumours had any factual basis or not, sex was plentifully available to Klimt with the models who came to pose in his studio on a daily basis throughout his career. It was generally assumed in the nineteenth century that any woman who was prepared to take her clothes off for money would also be available for sex. Earlier in the century Delacroix marked the margins of his diary entries with crosses for the number of times he had sex with his models and lamented the energy he expended upon sex rather than painting. Ellen Andrée, a popular artist's model who posed for Degas and Renoir amongst many others, was described thus in *The Pretty Women of Paris*: 'A very pretty fair woman, whose talents are small, although her body is in splendid proportion for such a tiny creature. Her principal lovers are among the artists of the capital, to whom she has often stood as a model. She has been photographed in many attitudes, but always destitute of all clothing, and these studies from life are to be bought all over Paris for a small sum.' The loose fitting smock resembling a monk's robe that Klimt wore in his studio was practical not only for the messy business of painting but also for impromptu sex with his models.

Klimt may have had up to sixteen illegitimate children. After he died, fourteen claims of paternity were made against his estate of which four were acknowledged. These did not include his son Otto, who had died in infancy, and the Baroness Elisabeth Bachhofen-Echt, who later claimed that her biological father was Klimt in order to escape Nazi persecution. Klimt himself acknowledged three of his children – a son, Gustav, with the model Maria Ucicka and two sons, Gustav and Otto, with another of his models Mizzi Zimmermann, whom he supported financially and with whom he maintained an affectionate correspondence over many years.

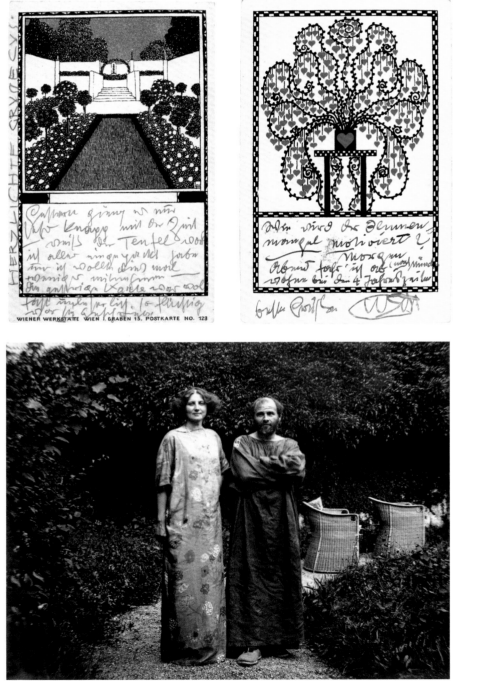

RIGHT Wiener Werkstätte postcard no. 69, written by Gustav Klimt to Emilie Flöge, dated 7 July 1908

BELOW Gustav Klimt and Emilie Flöge in the garden of the Oleander villa, Attersee, 1910

Portrait of Emilie Flöge, pastel on card, 67 × 41.5 cm, with frame painted by Klimt, 1891, private collection

Klimt never married. Perhaps like George Bernard Shaw he believed that 'Of all human struggles there is none so treacherous and remorseless as the struggle between the artist man and the mother woman', and that creativity and domesticity are incompatible. Klimt's multiple and careless paternities put him in a league with Gauguin and Rodin, though to give Klimt his due there is evidence that he was a caring if somewhat distant parent to three of his offspring.

Klimt maintained one relationship with a woman throughout his adult life and that was with his sister-in-law Emilie Flöge. Ernst Klimt junior and Helene Flöge married in 1891 and had a daughter, Helene, soon after. When Ernst died suddenly in 1892, Klimt was made his niece's guardian and became a frequent guest of the Flöge family. Emilie was eighteen when they first met and opinions differ as to whether their relationship was a physical one or not. There are those who believe that there was a brief love affair that morphed into deep friendship and others that the relationship was never consummated physically. Klimt's friend from his Attersee holidays, Rudolf Schuh, noted, 'He [Klimt] has taken the youngest Flöge sister as his bride, a fabulously beautiful creature.'[2] What we can see from the many photographs taken of them together over the years, is that they had a loving and intimate friendship. A collection of around two hundred letters and postcards that Klimt wrote to Emilie that came up for sale at Sotheby's in 1999 gave the same impression. Klimt would write up to eight missives a day to Emilie with intimate details of daily life and health but no great declarations of passion. It is possible that Klimt, like Degas, was one of those men who divided women into those with whom one could have social intercourse and those with whom one could have sexual intercourse, though in Klimt's case it is complicated by the sexual affairs he was rumoured to have had with the society women who commissioned portraits from him.

Klimt was one of the highest earning portrait painters of his day. Had he so chosen he could easily have commissioned his friend and colleague Josef Hoffmann to build a palatial studio-villa like those of Frederic Leighton, Lawrence Alma-Tadema, Lenbach, Franz von

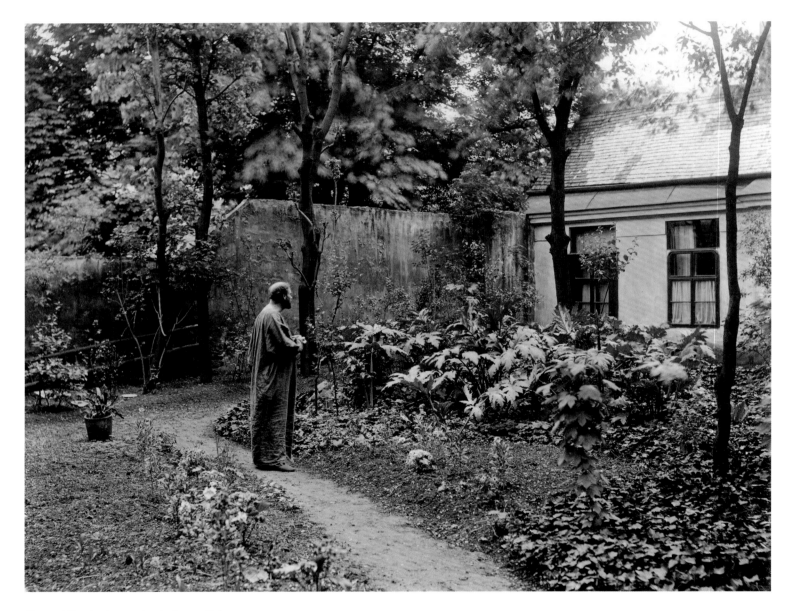

Gustav Klimt in the garden in front of his
studio at Josefstädterstrasse 21 in Vienna's
8th district, c.1910

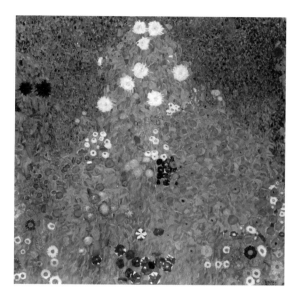

Flower Garden, 1905–07, oil on canvas,
110 × 110 cm, private collection

Stuck and many other successful painters of the late nineteenth century. Houses and studios were often used to attract wealthy clientele. Edmond de Goncourt left a splendidly bitchy account of a visit to James Tissot's studio-villa in the elegant inner London suburb of St John's Wood, where Tissot employed liveried footmen to serve champagne to the well-heeled visitors and to polish the leaves of plants. In Vienna itself Hans Makart had occupied a huge and luxuriously appointed studio recorded in photographs and in a meticulous watercolour by Rudolf von Alt. Makart's studio became an important centre of Viennese cultural life. As a student Klimt was sufficiently curious about Makart's famous studio to bribe his servant to let him in to look around during the master's siesta[3] but felt no desire to emulate the princely splendour of his lifestyle. Instead, Klimt continued to share the apartment with his mother and sisters on the Westbahnstrasse.

From 1891 Klimt worked in a studio in the Josefstädterstrasse, sharing it initially with his brother Ernst and their partner Franz Matsch and later, after his brother's death and his split with Matsch, taking it over entirely himself until its demolition in 1911. The Josefstädterstrasse studio was far from luxurious by standards of the Belle Epoque but it boasted a charming walled garden that compares interestingly with other famous artists' gardens of the period such as those of Max Liebermann, Emil Nolde and of course Claude Monet. The unkempt profusion of Klimt's garden, in which he cultivated the flowers he liked to paint, expressed his personality every bit as much as the more ordered and calculated prodigality of Giverny did that of Monet. In Klimt's depictions of gardens (other people's as well as his own) it was the gorgeous – one might even say the erotically charged – fecundity of nature that principally attracted him.

The Josefstädterstrasse studio and its gardens were inhabited by a tribe of cats. One friend, Emil Pirchan, recounted, 'Six, eight and more cats chased to and fro within, and as he was unable to part with any of these animals so dear to him, one had to secretly kill some of them off from time to time, for the rapidly reproducing throng had already wreaked all manner of destruction to his drawings.'[4] The appearance of the simple low-ceilinged hall to the Josefstädterstrasse studio was recorded in a photograph in 1911 shortly before Klimt was forced to leave it. We see a skeleton in a corner and Klimt's painting *Hope* propped against the back wall. The sleekly elegant studio furniture given to Klimt by his designer colleague Josef Hoffmann looks oddly incongruous in such simple, almost rustic, surroundings.

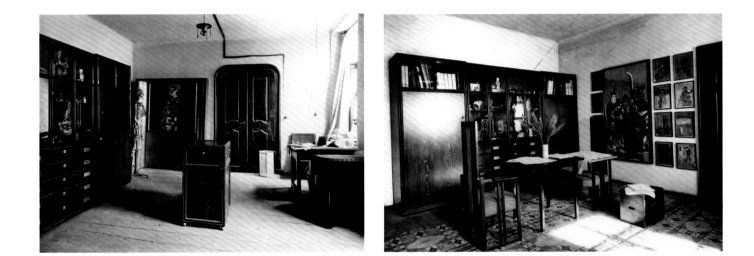

Klimt's final studio in the Feldmühlgasse, which he took in 1912, was photographed shortly after his death in 1918. While it is far more elegant than the Josefstädterstrasse, it is still a far cry from the opulent clutter of Makart's studio. The Hoffmann furniture was now rather more artfully arranged and the white walls decorated with a large Chinese painting and Japanese woodcuts framed simply and hung symmetrically. The young Egon Schiele recorded his awed impression after a visit to this studio. 'Upon entering one first came into the hall, from which the left door led into his reception room. In the middle stood a square table, all around Japanese woodcuts were hung closely side by side, and two large Chinese pictures, while on the floor lay Negro sculptures, in the corner there stood a red and black Japanese suit of armour. From this room one reached two other rooms, from which one had a view over rose bushes . . . There Klimt showed me his pictures that were in progress. He painted a series of women portraits and pictures of figures in Hietzing . . . moreover a large number of best landscapes of the Attersee and Lake Garda, which Vienna did not yet know . . . Moreover, hundreds of hand drawings are lying in Feldmühlgasse, of which one surely saw only occasional sheets in exhibitions.'[5] After Klimt's death Schiele commented, 'Nothing should be removed, for the structure of Klimt's house is an entity, it is a work of art in itself, which should not be destroyed. The unfinished pictures, the paintbrushes, the painting table, the palette should be left untouched, and be made accessible as a Klimt museum.'[6]

LEFT Anteroom of Gustav Klimt's studio at Josefstädterstrasse 21, c.1910.

RIGHT Anteroom of Gustav Klimt's studio at Feldmühlgasse 11, used by Klimt from 1914 until his death, photograph c.1915

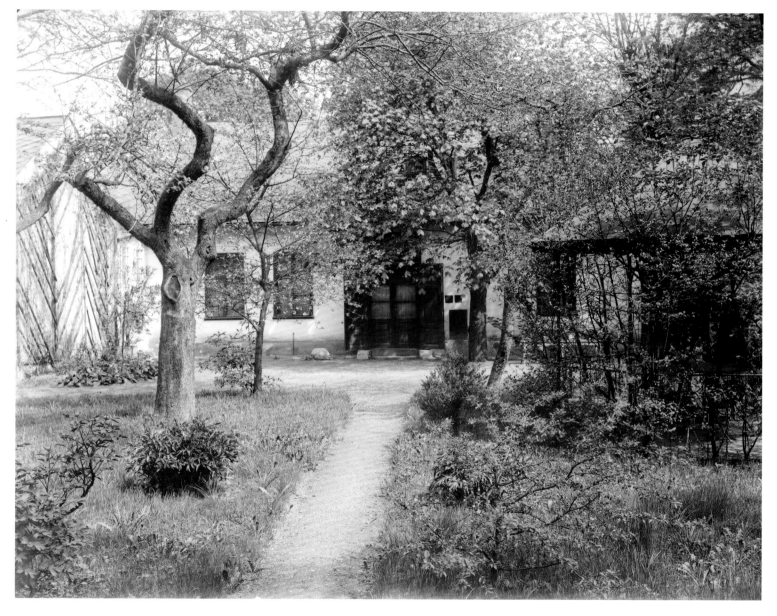

The garden of the studio at Feldmühlgasse 11, c.1915

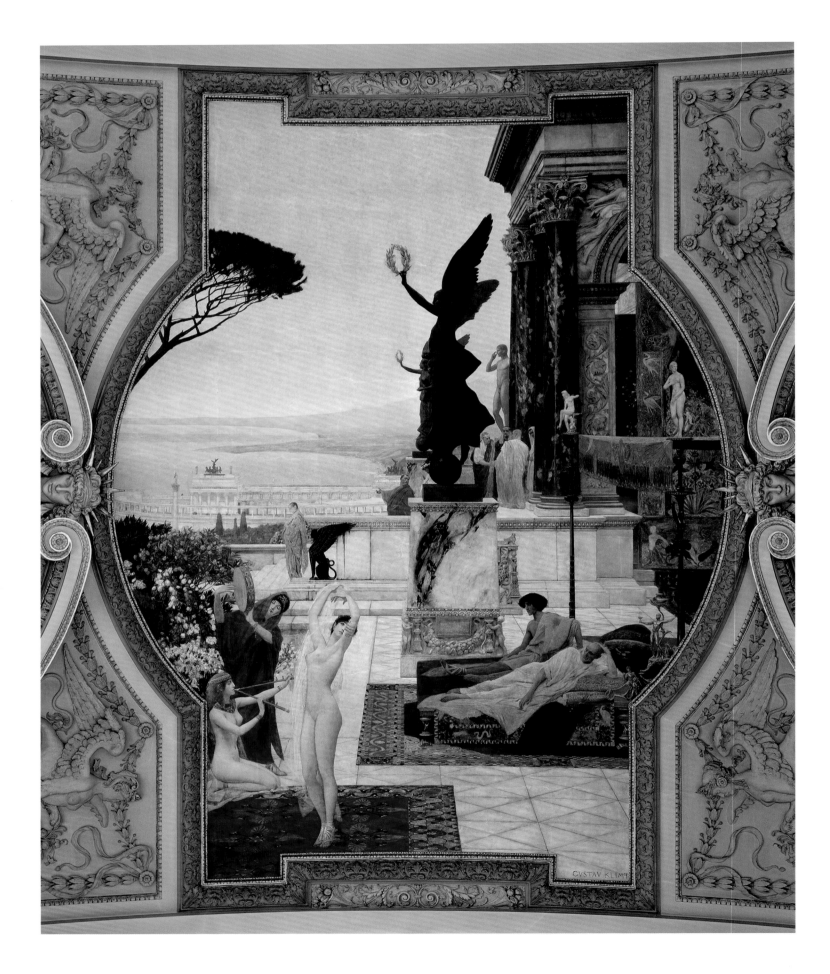

THE ORIGINS OF KLIMT'S STYLE

· ·

The Theatre in Taormina, 1886–88, oil on marble plaster, ceiling painting at the Burgtheater, Vienna

There can be few artists whose work is as easily recognisable from across a wide gallery space as that of Gustav Klimt. There can also be very few artists who have thieved as widely and blatantly from other artists as did Klimt. Amongst the extraordinarily varied ingredients of Klimt's mature style are the festive decorations of Hans Makart, the Pre-Raphaelites, the Aestheticism of James McNeil Whistler, the Symbolism of Fernand Khnopff, the Impressionism of Claude Monet, the expressionism of Vincent van Gogh, the stylisations of Ferdinand Hodler and Franz von Stuck, the Habsburg portraits of Velazquez, Ravenna mosaics, Greek vase painting and Japanese woodcuts. A musical equivalent of this magpie eclecticism would be Klimt's close contemporary Giacomo Puccini. Both were able to fuse their borrowings into a highly individual style that is entirely their own. As Picasso liked to say, only bad artists borrow. Good artists steal. The ability of both Klimt and Puccini to fuse their disparate borrowings into a style that was utterly personal was a sign of strength rather than of weakness.

Following in the footsteps of his father, who, as a gold engraver, was a craftsman rather than an artist with a capital 'A', Gustav Klimt enrolled in the Vienna School of Applied Arts (Kunstgewerbeschule), rather than in the more prestigious Academy of Fine Arts. The Kunstgewerbeschule had been created in 1868 in conjunction with the Austrian Museum for Art and Industry, both inspired by the South Kensington Museum (later Victoria and Albert Museum) and its attendant school (later Royal

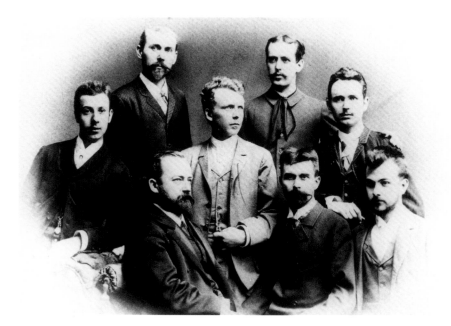

The class of Ferdinand
Laufberger at the Wiener
Kunstgewerbeschule: in
the front row, Ferdinand
Laufberger, Gustav and Ernst
Klimt, and in the third row
(wearing a dark suit) Franz
Matsch, c. 1880

College of Art) in London. The intention was to train skilled art workers rather
than fine artists. It was perhaps to Klimt's advantage that he did not attend the
notoriously conservative and prescriptive Academy, an institution whose greatest
claim to fame is that it rejected Adolf Hitler twice on grounds of his 'unfitness
for painting' – a decision that may have had more impact on the course of the
twentieth century than any other taken in Vienna at this time.

A few years earlier Rodin had taken a similar path, training as an applied artist
at the Petite École, after failing to gain entrance to the more prestigious Écoles des
Beaux-Arts in Paris. This left both Klimt and Rodin more open perhaps to other
influences and freer to experiment. However, even for artists destined for the
applied or decorative arts, life drawing was considered the basis of all art education.
There are plenty of life drawings surviving from Klimt's student years and shortly
after that could be by any well trained artist of the late nineteenth century. As with
Rodin, the competence that Klimt gained in drawing the human figure continued to
serve him well for the rest of his career.

Klimt was joined at the Kunstgewerbeschule by his younger brother Ernst.
The brothers formed a close alliance with fellow student Franz Matsch. The three

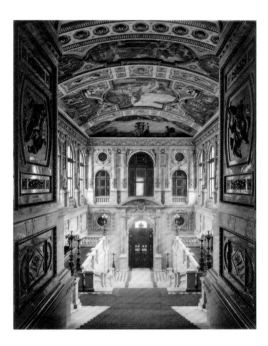

The north staircase of the
Burgtheater in Vienna, with
paintings by Gustav Klimt, 1894

young artists found a mentor in their professor Ferdinand Laufberger, who not
only ensured that they had a thorough grounding in all the techniques they would
later need but provided them with their first great career break, even before they
graduated from the school in 1883, by recommending them to the architectural
firm of Fellner and Helmer, which specialised in the design of theatres. The period
1870–1914 saw an extraordinary proliferation of theatre building all over Europe.
In Britain more than two hundred theatres were built to the designs of just three
architects; Frank Matcham, Bertie Crewe and W.G.R. Sprague. Fellner and Helmer
were the equivalent in Germany, the Habsburg Empire and as far east as Odessa,
designing around two hundred buildings that were mainly theatres.

The team of the Klimt brothers and Matsch, working from the studio in
Josefstädterstrasse that they took together, produced a whole series of decorative
schemes for theatres designed by Fellner and Helmer, including the Kurhaus in
Karlsbad (1880), the Stadttheater in Reichenberg (1882–3), the Stadttheater in
Fiume (1883–5), the National Theatre in Bucharest (1885) and the Stadttheater in
Karlsbad (1884–6).

After the team had proved itself in the provinces and abroad, this phase of their
careers culminated in 1886 with the prestigious commission to paint murals on the
staircases of the new Burgtheater constructed on the Ringstrasse to the designs
of Gottfried Semper and Karl Freiherr von Hasenauer. The theme of the murals
was the history of Western theatre. Gustav Klimt was assigned *The Cart of Thespis*,
Shakespeare's *Globe Theatre in London*, *The Theatre of Taormina*, *The Altar of Dionysus*
and *The Altar of Apollo*. The technique used was oil on a specially prepared surface
of ground marble and chalk, enabling much brighter colour and sharper detail than
would have been possible in fresco.

Klimt's biographer Christian Nebehay has pointed out the striking similarity of
pose between the nude female in the foreground of Klimt's *The Theatre in Taormina*
and Frederic Leighton's *The Bath of Psyche*. Though Klimt would certainly have
been aware of Leighton's work, *The Bath of Psyche* was not exhibited till 1890, two
years after the completion of the Burgtheater murals and the similarity must derive
from the use of a common source, most likely the antique statue known as the
Callipygian Venus in the Capodimonte Museum in Naples. In fact, Klimt's cluttered
and somewhat cinematic vision of the antique world has less to do with such
high-minded nineteenth-century classicists as Leighton, Feuerbach, Albert Moore

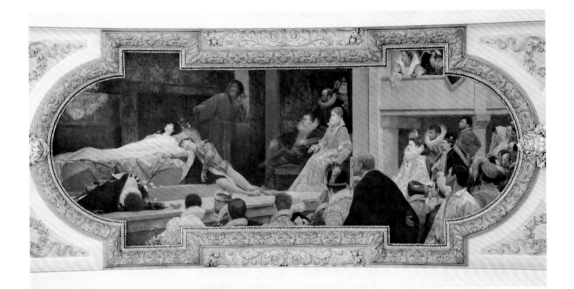

Shakespeare's Globe Theatre in London, 1888, oil on marble plaster, Burgtheater staircase, Vienna

or Puvis de Chavannes than with artists such as Alma-Tadema and Gérôme, who attempted to create an archeologically correct and quasi-photographic version of the ancient world.

In *Shakespeare's Globe Theatre in London*, which depicts an Elizabethan performance of the final scene from *Romeo and Juliet*, Klimt's photographic style and his dependence on photographic studies is even more evident. Several photographic studies of members of Klimt's siblings dressed in historical costume, including one of Ernst Klimt in the pose of the dying Romeo, still exist. The glossy, academic technique used in this picture resembles the work of artists popular at the Paris Salon, such as Gérôme and Cabanel, and indeed the similarity to Cabanel's *Death of Francesca da Rimini and Paolo Malatesta* of 1870 is too strong to be coincidental.

Klimt's work at the Burgtheater is highly accomplished but somewhat anonymous in character. Indeed, without documentary evidence it would be quite hard to distinguish Klimt's work from that of his two colleagues. A more personal and individual Klimtian style first became evident in the paintings Klimt provided for the entrance staircase of another great building on the Ringstrasse, the Kunsthistorisches Museum, constructed again by Gottfried Semper and Karl Freiherr von Hasenauer, between 1871 and 1891. The original and almost inevitable choice of artist for this scheme was Hans Makart, the 'painter-prince' of the Ringstrasse. But Makart died at the early age of 44 in 1884, having completed just twelve of the lunettes. At first it was intended to offer the painter trio of Matsch and the Klimt brothers the somewhat thankless task of painting

Drawing for *Tragedy*, 1897,
black chalk, pencil, wash,
white and gold highlights,
41.9 × 30.8 cm, Wien
Museum, Vienna

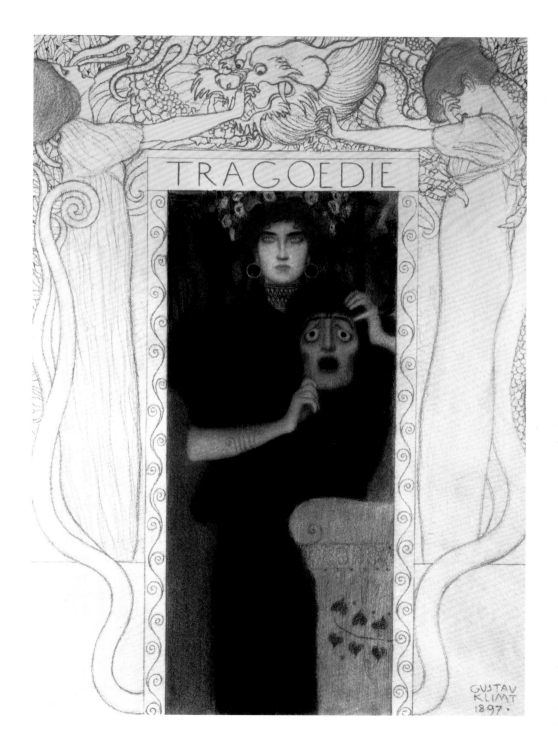

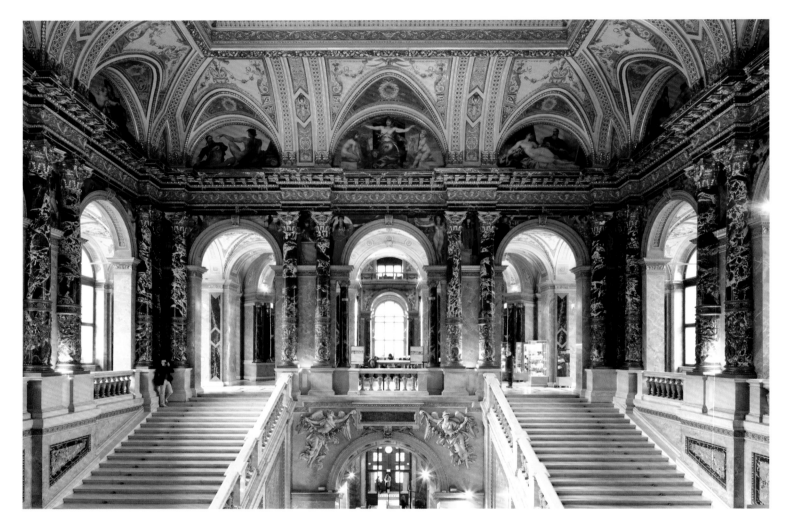

Staircase of the Kunsthistorisches
Museum, built in 1891 by Karl von
Hasenauer and Gottfried Semper

Ancient Greece II, 1890–91, oil on stucco base,
230 × 80 cm, Kunsthistorisches Museum, Vienna

the great central panel of the ceiling from Makart's
sketches, but in the end the commission for this space
was entrusted to another celebrated 'painter-prince',
the Hungarian Michael von Munkácsy, who was paid
the enormous sum of 50,000 gulden.

Klimt was given another task that many artists
would have found thankless. He had to fill the
awkward spaces of eight spandrels and three inter-
columnar panels. The challenge brought out what was
to be Klimt's most telling characteristic – his ability to
fill space decoratively and meaningfully. The fact that
each panel had to illustrate a different period of art
from the museum's collections, from ancient Egyptian
to Italian Renaissance, also played to Klimt's penchant
for eclecticism. Klimt clearly delighted in rummaging
through the museum's collections in search of
authentic historical detail with which to embellish
each image of a particular period, but whether
Egyptian, Greek, Flemish or Italian Renaissance it all
turns out unmistakably Klimt. The young girl in the
panel illustrating Greek art, with her Pre-Raphaelite
hair and her decidedly fin-de-siècle allure, is especially
prophetic of Klimt's later images of women.

Though Klimt's panels for the Kunsthistorisches
Museum were considered a success, the somewhat
incongruous contrast they present with all the other
panels on the staircase and in particular with the flashy
perspectival illusionism of von Munkácsy's ceiling was a
sign of things to come and of the impending problems
with his next, and last, public commission for ceiling
paintings for the Aula of Vienna University.

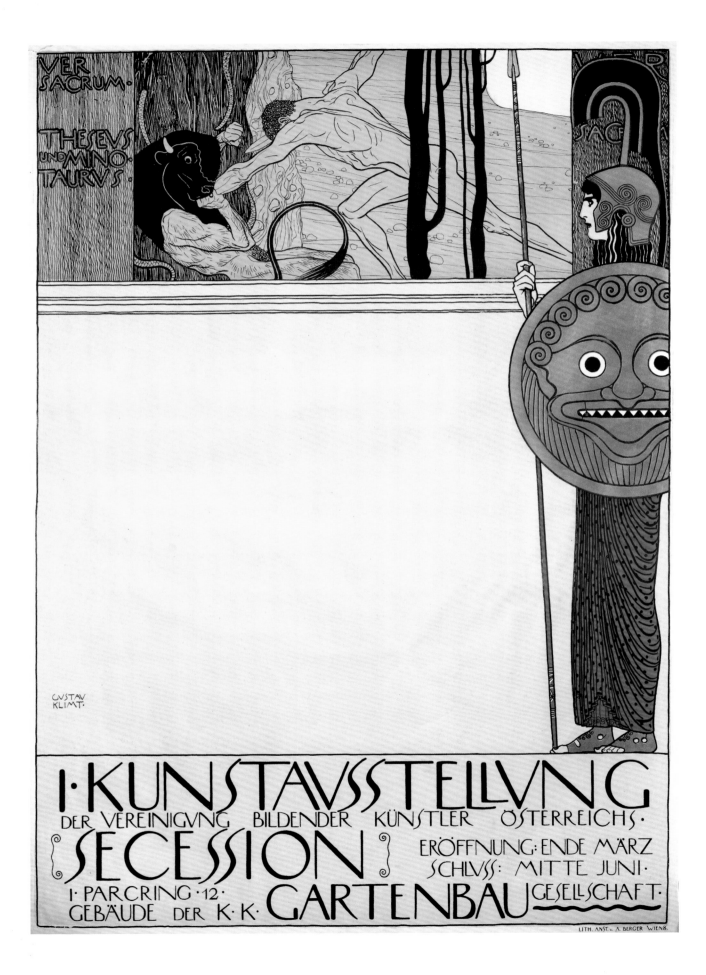

SECESSION

· ·

Poster for the exhibition of the
First Secession, censored version,
1898, lithograph, 62 × 43 cm,
Wien Museum, Vienna

In the last years of the nineteenth century several German-language art magazines were launched with the common aim of promoting modern German art and raising awareness in German speaking countries of international modernism. These included *Dekorative Kunst* (founded in 1887 by Friedrich Bruckmann and Julius Meier-Graefe), *Pan* (founded in Berlin in 1895 by the poets Richard Dehmel and Otto Julius Bierbaum and the ubiquitous Julius Meier-Graefe) and the somewhat more conservative and nationalist *Deutsche Kunst und Dekoration* (1897). Initially the editorial attitude of these magazines towards Vienna and its art scene was condescending, if not outright contemptuous. Vienna was seen as a bastion of conservatism and represented everything dusty and reactionary that these magazines wanted to sweep away. In particular, they mocked the pompous wedding-cake historicism of the Ringstrasse and the kind of overblown art associated with it. A particular problem, as far as the fine arts were concerned, was the strangle-hold exerted by the Künstlerhausgenossenschaft, founded in 1861 under the presidency of August Sicard von Sicardsburg, architect of the Imperial Opera House. As the only viable exhibiting body in Vienna, the Künstlerhausgenossenschaft held a position similar to that of the Salon in Paris in the mid-nineteenth century.

All that changed almost overnight when Vienna 'went modern' in 1897. In that year the dynamic young Mahler brought a new broom to the Court Opera, making it the most dynamic and progressive opera company in the world, and a group of more

progressive artists, who had been conspiring in the cafés of Vienna to create a more liberal exhibiting body, broke away from the Academy to form the Vienna Secession. The Vienna Secession was not the first in the German speaking lands. It was preceded by the Munich Secession in 1892 and followed by the Berlin Secession in 1898, but it became by far the most important and influential. The desire of young and progressive artists to break with a stuffy and repressive establishment was an international phenomenon in the second half of the nineteenth century. As usual, Paris led the way with the eight Impressionist shows between 1874 and 1886 and the creation of the Salon des Independents in 1884. In London in the 1870s the Grosvenor Gallery showed pictures such as Whistler's 'Nocturnes' and the paintings of Burne-Jones that would have been unlikely to be accepted by the Royal Academy. This was followed in 1885 by the creation of the more radical New English Art Club, which, despite its name, was remarkable for its openness to new tendencies in French painting.

The Union of Austrian Artists (Vereinigung Bilderer Künstler Österreichs), known as the Secession, was founded on 3 April 1897. Initially the founding members did not intend to resign from the Künstlerhausgenossenschaft. Klimt wrote to the committee of that organisation in emollient terms to explain the motives of the dissident artists: 'As the committee must be aware, a group of artists within the organisation has for years been trying to make its artistic views felt. These views culminate in the recognition of the necessity of bringing artistic life in Vienna into more lively contact with the continuing development of art abroad, and of putting exhibitions on a purely artistic footing, free from any commercial considerations; of thereby awakening in wider circles a purified, modern view of art; and lastly, of inducing a heightened concern for art in official circles.'[1] But the committee of the Genossenschaft under its irascible, reactionary president Eugen Felix was not prepared to be mollified and passed a motion of censure against the rebel artists prompting the resignation of Klimt and twelve others, including Joseph Maria Olbrich, Carl Moll and Kolomon Moser. Other resignations followed, though the respected architect Otto Wagner remained a member of both organisations until November 1899.

In 1898 the first volume of the Secession magazine *Ver Sacrum* listed fifty founding members. These included the painters Josef Engelhart, Max Kurzweil, Carl Moll, Kolomon Moser (better known for his graphic work and design) and Alfred Roller (best known as a stage designer), and the architect-designers Otto Wagner,

ABOVE Joseph Maria Olbrich (far left) with Kolomon Moser and Gustav Klimt (on the right) in the garden of Fritz Wärndorfer in Vienna

BELOW Group picture, taken at the time of the foundation of the Vienna Secession, including Josef Hoffmann on the far left, Carl Moll with hat and stick, Gustav Klimt, Alfred Roller, Fritz Wärndorfer in front, and Kolomon Moser standing behind on the right wearing a stove-pipe hat

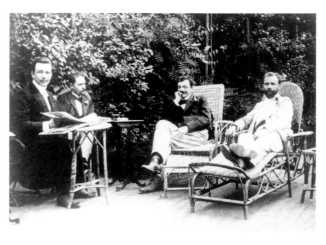

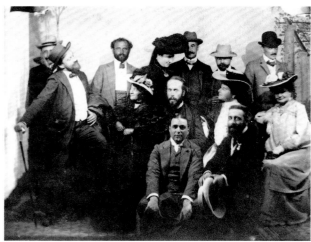

Josef Hoffmann and Joseph Olbrich. The Paris-based Czech artist Alphonse Mucha, as a citizen of the Habsburg Empire, also qualified for full membership. Guest members from abroad included the French artists Aman-Jean, Bartholomé, Carabin, Carrière, Helleu, Puvis de Chavannes and Rodin, and Franz von Stuck, Max Klinger and Max Liebermann from Germany. Giovanni Segantini represented Switzerland (Hodler is a surprising omission at this stage) and Meunier Belgium. Walter Crane was the sole British artist included. Though these foreign artists represented a wide range of advanced tendencies, none, with the possible exception of Rodin, could be described as revolutionary. It would seem that at this stage at least, the Secession was opening up the Viennese art scene to international modernism with a degree of caution.

The editorial of the first issue of *Ver Sacrum* set out the programme of the new organisation: 'We desire an art not enslaved to foreigners, but at the same time without fear of hatred of the foreign. The art of abroad should act as an incentive to reflect upon ourselves; we want to recognise it, admire it, if it deserves our admiration; all we do not want to do is imitate it. We want to bring foreign art to Vienna not just for the sake of artists, academics and collectors, but in order to create a great mass of people receptive to art, to awaken the desire which lies dormant in the breast of every man for beauty and freedom of thought and feeling.'[2]

Initially many of the links with foreign artists were established through the painter Josef Engelhardt, an artist of a very different stamp than Klimt but who was well travelled, multi-lingual and had studied in the two most important art centres of Europe, Paris and Munich. In his memoirs Engelhardt recalled, 'Since I knew many of the artists in question through my studies in Germany and France, and also possessed the necessary knowledge of languages, it devolved upon me to undertake trips to Germany, France, Belgium and England in the service of the organisation. On these trips, I made the personal acquaintance of nearly all the great painters and sculptors of the day, and for the most part succeeded in convincing

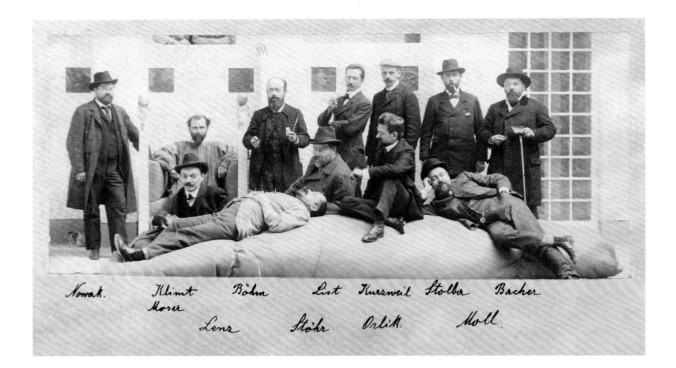

them of the honourable, artistic intentions of the newly founded association. In this way, I met the sculptors Rodin, Barthomomé, Lagae, the painters Besnard, Boldini, Brangwyn, Carrière, Dagnan-Bouveret, Dill, Herterich, Khnopff, Klinger, Lavery, Meunier, Puvis de Chavannes, Raffaëlli, Roll, Rops, Sargent, Swan, Uhde, Whistler and others. All these and many other important artists willingly declared their support, and made their works available for the exhibitions of the Secession, as the new association was called.'3

The honorary president of the new organisation was the veteran watercolourist Rudolf von Alt, much admired by the younger generation for his meticulous technique and the truthfulness of his vision. Alt, who had been ennobled in 1889, was delegated to invite the Emperor to the first Secession exhibition. The Emperor received Alt personally and was surprised to find an 86-year-old representing the young artists. Punning on his name (*alt* means old in German), Alt told the Emperor 'I really am Alt, Your Majesty, but I feel young enough to start all over again.'4

Group picture of the Secession artists in the main hall of the fourteenth exhibition, 1902
From left to right: Anton Nowak, Gustav Klimt (in a chair crafted by Ferdinand Andri), Kolomon Moser (sitting in front of Klimt), Maximilian Lenz (lying outstretched)
Standing: Adolf Boehm, Wilhelm List, Maximilian Kurzweil, Leopold Stolba, Rudolf Bacher
Sitting in front: Ernst Stoehr, Emil Orlik, Carl Moll.

Klimt was the inevitable choice as executive president of the Secession. Though a man of few words, he was also a man of unmistakable authority. A famous photograph shows Klimt at the Secession seated magisterially in an armchair surrounded by his colleagues and looking like a king amongst his court.

The first exhibition of the Secession opened just under a year later in March 1898 in the building of the Horticultural Society exhibition on the Ringstrasse, dating back to the 1860s. But if the building itself represented everything the young artists were rejecting, Joseph Maria Olbrich and Josef Hoffmann supervised the décor and made sure that the display was aesthetic and pleasing and quite unlike the dreary frame to frame and floor to ceiling hanging typical of nineteenth-century academic exhibitions. The catalogue too was a thing of beauty with a cover designed by Klimt and vignettes by Olbrich, Hoffmann, Alfred Roller and others.

For this first show, Klimt produced his most original and memorable poster design. The stylised figures depicted in profile derive from Greek vase painting but the strikingly asymmetrical composition with the central empty space containing Klimt's signature taking up approximately half the entire surface shows the influence of the Japanese aesthetic that had been so important to the Western avant-garde since the 1860s. The juxtaposition of Greek and Japanese elements recalls the famous closing statement of Whistler's 'Ten o'clock Lecture': 'The story of beauty is complete. It is hewn in the marbles of the Parthenon and embroidered on the fan of Hokusai.'

The frieze-like depiction of Theseus slaying the Minotaur along the top of the poster was intended to represent the struggle of the Secessionists against the forces of conservatism and philistinism. These struck back by ordering the censorship of Theseus's genitalia. Klimt had the last laugh. Instead of resorting to the cliché of a fig-leaf, no doubt expected by the censorship, Klimt covered the offending body part with the trunk of a tree, cheekily adding another element of Japanese asymmetry to the composition.

Amongst the foreign artists represented in the first Secession exhibition were John Singer Sargent, James McNeil Whistler, Frank Brangwyn, Walter Crane, Giovanni Segantini, Arnold Böcklin and the Belgian Symbolist Fernand Khnopff, whose work would have a marked influence on Klimt's depiction of women, as well as on his early landscapes. But undoubtedly the greatest coup of the Secession was to win the participation of the two most internationally venerated living artists – the sculptor Auguste Rodin and the Symbolist painter Pierre Puvis de Chavannes. Puvis

de Chavannes, who would die later that year, sent the cartoons for his final masterpieces, murals celebrating the life of Saint Geneviève commissioned for the Panthéon in Paris. The high-minded gravitas of Puvis de Chavannes' murals was a far cry from anything that Klimt would ever have wanted to paint, and Puvis always eschewed the kind of illusionism inherent in ceiling painting, but while Klimt was struggling with his commission for the university ceiling he would certainly have paid close attention to the work of an artist universally regarded as the world's greatest muralist. In particular, he would have been interested in Puvis' ability to simplify and synthesise form. The Nabis painter Eduard Vuillard wrote, 'The experiments in stylisation and in expressive synthesis which are typical of today's art were all present already in the art of Puvis.'[5] In this respect the influence of Puvis was as relevant to Klimt as it was to Gauguin, Seurat and the Nabis.

In a city notorious for its conservatism, the first Secession exhibition turned out to be an unexpected and more or less unqualified success, despite the inevitable sour reviews. There were 57,000 visitors and of the 534 objects on display 218 were sold.

The writer Hermann Bahr, who was one of the most consistent supporters of the new movement, was exultant. 'We have never seen such an exhibition. An exhibition in which there is not a single bad picture. An exhibition, in Vienna of all places, which is a resumé of the entire modern movement in painting. An exhibition which shows that we in Austria can boast of artists fit to appear beside the best of the Europeans, and measure ourselves by their standard. A miracle! And, what is more, a great joke! For this exhibition has shown that, even in Vienna, art, real art, can be big business! The hawkers in the Genossenschaft must be wringing their hands! Business, Herr Felix, big business! Just think! The Viennese – your Viennese, Herr Felix, whom you thought you knew so well – come by the dozen to buy works of art. They're buying Khnopff, Herr Felix!'[6]

Emboldened by the unprecedented success of their first exhibition, the Secessionists decided to create a permanent purpose-built space for their exhibitions. Thanks to the generous funding of

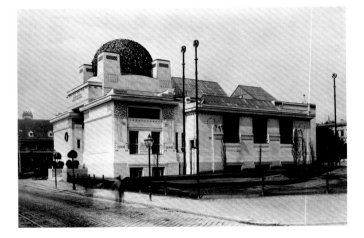

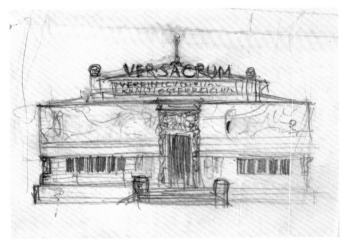

ABOVE The building of the Viennese Secession shortly after its completion, c. 1898

BELOW Sketch by Klimt for the facade of the exhibition building of the Viennese Secession, 1897

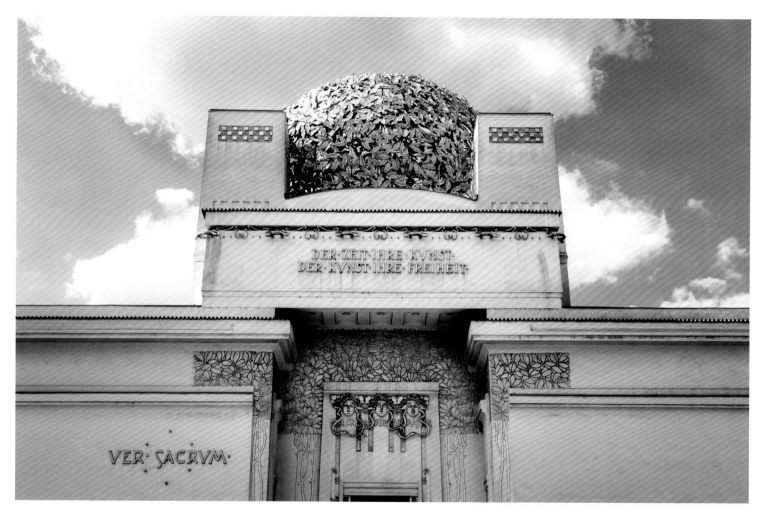

Secession building in Vienna with the inscription
'Der Zeit Ihre Kunst, Der Kunst Ihre Freiheit' – to
every time its art, to art its freedom

the steel tycoon Karl Wittgenstein, this was achieved in a remarkably short space of time in a prime location just off the Ringstrasse and, provocatively, in full view of the Academy of Fine Arts. The foundation stone was laid on 28 April 1898 and the building was ready for the second Secession exhibition by November of the same year. The design was by the architect Joseph Maria Olbrich, though surviving drawings show that Klimt had considerable input and influenced Olbrich to move towards a simpler and less pompous exterior. Klimt's sketches and comments in his letters suggest that he envisaged decorating the flat unbroken façade with mosaics or murals, but this was never carried out. The most striking feature of the exterior is the huge dome formed from three thousand gilded laurel leaves and seven hundred berries, earning the building the popular nickname of 'the golden cabbage'. The exotic form of the building, more like a mosque or a synagogue, and in striking contrast to the operatic baroque of the nearby Karlskirche (Church of Saint Carlo Borromeo), did not please everyone and one critic complained of its 'Asiatic silhouette'[7]. Other less polite descriptions included 'the Mahdi's Tomb' and 'the Assyrian toilet'. Inside, the most remarkable feature of the building was the flexibility of the spaces, enabling a wide variety of exhibitions.

Twenty-two exhibitions were held in the building between 1898 and 1905 in what may be regarded as the golden age of the Secession and of early modern art in Vienna. As president from 1897 to 1899 and the dominant figure at the Secession until 1905, Klimt must have exercised considerable influence over which foreign artists were invited to exhibit there, and in his own work he derived great benefit from them.

In the new purpose-designed premises, the ideal of the exhibition as *Gesamtkunstwerk*, with all the exhibits in harmony with one another and their surroundings creating a total work of art, could at last be realised. Inspired by the ideas of William Morris, the Secessionists also believed that there should be no differentiation between fine and applied arts. Kolo Moser, Josef Hoffmann and Joseph Maria Olbrich provided settings in which paintings and decorative art could be seen together in harmony. This time there were fewer foreign artists, though Khnopff and Anders Zorn were each represented by a number of works. Klimt exhibited seven pictures of which the most important were the exquisite portrait of Sonja Knips, marking his full maturity as a portrait painter, and the striking but sinister *Pallas Athene* in a metal frame made by his brother Georg. The fin-de-

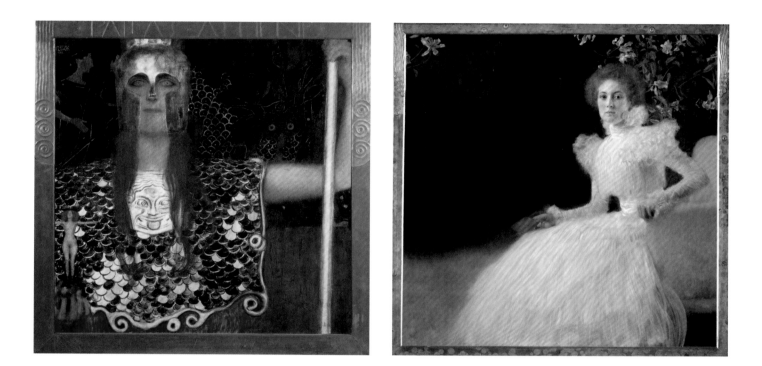

LEFT *Pallas Athene*, 1898, oil on canvas, 75 × 75 cm, Wien Museum, Vienna

RIGHT *Portrait of Sonja Knips*, 1898, oil on canvas, 145 × 146 cm, Österreichische Galerie Belvedere, Vienna

siècle flavour of this picture is strongly reminiscent of Franz von Stuck, whose work engaged Klimt around this time. In an ominous premonition of the scandal shortly to surround Klimt's university commissions, this picture was received with incomprehension and hostility. The flattened, cropped and asymmetrically placed forms were deemed ugly and eccentric and the tiny naked figure in the goddess's hand with bushy red pre-Raphaelite hair and pubic hair to match was a provocation.

Amongst the guest artists shown in the third Secession show (12 January–20 February 1899) were two Belgians whose work Klimt must have studied with particular interest, Theo van Rysselberghe and the recently deceased Félicien Rops. From the Neo-Impressionist Van Rysselberghe, Klimt borrowed the flickering pointillist technique that characterised several of his works around this time, including *Schubert at the Piano* shown at the following Secession exhibition; from Rops, the image of the femme fatale that first manifests itself in Klimt's oeuvre in the above mentioned tiny redhead in *Pallas Athene*.

The fifth Secession show (5 September 1899–1 January 1900) was entirely devoted to a group of French artists, evidently chosen to demonstrate the rich variety of tendencies in French art at the turn of the century. Though the term 'Impressionist' was applied to many artists in the late nineteenth century, the Viennese were now, for the first time, given the opportunity to see the work of artists who captured that mood and feeling. Eugène Carrière depicted domestic scenes suffused with pale brown fog. Degas' cynical comment was, 'Tut, tut. Who's been smoking in the nursery?' but the effect may have appealed to Klimt, who introduced a similar mistiness into several of his pictures at this time. The other artists represented were the familiar Puvis de Chavannes and the Intimist and brilliant graphic artist Felix Vallotton.

The seventh Secession show, in addition to occasioning the scandal surrounding Klimt's *Medicine*, presented the work of the Dutch Symbolist Jan Toorop, whose stylised pattern making and rampant female hair clearly influenced *Philosophy*, the last of Klimt's university paintings.

The eighth show (3 November–27 December 1900) was notable for the introduction of the Glasgow Four (Charles Rennie Mackintosh and his wife Margaret Macdonald, Herbert and Frances McNair) for whose work the Viennese artists and designers felt a profound affinity, and for the consequent commission from the Mackintoshes of the famous Wärndorfer music room.

The twelfth and thirteenth Secession exhibitions presented the Norwegian Edvard Munch and the Swiss Ferdinand Hodler, both of whom fed Klimt's inspiration (particularly the latter). Other notable Secession shows included the fourteenth (15 April–27 June 1902) in which Max Klinger's huge polychrome sculpture was displayed and for which Klimt created his *Beethoven Frieze*, the sixteenth which presented an ambitious retrospective of modern French art, and the eighteenth which, for the first time, was devoted entirely to the work of Klimt.

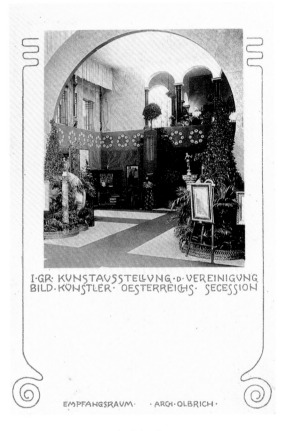

Promotional postcard of the first exhibition of the Secession, design by Joseph Maria Olbrich, 1898

LEFT Room designed
by Charles Rennie
Mackintosh and Margaret
Macdonald Mackintosh
for the eighth exhibition
of the Secession,
reproduction from *Ver
Sacrum*, volume 4, 1901

RIGHT Photographic
postcard of the fourteenth
exhibition of the Vienna
Secession, showing Klimt's
Beethoven Frieze and a
view in the central hall to
Max Klinger's Beethoven
sculpture

BELOW Poster of the
fourth exhibition of the
Vienna Secession, colour
lithograph, 1899

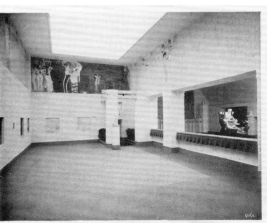

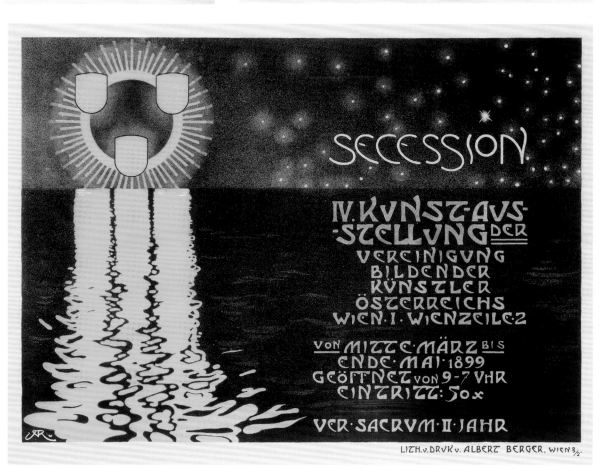

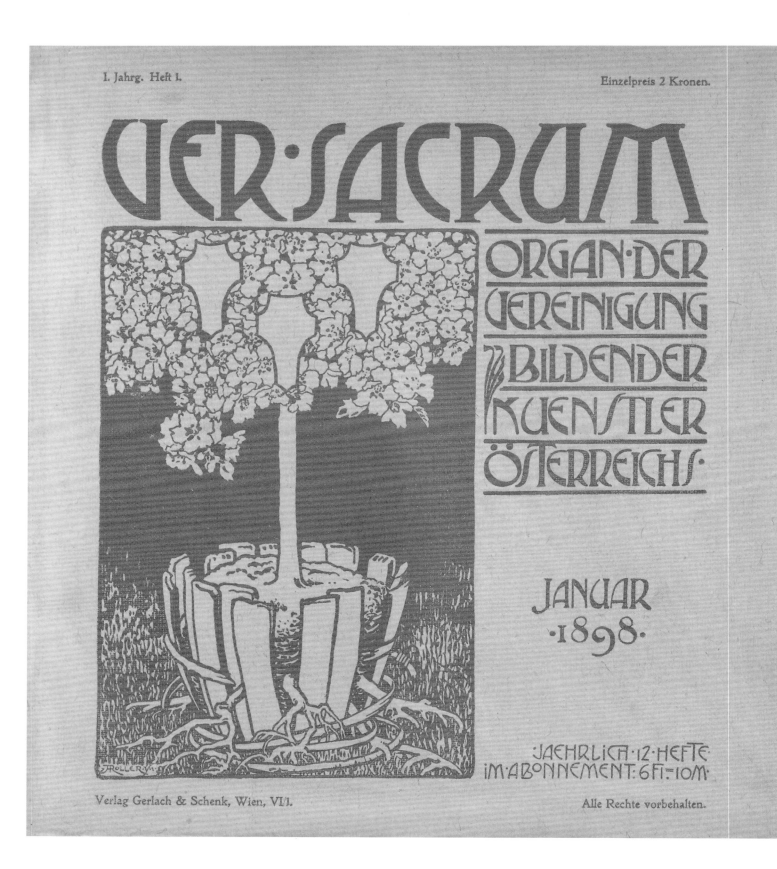

VER SACRUM

· ·

Cover of the first issue of *Ver Sacrum* by Alfred Roller, published by Gerlach & Schenk, Vienna 1898

The 1890s saw a remarkable flowering of illustrated art magazines that played an important role in the dissemination of new styles and art movements. Much of this was down to technology. The art magazines with line-engraved illustrations had limited visual value. Improved photographic reproduction made magazines far more informative and the introduction of colour lithography made them more attractive to the eye. Inspired by William Morris' revival of the art of the book, the more expensive magazines such as *La Revue Blanche* in Paris, *Pan* in Berlin and *The World of Art* in St Petersburg turned themselves into works of art, printed on luxury papers with beautiful bindings and including illustrations in a variety of graphic media. The monthly *Ver Sacrum* cost 10 marks if bought in a yearly abonnement but could also be bought in a luxury edition on expensive papers with added original prints.

Though it was less expensive and luxurious than the above-mentioned publications, *Studio* (from 1893) was probably the most widely disseminated and influential of these magazines and was subscribed to by Klimt himself. A notable example of how effective these magazines could be is provided by the role that *Studio* played in the creation of the Glasgow School and the spread of its international reputation. Like the Secession style and the mature work of Klimt, the Glasgow style was a brilliant and highly individual synthesis of borrowed elements. The Glasgow Four were provided with most of the elements they needed by *Studio* in its first year, with illustrated articles on Edward Burne-Jones and William Morris,

the architected-designer Charles Voysey and the Dutch Symbolist artist Jan Toorop. It was as a result of articles about them in *Studio* that the Glasgow Four were invited to exhibit at the Vienna Secession in 1900.

Like *La Revue Blanche* in Paris, *Ver Sacrum* was not just an art magazine but a cultural journal that paid tribute to the Wagnerian concept of the unity of the arts with important literary and musical elements. Amongst the writers who contributed were Hugo von Hofmannsthal, Rainer Maria Rilke, Maurice Maeterlinck and Knut Hamsun. Like the Secession itself, its declared aims were to promote modern Austrian art and knowledge of international art in Austria. *Ver Sacrum* remains an important source of information about Klimt and his career with photographic illustrations of his work in the context of the Secession shows, sometimes showing them in intermediary states while he was still working on them. *Ver Sacrum* also contains a wealth of graphic work which Klimt created specifically for the magazine.

LEFT The first year of the magazine *Ver Sacrum*, with original cloth binding by the Viennese Secession, 1898, from the collection of Sonja Knips

RIGHT Fifth and last year of the magazine *Ver Sacrum*, with original cloth binding by the Viennese Secession, 1903, from the collection of Sonja Knips

Illustration by Klimt in the pages of
Ver Sacrum, volume 3

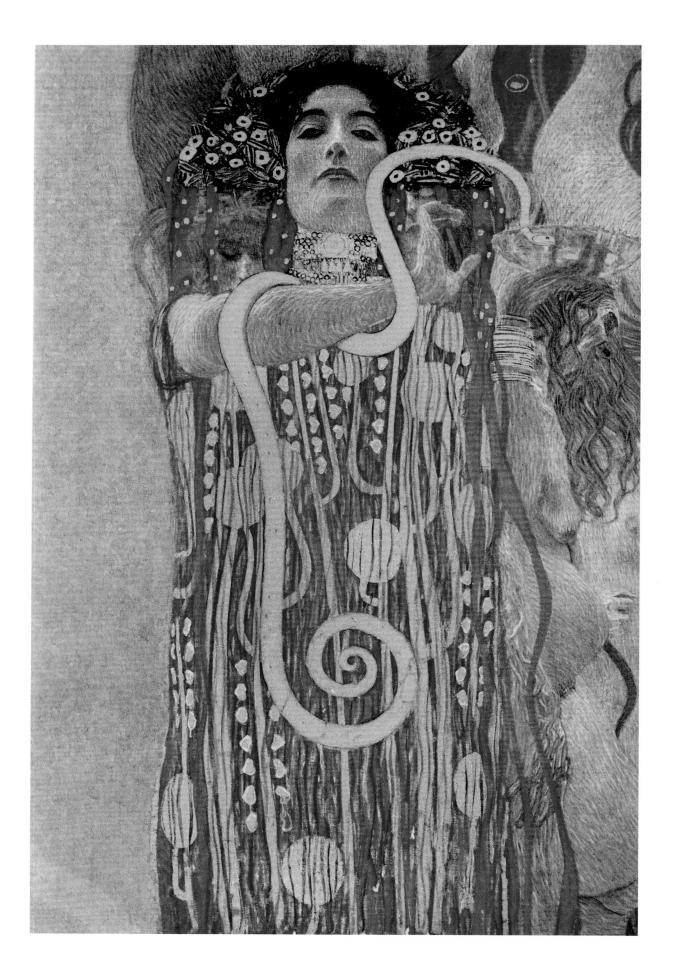

SCANDAL

· ·

Hygieia, detail from *Medicine*, 1900–07, oil on canvas, overall dimension 430 x 300 cm, from the series of faculty paintings for the University of Vienna, destroyed by fire in 1945 at Schloss Immendorf

The commission to paint ceiling panels for the Aula, or great hall, of Vienna University should have marked the zenith of more than ten years of successful collaboration between the Klimt brothers and Franz Matsch, and anointed them as the successors of Makart as Viennese painter-princes and official artists to the Habsburg Empire. In 1892 Matsch alone received the commission, the start of what was to become a tortuous process. The following year Matsch's initial designs were rejected and in 1894 the project was reassigned to Matsch and Klimt. For a huge central panel, four large corner panels and ten spandrels they were to be paid 60,000 gulden (surpassing the 50,000 gulden previously paid to von Munkácsy for the central panel of the Kunsthistorisches Museum ceiling) to be divided equally between them. Klimt was to paint the ten spandrels, though he pulled out of this part of the commission as early as 1904. Matsch took the largest central panel representing 'The Triumph of Light over Darkness'. Of the surrounding four corner panels, representing the university faculties of medicine, philosophy, jurisprudence and theology, Klimt took the first three and Matsch the last. It was no doubt significant that the sensualist Klimt chose not, or was not chosen, to paint theology. By the time all the panels were completed in the early 1900s it was painfully obvious that Matsch and Klimt had travelled in different directions and that their styles were irreconcilable. Photographic reconstructions of the complete ensemble show not only the discord between Klimt and Matsch, but also the progress that

Klimt made while working on his three panels and that his work no longer sat comfortably within the Neo-Renaissance framework provided by the architect. The scandals that attended the unveiling of each of Klimt's panels ended his career as a decorator of public buildings and confirmed his reputation as the leader of the Viennese avant-garde.

The first of the three faculty pictures to be exhibited was *Philosophy* which was shown at the Secession's seventh show in March 1900 before being sent to the Paris World Fair where it was awarded a gold medal. Klimt struggled to complete it on time (in fact he continued to work on it until 1907) and wrote a letter to the secretary of the Secession shortly before the opening of the show excusing himself for not being ready on the grounds of a bad cold. The picture was elaborately described in the exhibition catalogue in abstract Germanic terminology that does not translate well into English: 'Philosophy; one of five allegorical ceiling paintings for the Aula of the University (commission from the Ministry of Culture and Information). Left figure group: Creation, fruitful existence, passing. Right: the globe, world mystery. Underneath, an emerging luminous form: Knowledge.'

The striking asymmetry of the composition flouted post-Renaissance convention as did the lack of any perspective setting and the cropping of figures to the top, bottom and left of the composition. The cascade of figures on the left is reminiscent of Rodin's *Gate of Hell* which in turn had been inspired by the swirling figures of Blake's illustration to Dante's *Inferno, The Circle of the Lustful.* Given Klimt's insatiable curiosity and appetite for earlier art, it is more than likely that Klimt too was familiar with Blake. He was certainly familiar with Rodin's work which had been shown at the Secession since 1898. When Klimt and Rodin met during the latter's quasi-royal triumphant progress through central Europe in 1902, the two basked in mutual admiration.

As the picture survives only in black and white reproduction we are dependent upon contemporary verbal descriptions for its colour.

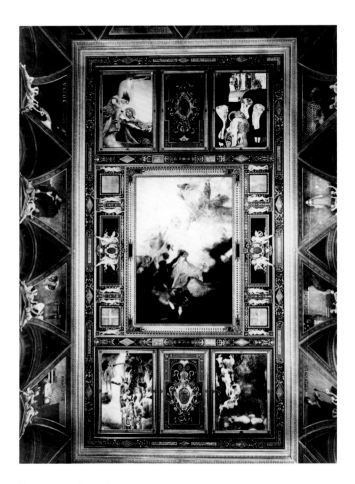

Reconstruction of the planned assembly of the faculty paintings at the University of Vienna

The most detailed of these comes from a review written by Ludwig Hevesi. 'We see part of cosmic space full of mysterious agitation, a movement that only allows you to speculate. And the forms are veiled in a mystical vagueness, that the eye perceives in a coloured mist. The painter has to deal with this mystery as far as possible in a painterly way. This shows itself primarily through colour. In this cosmos the most varied blues, violets, greens and greys are brewed together and their density is penetrated with shimmering yellows that rise to pure gold. One thinks of earth dust and whirling atoms, of elementary powers that are searching out things in order to make themselves perceptible. Swarms of sparks fly around, every spark a star, red, blue, green, orange-yellow, sparkling gold. But the whole chaos is a symphony, whose colours the artist has mixed out of his sensitive soul.'[1] Not all Klimt's reviews were so gushingly enthusiastic. Indeed, several were poisonous.

An open letter of protest against Klimt's *Philosophy* signed by a group of professors from the University of Vienna triggered the kind of scandal and controversy with which the Parisians had been familiar since Manet's *Dejeuner sur l'herbe* had been exhibited at the Salon des Refusés in 1863 but which was new to Vienna. The professors objected reasonably enough that Klimt's painting did not harmonise with the architect Heinrich von Ferstel's Neo-Renaissance building. One of the signatories, a Professor Jodl, explained further that the professors did not object to nudity (how could they when most of the great buildings on the Ringstrasse were adorned with nude figures) nor even to artistic freedom, but merely to 'ugly art'. On the day after the publication of the professor's letter, a golden laurel wreath was laid in front of Klimt's picture at the Secession with the inscription that adorned the exterior of the building: 'To every time its art, to art its freedom'. Klimt's supporters pointed out that the professors were not qualified to make aesthetic judgements. The journalist and controversialist Karl Kraus took up cudgels on behalf of the professors and dipped his pen in bile and sarcasm to attack Klimt and his supporters in a series of articles in his magazine *Die Fackel*. Condescendingly, he advised Klimt to consult the experts who knew about such things before tackling such subjects as philosophy, jurisprudence and medicine. His article of May 1900 concluded with the characteristically anti-Semitic jibe that for all Klimt's success in Paris, his art was dismissed there as representative of '*Gout juif*' (Jewish taste).

At the time of Klimt's Parisian triumph in 1900 the art scene in the city that had been the engine room of modern art since the mid-nineteenth century was

in a state of relative stasis between the revolutionary innovations of the Post-Impressionists in the 1890s and the next great irruptions of Fauvism and Cubism that took place between 1905 and the outbreak of war in 1914. The 'pompiers', the old masters of Academicism such as Jean-Léon Gérome and William Bouguereau, were still on show and widely admired. The fact that Bouguereau's slick and coy painting *Admiration* could also win a medal shows just how confused and confusing aesthetic tendencies were. The Impressionists Monet and Renoir, now in late middle-age and prosperous thanks to wealthy American collectors, had not been fully accepted into the French artistic establishment and their works were exhibited in a separate room. The die-hard reactionary Jean-Léon Gérôme, wearing a top hat and sporting his *legion d'honneur*, barred the President of France from entering the Impressionist room with the words, 'Sir, in there France is dishonoured!'. The great Post-Impressionists Gauguin, Van Gogh, Seurat and Cézanne were nowhere to be seen, nor were younger artists who had come to the fore in the 1890s such as the Nabis and Henri de Toulouse Lautrec. It is telling that other foreign artists who were honoured in the 1900 show, such as Joachìn Sorolla and Akseli Gallen-Kallela, like Klimt, deftly and judiciously absorbed certain aspects of modernism into essentially conservative academic techniques.

Another medal-winning artist of the same tendencies who presents fascinating and hitherto unexplored parallels with Klimt is Albert Besnard. At the time, Besnard was at the height of his reputation and a member of the jury that awarded Klimt his gold medal. His ceilings for the Salon des Sciences in the reconstructed Paris Town Hall, dating from 1890, directly anticipate Klimt with their mixture of slightly pretentious philosophising and their free-floating, luminescent, cosmic erotica. Klimt must also have taken an interest in Besnard's recently completed decorative scheme for the chemistry amphitheatre at the Sorbonne. Besnard's fusion of borrowings from the Impressionists and the Symbolists with a basically academic technique was perhaps less convincing and less individual than Klimt's. Again one thinks of Picasso's dictum that bad artists borrow and good artists steal. But this cannot entirely explain the strange fact that after being the first French artists to receive a state funeral in 1934, Besnard fell into almost total oblivion, whereas as Klimt's reputation has continued to climb ever higher since the Second World War.

Klimt's Parisian success cut no ice with the Viennese professors and indeed may have worked against him in a time of growing mutual suspicion and hostility

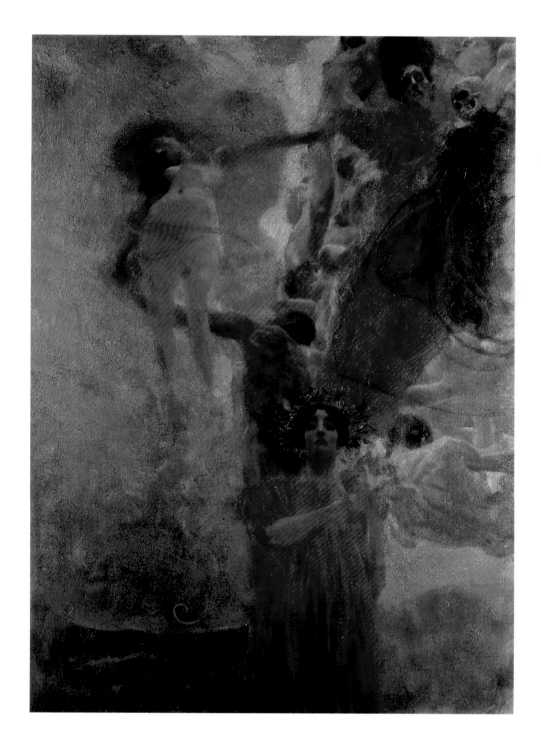

Study for *Medicine*, 1897–98,
oil on canvas, 72 × 55 cm,
private collection

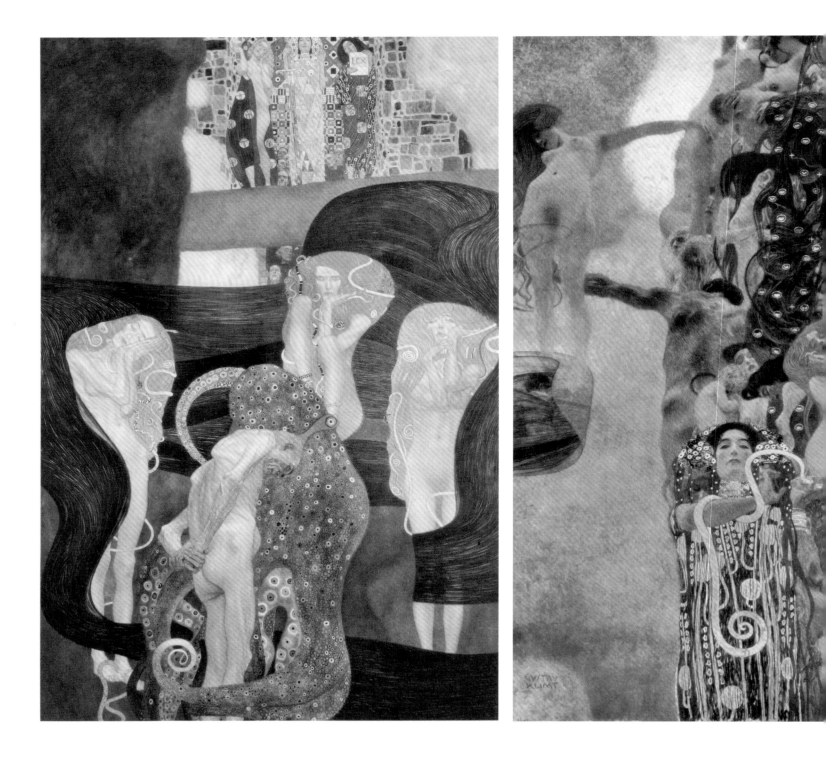

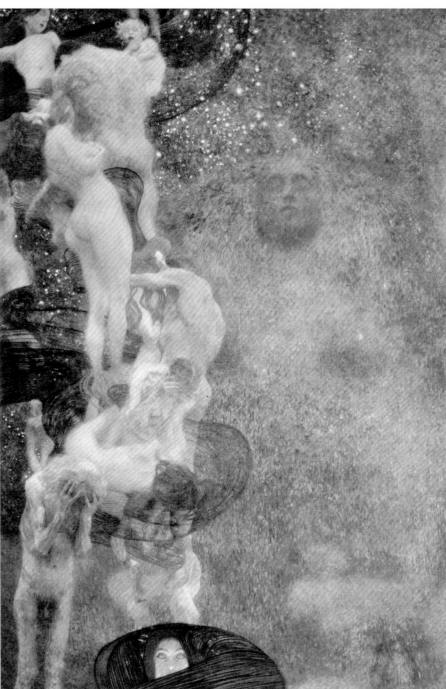

LEFT TO RIGHT

Jurisprudence, 1903–07, oil on canvas, 430 × 300 cm, from the series of faculty paintings for the University of Vienna, destroyed by fire in 1945 at Schloss Immendorf

Medicine, 1900–07, oil on canvas, 430 × 300 cm, from the series of faculty paintings for the University of Vienna, destroyed by fire in 1945 at Schloss Immendorf

Philosophy, 1900–07, oil on canvas, 430 × 300 cm, from the series of faculty paintings for the University of Vienna, destroyed by fire in 1945 at Schloss Immendorf

amongst European powers. The polemics for and against *Philosphy* were gathered together by Hermann Bahr and published in a volume entitled *Gegen Klimt* (Against Klimt) in 1903. In an article published in the *Deutsches Volksblatt* on 17 March 1900, Karl Schreder compared *Philosophy* with Richard Strauss's philosophical tone poem *Also sprach Zarathustra*. Though the intention was hostile, both artist and composer would probably have been flattered by the comparison and Strauss himself later likened the shimmering textures of his opera *Salome* to the paintings of Klimt. An unsigned article in the same magazine denounced Klimt's work as indecent and made the by now familiar accusation that it was somehow Jewish. Attacking Franz Wickhoff, an art history professor who had come to Klimt's defence, the unknown writer fulminates '… or has he not understood that the painting in a very obvious and repulsive way is indecent? … One knows, of course the Jewish shamelessness in poisoning the people by proclaiming the lowest and meanest attitudes as principles.'[2]

The second of Klimt's faculty ceiling pictures, *Medicine*, was presented in March 1901 at the tenth Secession exhibition to equally divided responses. The composition with a torrent of figures placed asymmetrically, this time on the right side, corresponded with that of *Philosophy*. An entry in the exhibition catalogue explains the meaning of the picture: 'Between becoming and passing life plays out and life itself on the way from birth to death creates sufferings for which Hygieia, the miraculous daughter of Aesculapius has found soothing and healing cures.'

Once again we are indebted to Ludwig Hevesi for a detailed description of the colour, though this time we can gain some impression of the colours both from a surviving oil sketch and also from a colour photograph that was taken of the dominant figure Hygieia in the foreground, who wore a gorgeous robe of scarlet and gold. Hevesi elaborates: 'While the mood of *Philosophy* was expressed in a cool harmony of green and blue tones, so here it is correspondingly warmer with rosy tones pushed to shimmering purples. On the human figures play a whole symphony of flesh tones, with the finest shadings, contrasts and reflections without end contributing. It is the break of day with the breeze of the dawning day, already reddening the mist and on the horizon the first rays of the sun are trying to burst forth.'[3]

With *Medicine* Klimt made no attempt to placate the critics of *Philosophy*. On the contrary he seems to have wanted to provoke them further with his depiction of the hitherto taboo subjects of pubic hair and naked pregnancy. If this was the case,

COLLECTIVAUSSTELLUNG GUSTAV KLIMT.
SECESSION WIEN. NOVEMBER=DEZEMBER 1903.

Main exhibition room of the
eighteenth exhibition of the Viennese
Secession, with Klimt's *Music II* on the
left wall and *Medicine* and *Philosophy*
on the right wall, 1903

his strategy worked and the critical attacks, including further diatribes from Karl Kraus in *Die Fackel,* were even more furious than they had been on *Philosophy.*

Jurisprudence, the third and last of Klimt's faculty ceilings, was presented alongside the other two in November 1903 in the context of a Klimt retrospective that formed the eighteenth Secession exhibition. Hevesi recognised the influence of the Ravenna mosaics that Klimt had been to see twice earlier that year, and that were to play such an important role in the next phase of his career, and also that *Jurisprudence* represented a 'newly developed style after the painterly orgies of the past decade'. As Hevesi pointed out the flat, stylised and hieratic *Jurisprudence* looked very different from its companions *Philosophy* and *Medicine.* Not only was there a disturbing discrepancy between the panels of Klimt and Matsch but also between the different panels of Klimt himself. In addition to the continuing controversies about Klimt's work, this discrepancy may have played an important role in his disenchantment with the entire project.

In an interview given to Berta Zuckerkandl in 1905, Klimt claimed that the controversies surrounding his university pictures played no role in his decision to withdraw them, that he was not sensitive to criticism and that it mattered more to him that the university itself was not satisfied with his work. All this may have been true. But it is also likely that an artist devoted to the ideal of the *Gesamtkunstwerk* – total and unified work of art – was appalled at the disparate effect that the various panels of the university ceiling would have presented. In 1905 Klimt requested the annulment of his contract with university and the return of his three completed pictures. With the financial help of August Lederer, Klimt was able to return his fee. Lederer acquired *Philosophy* and in 1911 *Medicine* and *Jurisprudence* were sold to the artist Kolomon Moser. From this moment, with the inevitability of a tragedy, the three pictures followed various routes towards their destruction in the conflagration at Schloss Immendorf in 1945.

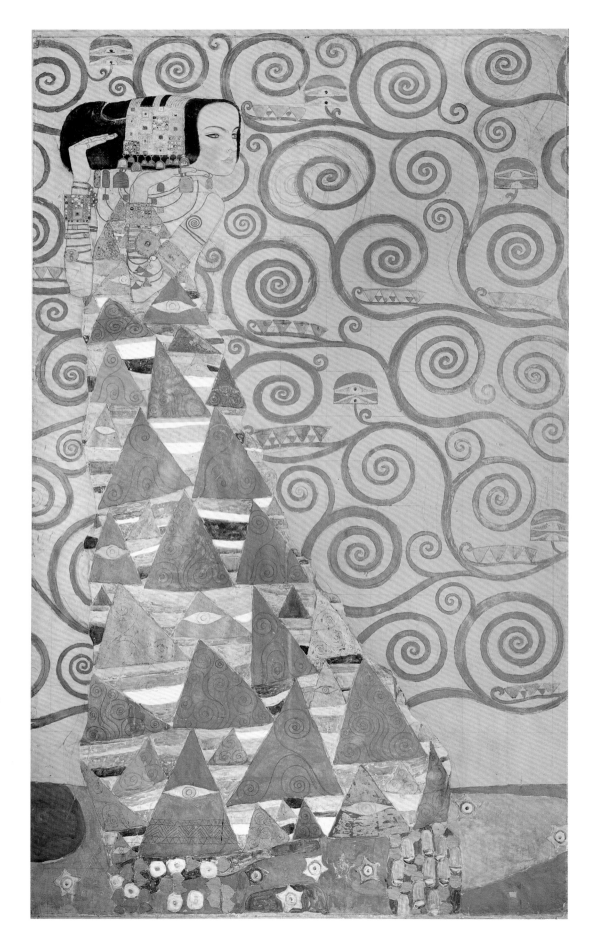

LEFT *Expectation*, study for the *Stoclet Frieze*, 1905-09, watercolour and gold leaf on paper, 195 × 120 cm, MAK (Austrian Museum of Applied Arts), Vienna

OPPOSITE *The Knight*, sketch for the *Stoclet Frieze*, 1905–09, mixed media on paper, 197 × 90 cm, Österreichisches Museum für angewandte Kunst, Vienna

DECORATIVE ARTS

In his speech at the opening of the 1908 Kunstschau Klimt said, 'We do not belong to any association, any society, any union, we are united, not in any compulsory manner, simply for the purpose of this exhibition – united in the conviction that no aspect of human life is so trifling, so insignificant as not to offer scope for artistic endeavour. In the words of Morris, even the most insignificant object, if perfectly made, helps to increase the sum total of beauty on this earth. It is only upon the continuing penetration of life by art that the progress of the artist is to be grounded.'[1]

When William Morris set up the firm of Morris, Marshall, Faulkner and Co. (later Morris and Co.) in 1861, his decision to involve his artist friends Dante Gabriel Rossetti and Edward Burne-Jones and the architect Philip Webb as designers had far-reaching consequences. His belief that design and the applied arts should be raised to the status of fine art was taken up by other artist-designers of the late nineteenth century, such as the Belgian Henry van de Velde, and was embraced by the founders of the Vienna Secession.

The period between 1870 and 1914 was one in which the interaction between fine and decorative arts was particularly intense and fruitful. A number of artists who were trained as painters such as Henry van de Velde and Louis Comfort Tiffany turned to the decorative arts, and the work of artists such as Burne-Jones, Gauguin, the Nabis and Klimt himself, was deeply marked by their involvement in

Letterhead of the Wiener
Werkstätte with its rose signet by
Charles Rennie Mackintosh

the decorative arts. Architects such as Charles Voysey, Charles Rennie Mackintosh,
Otto Wagner and Josef Hoffmann involved themselves with interior design and
the design of everything from wallpaper to cutlery. William Morris' Red House,
designed in 1859, was a prototype for many later attempts to transform the home
and its contents into a total work of art, unified in every aspect. Henry van de
Velde took the idea further with his house at Uccle on the outskirts of Brussels,
built in 1895, in which he designed every detail down to the door handles and key
holes, and integrated his wife into the scheme by supervising every aspect of her
appearance and clothing. The ideal of living life as part of a *Gesamtkunstwerk* was
something that appealed to many of Klimt's patrons.

From the first, the Vienna Secession under Klimt's presidency signalled the
importance of design and decorative arts, both by the inclusion of decorative
arts in their exhibitions and by the meticulous attention given to the display.
Klimt's interest in interior design was furthered through his involvement with the
Wiener Werkstätte, founded in 1903 with the financial support of the banker Fritz
Wärndorfer and under the direction of Josef Hoffmann. The ideas of Morris and
various craft guilds set up in Britain provided the immediate inspiration. Wärndorfer
travelled to Glasgow to consult with Charles Rennie Mackintosh who provided
the Wiener Werkstätte with its famous logo and expressed his enthusiasm and
encouragement for the project: 'If one wants to achieve an artistic success with
your programme ... every object which you pass from your hand must carry an
outspoken mark of individuality, beauty and most exact execution. From the outset
your aim must be that every object which you produce is made for a purpose and

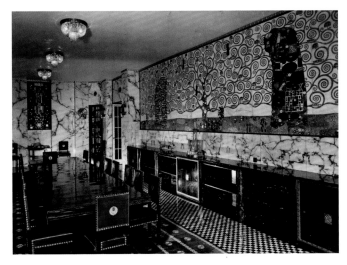

ABOVE The Palais Stoclet, designed by Josef Hoffmann and furnished by artists of the Wiener Werkstätte, 1912

BELOW Dining hall of the Palais Stoclet with frieze by Klimt, c.1911

place. Later … you can emerge boldly into the full light of the world, attack the factory trade on its own ground, and the greatest work that can be achieved in this century, you can achieve it: namely the production of objects of use in magnificent form and at such a price that they lie within buying range of the poorest …'[2]

With this last comment Mackintosh was paying lip service to the Arts and Crafts idea that art should be 'made by the people for the people', but the idealistic anti-elitism of William Morris was very rapidly jettisoned by the Viennese and from the first the products were shamelessly elitist and expensive. Despite his working class origins, Klimt never had a problem with working for what William Morris would have called the 'swinish' luxury of the rich.

Certainly no expense was spared in the construction of the Palais Stoclet in Brussels, the greatest achievement of the Wiener Werkstätte. Severe lines and a certain sober functionality were combined with the most luxurious materials and the highest level of craftsmanship. It is strange that the ultimate expression of the Viennese aesthetic should find itself in the birthplace of the Art Nouveau style and surrounded by the curvilinear forms of the local version of that style.

Adolphe Stoclet, the Belgian heir to an industrial fortune, and his young wife Suzanne were deeply impressed by the villas of Josef Hoffmann while walking around the fashionable Viennese suburb of Hohe Warte. They were spotted by Carl Moll, the close friend and colleague of Hoffmann and Klimt, who invited them to view his house and made the necessary introductions. Initially Adolphe Stoclet intended to commission another villa on the Hohe Warte, but after he inherited the family fortune in 1904, it was decided to erect a more splendid house on the Avenue de Tervueren in the Brussels suburb of Woluwe-Saint-Pierre. In the words of Stoclet's son Jacques, 'To be able to give free flight to his imagination and his talent as regards the realisation of this ensemble, in such a way as to create a perfect unity out of the smallest details of the architecture of the house and garden, the iron-work, the means of illumination, the

furniture and flooring, the carpets and even the silver-ware, and, moreover, using the most costly materials, represents for an architect, even for a genius like Professor Hoffmann, an ideal, a dream which one cannot realise more than once in a lifetime.'[3] Whole rooms with their entire contents were assembled in Vienna to gage the effect before being dispatched to Brussels. Klimt's contribution to the Palais Stoclet consisted of designs for the magnificent mosaic murals in the dining room. Executed between 1905 and 1912 these murals represented the ultimate development of Klimt's 'golden' phase. It is Klimt's most abstract work and indeed a tall intermediary panel on an end wall consists entirely of abstract ornament. Inspired no doubt by Klinger's similar use of diverse and precious materials for the Beethoven monument, Klimt used gold, silver, coral, enamel and semi-precious stones set into a white marble ground. Each side of the elongated room consists of seven tall panels unified by the overall background of a highly stylised tree of life.

As Stoclet gave his artists an entirely free hand, Klimt was able to explore his favourite themes of sexual desire and fulfilment – themes that might not have been thought entirely appropriate for the decoration of a bourgeois dining room. The young woman representing Expectation wears something like a kimono and with her hair tied up in a bun has a decidedly Japanese air. With the influence of the Ravenna mosaics, which Klimt visited in 1903 and which had an immediate impact on his work, it is a case of Kyoto meets Byzantium with a touch of Ancient Egypt and Mycenae thrown in. The male figure of the embracing couple representing Fulfilment is seen from the back and wears a highly decorated version of the kind of loose smock that Klimt himself wore in his studio. As in the closely related painting *The Kiss*, the ornament carries erotic meaning but in this case the man's robe is decorated with elliptical 'female' ornament as well as with a panel of vertical rectangular 'male' ornament.

ABOVE Mosaic detail from the interior of the medieval church of San Giovanni Evangelista in Ravenna

BELOW Ancient mosaics on the ceiling in the Mausoleum of Galla Placidia in Ravenna

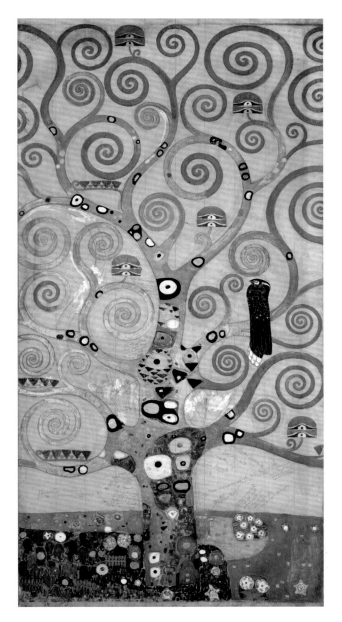

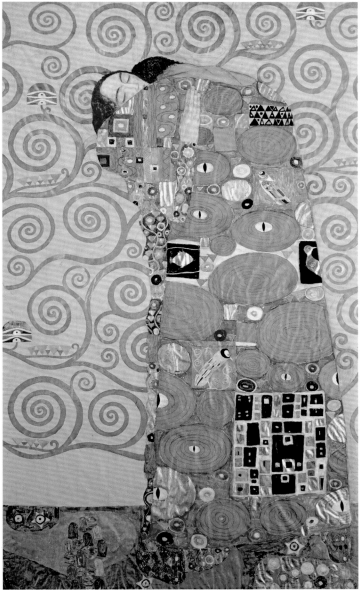

Tree of Life, study for the *Stoclet Frieze*,
c.1905–09, mixed media on paper,
195 × 102 cm, MAK (Austrian Museum of
Applied Arts), Vienna

Fulfilment, study for the *Stoclet Frieze*,
c.1905–09, mixed media on paper,
195 × 120 cm, MAK (Austrian Museum of
Applied Arts), Vienna

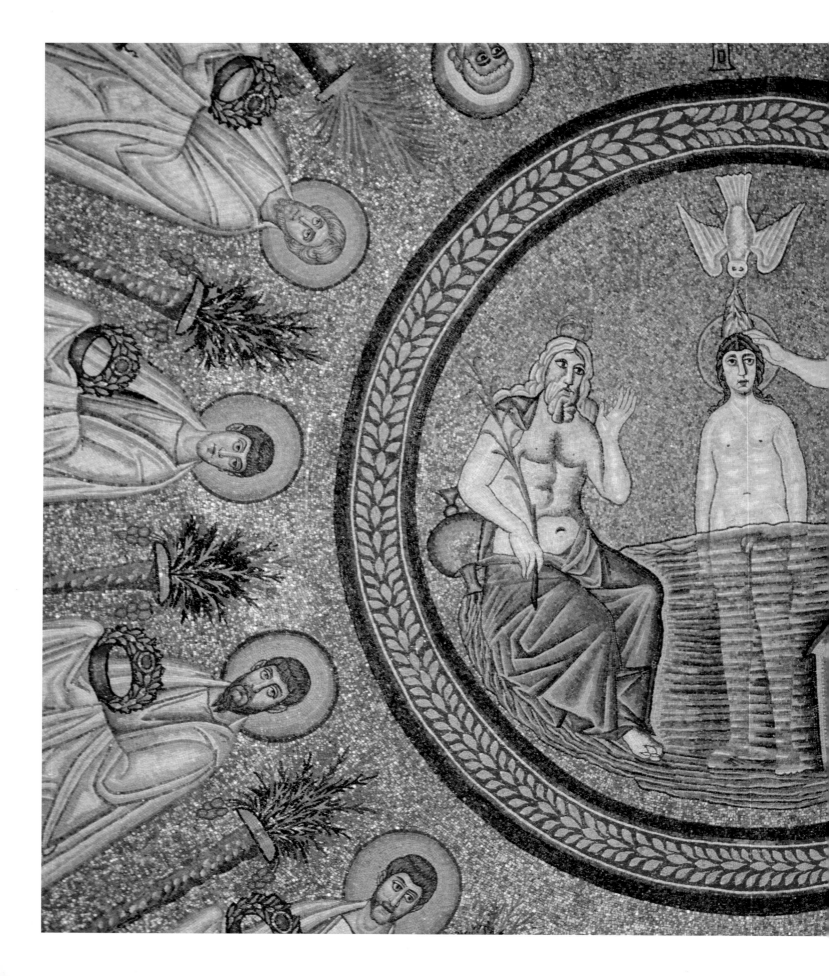

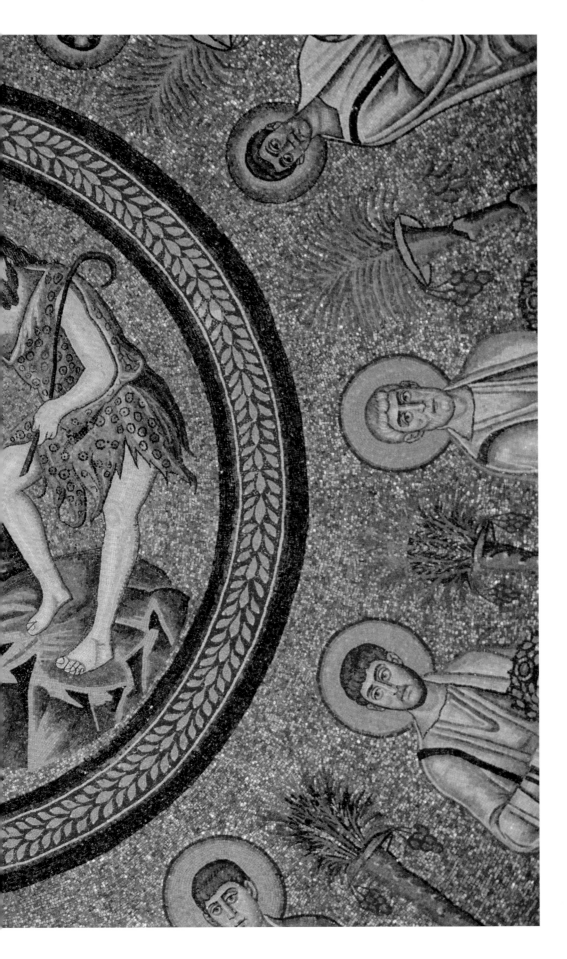

Byzantine mosaics of the Arian
baptistery, one of the eight
structures in Ravenna registered
as UNESCO World Heritage Sites

LEFT Klimt's photograph of Emilie Flöge in dress VIII, from a range of dresses designed by Klimt and Flöge, 1906

OPPOSITE, LEFT The parlour at Schwestern Flöge fashion house, furnished by Kolomon Moser and Josef Hoffmann, 1904

OPPOSITE, RIGHT Card with letterhead of the fashion house Schwestern Flöge, designed by Gustav Klimt, 1904

Klimt's openness to the applied arts is also evidenced by his interest in fashion. It was his relationship with the Flöge sisters that enabled him to try his hand at dress design. In 1895 Pauline Flöge opened a dressmaking school, where Emilie also worked. In 1899 the sisters won a prestigious dressmaking competition and in 1904 set up their fashion house, Schwestern Flöge, in the Casa Piccola in the Mariahilferstrasse, with elegant interiors designed by Josef Hoffmann and Kolomon Moser. The influence of Klimt was pervasive and showed itself not only in the dresses they sold to the kind of women who commissioned portraits from Klimt but also in the signage of the shop and the labels in the dresses. In 1906, no doubt in collaboration with Emilie, Klimt designed a series of dresses that were produced and sold by the sisters. Klimt photographed Emilie wearing some of these dresses in verdant open-air settings. The flowing forms of the dresses follow the ideas of the reform dress movement that encouraged women to abandon unhealthy and constricting corsets and padding, but the luxurious materials and elaborate geometrical ornament betray Klimt's input, as do the tight high collars that would seem to contradict the ethos of the reform movement.

The Graben, Vienna, late nineteenth century

JEWISH VIENNA

· ·

That none of the three important painters active in Vienna in the early 1900s – Gustav Klimt, Egon Schiele and Oskar Kokoschka – were of Jewish origin, whereas most of their patrons, collectors, dealers and commentators were, raises a number of contentious issues. It is difficult to think of any writers or intellectuals of note in Vienna at this time who were not of at least partly Jewish background. Karl Kraus, Robert Musil, Stefan Zweig, Hugo von Hofmannsthal, Arthur Schnitzler, Peter Altenberg, not to mention such towering cultural figures as Sigmund Freud, Gustav Mahler and Arnold Schönberg were all Jews or in the hateful racist jargon of later years 'Halb-Juden' (half-Jews).

According to the authoritative 1912 *Encyclopaedia Britannica*, Jews constituted under 10 per cent of the population of Vienna (146,926 out of 1,662,269). What is not clear is how these figures were reached and if the 146,926 were religious Jews or if assimilated and non-religious Jews were included on racial grounds.

This issue was confronted head-on in a remarkable and thought provoking lecture given by the great art historian Ernst Gombrich (himself a refugee of Viennese Jewish origin) at the St John's Wood Liberal Jewish Synagogue in 1996 in the context of a seminar organised by the Austrian Cultural Institute on fin-de-siècle Vienna and its Jewish Cultural Influences.

From the first moment, the frail and elderly historian, with the authority of an Old Testament prophet, electrified and polarised his audience. Gombrich opened

his lecture, at which the author was present, with the challenging statement, 'I am
of the opinion that the very notion of Jewish Culture was, and is, an invention of
Hitler and his forerunners and after-runners.'[1] Gombrich's point was that the Jewish
bourgeoisie of Vienna was thoroughly assimilated. Its cultural allegiance was to
Goethe and Beethoven and not to the Talmud. These people did not necessarily
define themselves as Jews and for us to do so would be an impertinence or worse
still doing the work of Hitler and his forerunners and after-runners. Gombrich's
argument is admirably high-minded and irrefutable in its logic but nevertheless
begs certain questions. There has to be an explanation of the fact that so many
of Vienna's intellectuals and art lovers were of Jewish origin (even if we cannot
define them as Jews) and that the artists themselves were not. There were clearly
historical, social and cultural reasons for this phenomenon. Emotive and pseudo-
scientific arguments about race can be side stepped entirely and indeed do nothing
but muddy the waters.

Many of Vienna's Jews were not religious and indeed many converted to
Christianity. The German poet and writer Heinrich Heine famously declared that
baptism was 'the card of admission to European culture'. For some it was still more
practical than that. Mahler needed to convert to Catholicism in order to take on
the direction of the Court Opera. Schönberg converted to Lutheranism (a route
often more congenial to Jews than conversion to Catholicism) only to revert to
Judaism in response to the Nazi persecution of the Jews.

When Gombrich remarks, 'Whatever Jewish culture may have been, it
was not a visual culture', he touches on a key element.[2] The traditional ban
on representational art in Orthodox Judaism must surely have played a role
in the relative paucity of great Jewish visual artists as opposed to writers and
musicians. In the inner city of Vienna, we are presented with a telling contrast if
we walk the short distance from the Seitenstettengasse Synagogue (the only
Viennese Synagogue to have survived Nazi violence) with the sky-blue ceiling of
its dome decorated only with geometrically arranged stars, to the equally domed
Peterskirche in which every square foot of interior surface writhes with figurative
decoration.

The passion of the Viennese Jewish bourgeoisie for all the arts (including and
perhaps especially the visual) has to do with the process of assimilation. The desire
for assimilation after hundreds of years of semi-isolation in the ghettos of Europe,

combined with the traditional Jewish reverence for the intellect, provided powerful motivation for Jews to involve themselves in culture. It was a pattern repeated to a greater or lesser extent in Paris, Berlin, Budapest and elsewhere in the Western world but seen at its most potent in Vienna. Once again, Stefan Zweig bore witness to the process: 'For Jews, adaption to the human or national environment in which they lived was not only a measure taken for their own protection, but also a deeply felt private need. Their desire for a homeland, for peace, repose and security, a place where they would not be strangers, impelled them to form a passionate attachment to the culture around them. And nowhere else, except for Spain in the fifteenth century, were such bonds more happily and productively forged than in Austria.' Zweig identified the aspiration towards the intellect as 'one of the most mysterious but deeply felt tendencies in the Jewish nature.' He continued, using Wagnerian analogies that are typical of this period but strike us as sinister, 'Unconsciously, something in a Jew seeks to escape the morally dubious, mean, petty and pernicious associations of trade clinging to all that is merely business, and rise to the purer sphere of the intellect where money is not a consideration, as if, like a Wagnerian character, he were trying to break the curse of gold laid on himself and his entire race.'[3]

Everywhere in Europe by the mid-nineteenth century the old aristocracies had ceased to play a significant role in the encouragement or patronage of new art. Zweig argued that in Vienna it was primarily the new Jewish bourgeoisie who took over this role. 'It was only in art that all the Viennese felt they had equal rights, because art, like love, was regarded as a duty incumbent on everyone in the city, and the part played by the Jewish bourgeoisie in Viennese culture, through the aid and patronage it offered, was immeasurable. They were the real public, they filled seats at the theatre and in the concert halls, they bought books and pictures, visited exhibitions, championed and encouraged new trends everywhere with minds that were more flexible, less weighed down by traditions. They had built up virtually all the great art collections of the nineteenth century, they had made almost all the artistic experiments of the time possible. Without the constant interest of the Jewish bourgeoisie as stimulation, at a time when the court was indolent and the aristocracy and the Christian millionaires preferred to spend money on racing stables and hunts rather than encouraging art, Vienna would have lagged far behind Berlin artistically.'[4]

Le Petit Journal, Paris, December 1894, featuring Alfred Dreyfus, the French army officer of Jewish extraction wrongly accused of giving secrets to Germany, in front of the War Council

Zweig's conclusion that 'nine-tenths of what the world of the nineteenth century celebrated as Viennese culture was in fact culture promoted and nurtured or even created by the Jews of Vienna' alarmed and infuriated Gombrich who saw it as a dangerous inversion of the very arguments used against the Jews by the Nazis. It was a danger of which Zweig himself was well aware, commenting, 'Admittedly, it is one of the eternal paradoxes of the Jewish destiny that this flight into intellectual realms has now, because of the disproportionately large number of Jews in the intellectual professions, become as fatal as their earlier restriction to the material sphere.'[5]

A coolly objective contribution to the heated debate about the contribution of Jews to the intellectual and cultural life of the early modern period was made by Bryan Magee in his slender but pithy volume on Wagner. Magee points out that the three thinkers who most influenced the twentieth century – Marx, Einstein and Freud – were all Jews and that considering the tiny percentage of the world's population that belong to the Jewish faith or come from a Jewish background, this requires an explanation. Magee argues that it was the process of assimilation, of coming in from the outside, that enabled Jews to think and create with such originality. Freed from the constraints of the ghetto and ironically of their religion, assimilated Jews 'are in a position unconsciously to articulate the deepest concerns of the age they live in. The Jew has become the archetypal modern man.'[6]

In her densely argued book Style and Seduction: Jewish Patrons, Architecture and Design in Fin de Siècle Vienna, Elana Shapira asserts that the conspicuous role of the Jewish bourgeoisie as patrons of modern art in Vienna was motivated less by the desire for assimilation than by a determination to create a new kind of Jewish identity or as she terms it 'Jewish identification'. 'The standard narrative is that most Jews erased all outward traces of Jewish history and culture to integrate. However, I claim that the relationships between Jewish and their artists and architects formed

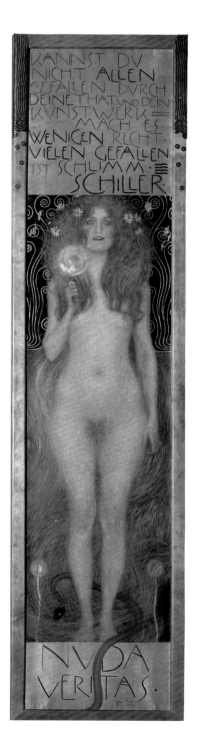

a new cultural program that embedded the Jewish micronarrative firmly in the macro-narrative of European history so that Jews and the aspects of Jewish culture they chose to retain would become part of the fundament of Viennese high culture. To this end, this book uses the term "Jewish identification" rather than "Jewish identity". The former implies a more conscious dynamic, whereby patrons, through their investment in modern art and design, and architectural objects, directly or indirectly redefined what Jewish culture meant.'[7]

For whatever reason, Klimt's patrons came predominantly from the Viennese Jewish bourgeoisie. Though Klimt himself was far from being either intellectually or politically engaged, his 1899 canvas *Nuda Veritas* has been interpreted as a protest against the flagrant injustice of the Dreyfus Affair then at its height in France. This injustice had been keenly felt in Viennese circles. The Austro-Hungarian journalist Theodor Herzl had been appalled by the anti-Semitism generated by the Affair which he covered as Paris correspondent of the influential liberal Viennese newspaper *Neue freie Presse*. The simultaneous rise of anti-Semitism in Paris and Vienna and the election of the anti-Semitic Karl Lueger as mayor of Vienna in 1895 convinced Herzl of the futility of assimilation and prompted him to write *Der Judenstaat* (The Jewish State) and to launch the Zionist movement. Elana Shapira argues that Klimt collaborated consciously in the project of creating a new 'Jewish identification' through his work for patrons and collectors such as Karl Wittgenstein, Fritz Wärndorfer and Adele Bloch-Bauer.

Nuda Veritas, 1899, oil on canvas, 252 x 56 cm, Österreichische Nationalbibliothek, Vienna

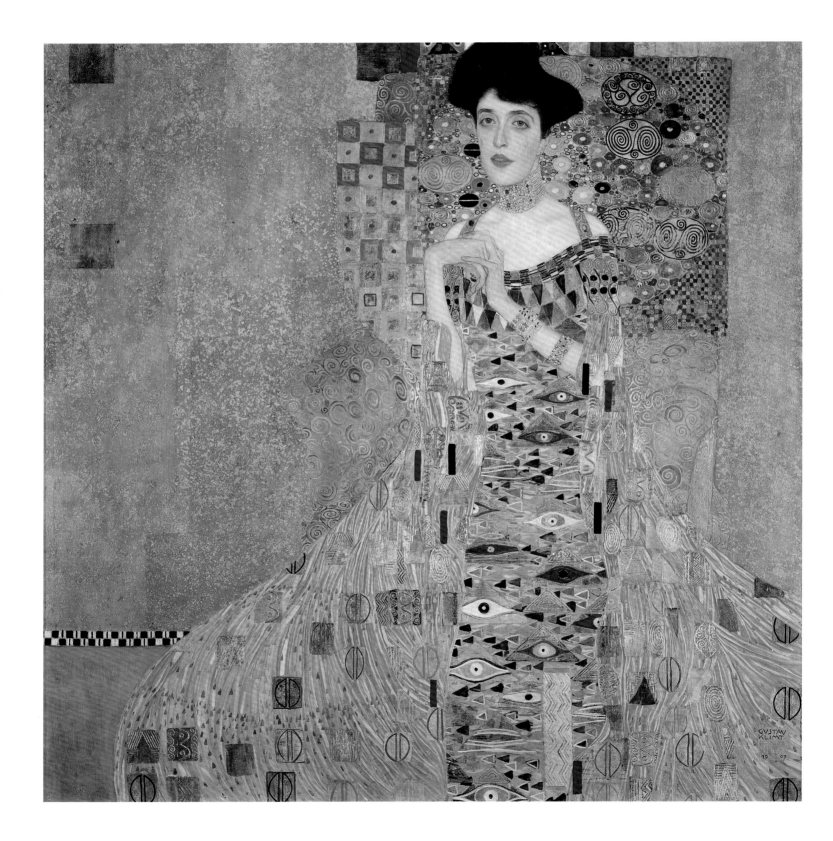

PATRONS &
COLLECTORS

· ·

Portrait of Adele Bloch-Bauer I,
1907, oil, silver and gold leaf
on canvas, 140 × 140 cm,
Neue Galerie, New York

Vienna lagged behind Paris and Berlin in the development of a commercial art scene of galleries and dealers in modern art. This, as much as personal inclination, led Klimt to depend upon a small circle of private patrons and collectors at the height of his career. After the fiasco of the Vienna University ceiling paintings, Klimt lost interest in public art and in view of the scandal he had caused it was unlikely that many more public commissions would have come his way. It is also striking that the aristocracy, who still played such an important part in Viennese public life, showed no interest in the art of Klimt. Instead, he depended almost entirely on the new wealthy bourgeoisie, many of whom were Jewish. There were parallels elsewhere, notably in Britain and France, where the old aristocracies abdicated from their former role as patrons, and in Russia, where the great collectors such as Sergei Shchukin came from the new rich merchant class.

BARON NICOLAUS DUMBA

An early and important Viennese patron of Klimt who was not Jewish, was the Greek merchant Baron Nicolaus Dumba, though many of the imperatives were similar to those of Klimt's Jewish patrons. Dumba was a self-made outsider from a different religious tradition who desired assimilation into Viennese society. There are similarities with the Ionides family in London, also Greek merchants, whose collecting tastes, including Degas, Delacroix, Ingres, Courbet, Millet and the

Music salon of Nicolaus Dumba, designed by Gustav Klimt with his painting *Music II* above the door, c.1900

Pre-Raphaelites, were wider and more adventurous than those of most of their British contemporaries.

The Dumba family built themselves a magnificent palace on the Ringstrasse (Parkring 4) where most of the newly wealthy preferred to live rather than in the cramped streets of the old city, where the palaces of the aristocracy were to be found. The Dumba palace was noted for its lavish historicist interiors. If the historicism of the Palais Dumba was jettisoned by artists and designers of Klimt's generation, the opulence and the ideal of the *Gesamtkunstwerk* left their mark on Viennese taste and would find their ultimate expression in the interiors of the Palais Stoclet in Brussels created in the new century by Klimt and Josef Hoffmann.

The most celebrated room in the Palais Dumba was the library, decorated with mural and ceiling paintings by Hans Makart. With characteristic generosity Dumba sent Makart to Italy at his expense and the instruction, 'Go to Venice. Do nothing but look and then make me a whole room.'

Two decades later Dumba entrusted two artists of a later generation with the decoration of rooms in his palace. Klimt was offered the music room and his colleague Franz Matsch the dining room. Klimt's choice of an elegant classicism for the furnishing and decoration of the room did not depart from the overall historicism of the palace's interiors but was already in marked contrast with the over-charged Neo-Renaissance of Makart's library.

Like many of Klimt's later patrons, Dumba was willing to allow art its freedom as exhorted over the door of the Vienna Secession. But when, after lengthy delays, Klimt fulfilled Dumba's commission for two *sopra porta* (over door) paintings for his music room he may have found both his generosity and his taste somewhat stretched as they departed so radically from anything else to be found in the palais. The commission was given in 1893 and it is probable that Dumba was expecting something in the quasi-photographic realist style of the recently completed decorations of the Burgtheater. But by the time Klimt completed the two panels, *Music* and *Schubert at the Piano*, Klimt's style had undergone a radical transformation. Modernism had entered the cluttered temple of Historicism. This did not go unremarked at the time and the sharp-tongued Karl Kraus commented ironically, 'Herr von Dumba as a Secessionist is altogether very amusing. It happened this way. He commissioned the pictures

Schubert at the Piano, 1899,
oil on canvas, 150 × 200 cm,
destroyed by fire in 1945 at
Schloss Immendorf

for a music room from Klimt when he still worked in the respectable manner of the Laufberger School and had allowed himself at most a few extravagances in the manner of Makart. In the meantime however the painter had encountered Khnopff, and has become so that the story does not remain pointless, a pointillist. And of course the commissioner has to go along with all of this. So Herr von Dumba has gone modern.'[1]

The depiction of Schubert playing the piano by candlelight and surrounded by decidedly fin-de-siècle young ladies became well known and was perhaps Klimt's most famous and widely reproduced work during his lifetime. According to Hermann Bahr it was 'the most beautiful picture ever painted by an Austrian'. A shared passion for Schubert may have been one of the factors that drew Dumba to this artist of a younger generation. Dumba put together an important collection of Schubert manuscripts which he bequeathed to Viennese institutions. After Dumba's death the two pictures for the music room were acquired by the Lederer family and subsequently destroyed at the end of the Second World War with many other masterpieces from their collection.

SONJA KNIPS

Klimt's only significant client of aristocratic origin was Sonja Knips. Her birth name Sophie Amalia Maria Freifrau Potier des Echelles was certainly resoundingly aristocratic but she married out of her social class into the new rich bourgeoisie. Her husband was the industrialist Anton Knips. In 1898 she commissioned a portrait from Klimt which was to be his first in the new Secession style. It is an exquisite harmony in pink, as Whistler might have described it, with a startlingly asymmetrical composition with artfully placed flowers in the Japanese manner and a lovely and telling touch of red provided by the leather-bound sketchbook which Knips holds in her right hand, similar to one that Klimt gave her or perhaps the very same. Despite the carefully contrived composition and the strong elements of stylisation, the picture suggests a quivering and momentary spontaneity. Its tender intimacy has led to speculation that Klimt's relationship with the unhappily married Knips may have been more than that of artist and client.

Knips later confirmed that it was Klimt who picked out the dress she wore for her portrait. Like several of Klimt's later sitters, Sonja Knips lived her life as a kind of *Gesamtkunstwerk*, with every aspect of her appearance, clothing, surroundings and lifestyle in harmony. Klimt's architect colleague Josef Hoffmann designed her Vienna and country residences supervising every detail of the interior decoration including the display of Klimt's pictures in simple and aesthetic frames. Knips would acquire two more of Klimt's paintings that are to be seen in photographs of her residences – a landscape with fruit trees and the unfinished painting of Adam and Eve which she bought after his death. Knips treasured Klimt's record of her youthful beauty for the rest of her long life. She sold it to the Austrian Gallery in 1950 on condition that she could keep possession of it for the rest of her life. She died more than forty years after Klimt in 1959.

THE BLOCH-BAUERS

As a result of a sensational and long drawn out court case, a world-record sum brought at auction and a popular movie made in 2015, Klimt's first portrait of Adele Bloch-Bauer or 'The Woman in Gold' has become his most famous portrait.

The Bloch-Bauers were typical of Klimt's clientele – industrialists whose wealth was based upon sugar, a very important commodity in a city famed for its cakes and puddings. Adele Bauer was born into a wealthy family with interests in banking,

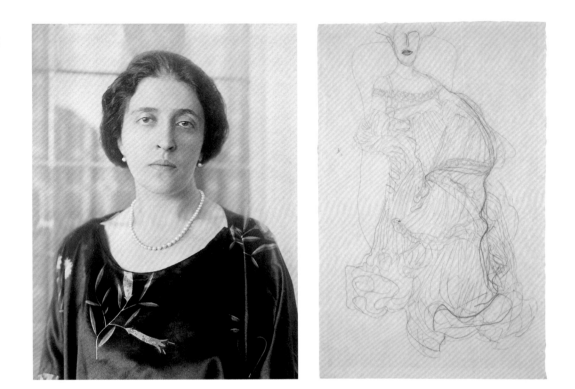

LEFT Adele Bloch-Bauer, wearing a dress from the Wiener Werkstätte, c.1910

RIGHT *Adele Bloch-Bauer, Seated in Three-Quarter Profile, Facing Right*, 1903–04, charcoal on paper, 44.9 × 31.8 cm, Neue Galerie, New York

railways and other industrial concerns. Her marriage at the age of eighteen to the much older Ferdinand Bloch looks like an alliance between two financial dynasties, especially as her sister Marie-Therese married Ferdinand's brother Gustav. The commission for Adele's golden portrait went back to the summer of 1903 when it was conceived as a wedding anniversary present for her parents. The gestation of the picture was slow and complicated as we see from a quantity of surviving preparatory drawings. It was not ready for exhibition until 1907. It was shown in Mannheim in the spring of that year and in Vienna the following year.

It is a picture to which it is impossible to remain indifferent. From the first, reactions were strong and not always favourable. According to one typically Viennese witticism, almost impossible to translate, it was '*Mehr Blech als Bloch*'[2] (more tin than Bloch) but the critic of the influential *Wiener Allgemeine Zeitung* was seduced by this 'Idol in a golden shrine'. Everything about the painting is intriguingly ambiguous. It is very fin-de-siècle in its sinister allure, despite being created at the beginning of a new century, Belle Epoque in sumptuousness and Jugendstil (Art Nouveau) in its intense decorativeness. Bloch-Bauer's pose is in itself ambiguous. Is she standing or sitting? Despite

indications of a throne-like chair, the pose is based on a preparatory drawing in which she is standing. Bloch-Bauer threatens to disappear entirely into the golden background. But so strongly are her distinctive facial features and her bony hands characterised that the picture remains compelling as a portrait of an individual rather than being a gorgeous piece of decoration. There is something claustrophobic about the picture and one wonders if consciously or unconsciously Klimt was making some comment about the restrictive impact of her wealth on a woman of intellectual aspirations who thirsted for knowledge and experience. A photograph of Adele Bloch-Bauer taken in 1910 in which she wears a similarly languid and alluring expression, with her eyes slightly upturned under heavy lids and lips parted, shows that Klimt's portrait, for all its stylisation, was in fact an accurate portrait of the woman.

Klimt's reputation as a womaniser and the erotic impact of the portrait, have once again led to speculation about the relationship of artist and sitter. It is certainly remarkable that Adele Bloch-Bauer was the only woman to inspire two major portraits by Klimt and also exceptionally amongst his wealthy clients may have modelled for two of his erotic subject paintings, *Judith I* and *Judith II*. The second portrait painted just five years later is in Klimt's later, more colourful and painterly style. Bloch-Bauer's facial expression in this second portrait is very similar, with weary heavy-lidded eyes and open mouth – a detail that would have been unthinkable in any society portrait of an earlier generation, unless smiling. The hieratic stillness of Adele Bloch-Bauer's full-length frontal pose is contrasted with the lively action of oriental horsemen in the background lifted from a Chinese ginger jar.

In addition to the two portraits of Adele, she and Ferdinand Bloch-Bauer also possessed four magnificent landscape paintings by Klimt. These were painted over a lengthy period from 1903 to 1916. As these are of identical format the supposition must be that after the first one at least, they were commissioned rather than bought 'off the peg'.

In the early 1920s the Bloch-Bauer Klimts formed an elegant backdrop to a remarkable salon conducted by Adele in which cultural

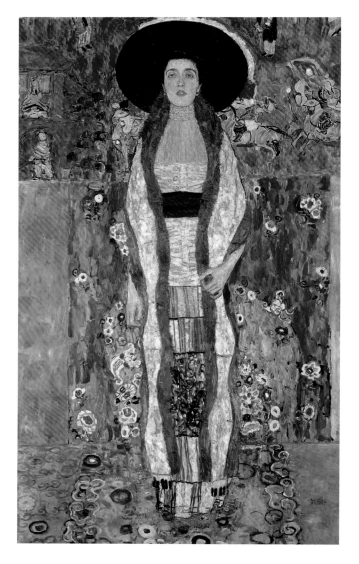

Portrait of Adele Bloch-Bauer II,
1912, oil on canvas, 190 × 120 cm,
private collection

figures such as Richard Strauss, Stefan Zweig, Alma Mahler and Franz Werfel could mingle with the left-wing political figures that she favoured. When Adele Bloch-Bauer died in 1925 she expressed that her Klimt paintings should go to the Austrian State but remain in the possession of her husband for his lifetime. After the Anschluss in 1938 Ferdinand was driven into exile and his property seized by the Nazis. The paintings went to the Austrian State Gallery where they were exhibited for the rest of the twentieth century and until the resolution of the legal action brought by Adele's niece, Maria Altmann, was resolved in her favour. Returned to Ferdinand's heirs as he had wished, Adele's golden portrait was auctioned for the record sum of $135 million in 2006 and now resides in the Neue Galerie in New York. As Adele Bloch-Bauer wished, this magical painting now belongs to the public that flocks to see it, even if the public is not the one that she had in mind.

KARL WITTGENSTEIN

Starting with nothing, Karl Wittgenstein made his fortune and his reputation as the 'Austrian Krupp' of the steel industry but in his fifties shifted his interests towards the arts. His first major purchase from Klimt was the imposing *Golden Knight*, exhibited in the 1903 Secession exhibition and based on a motif taken from the *Beethoven Frieze* exhibited the year before. In 1904 Wittgenstein and his wife commissioned a full-length portrait of their daughter Margarethe Stonborough-Wittgenstein from Klimt for which, as was often the case with Klimt, they had to wait over a year. The Wittgensteins had to pay him the astronomical sum of 5000 gulden for this portrait which put him in the very top league of European fashionable portrait painters at a time when such artists earned more in real terms than ever before or since. The historian Tobias B. Natter has calculated that Klimt's typical average yearly output of one major portrait and two or three landscapes would have earned him enough to buy a smart country house in the most desirable part of Austria. As Wittgenstein went on to buy the exquisite *Water Snakes* and at least three of Klimt's finest landscapes that means that they alone had paid him nearly enough to buy two such villas. Wittgenstein had himself commissioned a hunting lodge from Josef Hoffmann but the *Golden Knight* and the portrait of Margarethe Stonborough-Wittgenstein were displayed in what must by then have seemed the incongruous surroundings of their Vienna palace, which had been decorated in the 1880s in the pompous and cluttered Ringstrasse style.

OTTO AND EUGENIA PRIMAVESI

Otto and Eugenia Primavesi became interested in Klimt through their involvement with the Wiener Werkstätte. Wealth from Otto's family bank enabled them to build up an important collection of works from Klimt's final phase between 1912 and 1918. Their first important commission was for the portrait of their daughter Mäda in 1912, followed by another of her mother Eugenia. As usual, Klimt was paid a princely sum in advance and took his time to finish and deliver the portraits. Klimt clearly enjoyed painting the gorgeously patterned kaftan that disguises her plump figure but the portrait is not amongst his most successful. The relative failure of this picture makes us aware of his mastery of pose and composition in his best portraits and of the delicate balance between decoration and characterisation. The portrait of Mäda is one of Klimt's most striking and disturbing. There is something confrontational about the truculent frontal pose with splayed legs and hands hidden behind her back. Though only nine years old she already seems like a young woman and was, one suspects from a preparatory drawing showing pubic hair as though visible through her dress, the object of Klimt's sexual fantasy. For an artist whose depiction of hands was usually so masterful and often used to great expressive effect, as in the golden portrait of Adele Bloch-Bauer, the decision to hide the hands in this portrait was clearly a conscious one and not mere laziness, as with certain eighteenth-century English portraitists.

The Primavesis bought several landscapes by Klimt to display in their magnificent country house near Olmütz, designed for them by Josef Hoffmann. In 1914 they bought a picture from Klimt's earlier golden phase, *Hope II*, and after his death the wonderful *Baby* that had been left unfinished in his studio.

THE ZUCKERKANDL BROTHERS

Klimt's relationship with the three Zuckerkandl brothers, Emil, Victor and Otto, of Hungarian Jewish origin and all brilliantly successful in different areas of the medical profession, was forged through his friendship with Berta Zuckerkandl-Szeps, the wife of Emil Zuckerkandl,

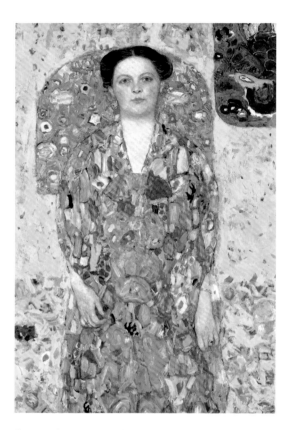

Eugenia Primavesi, c.1914, oil on canvas, 140 × 84 cm, private collection

Mäda Primavesi, 1912–13,
oil on canvas, 110.5 x 49.9 cm,
Metropolitan Museum of Art,
New York

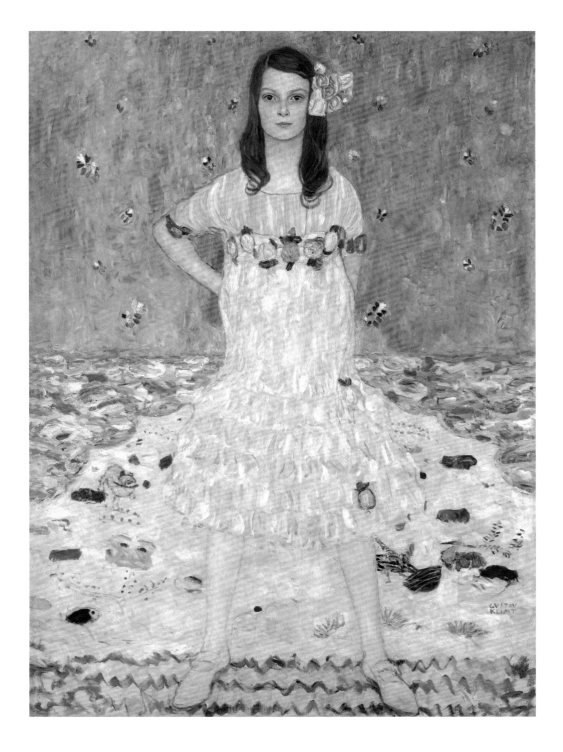

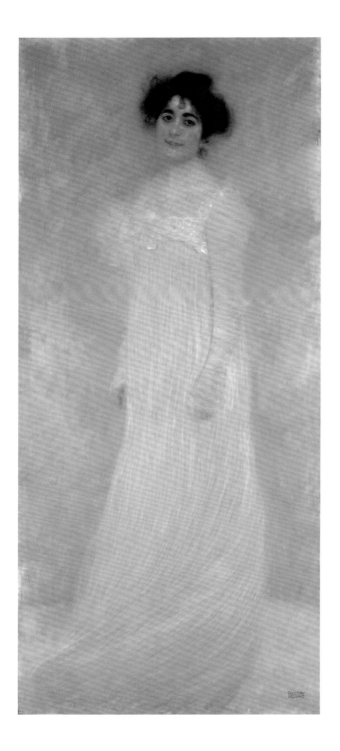

who was a distinguished professor of anatomy. Berta herself was
a noted journalist writing for the liberal *Neue Wiener Tageblatt* and
a tireless propagandist on Klimt's behalf. This was a period when
connections with journalists and newspaper editors could make an
artist's career. Even Manet was prepared to court the hostile journalist
Albert Wolff by offering to paint his portrait and the French painter
owed much of his extraordinary success to his contacts with journalists.

Berta Zuckerkandl also ran a noted Viennese salon, famously
claiming, 'In my salon is Austria'. There Klimt could meet with
Mahler, the theatre director Max Reinhardt, Arthur Schnitzler, the
critic Hermann Bahr and on his famous visit to Vienna, the French
sculptor Rodin. During the First World War, Berta Zuckerkandl
fruitlessly attempted to use her connections with the French political
establishment to bring about a negotiated peace.

Between them, the Zuckerkandl brothers collected a large
number of paintings by Klimt. Surprisingly though, Berta was the only
one of the Zuckerkandl wives not to be painted by Klimt, perhaps
because Klimt's sitters not only had to be prepared to pay a lot of
money for a portrait but also to be the right physical type for him,
which Berta evidently was not. The portrait of Victor's wife Paula
disappeared during the Second World War, probably destroyed. The
portrait of Otto's wife Amalie, interrupted by the outbreak of the First
World War, was left unfinished at Klimt's death in 1918. Like other
works left unfinished, it is fascinating because of the way it reveals how
he worked and built up the paint surface. It is also a poignant record of
a woman who suffered a tragic fate, following her half-Jewish daughter
to death in a Nazi concentration camp.

SERENA AND AUGUST LEDERER

Klimt's most prolific collectors over the entire twenty-year period
of his artistic maturity were Serena and August Lederer, beginning in
1898 with his full length Whistlerian portrait of Serena. The Lederer
family fortune was based on the manufacture of spirits. Unlike many
other assimilated Jews in Klimt's circle, Serena and August Lederer

did not convert to Christianity and remained faithful to their Jewish religion until
the widowed Serena was forced to withdraw from her congregation after the Nazi
Anschluss. There were frequent attacks on August Lederer, not without anti-Semitic
undertones, for his conspicuous wealth, which at one time was reputed to be
second only to the Rothschilds in Austria. Klimt and the aesthetic of the Secession
were inevitably imputed in these attacks because of their association with wealthy
Jewish clients. In 1900 the sharp-penned Karl Kraus, who was himself a Jew, but not
without an element of Jewish self-hatred, wrote with an unpleasant mixture of anti-
Semitism and salacious innuendo: 'As every aristocrat once had his house Jew now
every capitalist has his house Secessionist. Herr Moll is well known as the art agent
of criminal investor Zierer and the coal-userer Berl and Herr Klimt can instruct Frau
Lederer in Secessionist painting.'[3]

Klimt, whose studio on Josefstädterstrasse was walking distance from the
Lederers' town palace, was a frequent visitor, dropping by for dinner on Thursday
evenings according to recollection of their son Erich. Serena persuaded Klimt not only
to paint her lovely daughter Elisabeth but even her aged mother Charlotte Pulitzer.
This was a rare coup from an artist who liked to paint women he desired and the
only case of Klimt making portraits of women from three generations of the same
family. As well as several landscapes and hundreds of drawings, the Lederers acquired
two of Klimt's Vienna University ceiling paintings, Baron Dumba's Schubert painting,
the *Beethoven Frieze* and many other important works, building up by far the most
comprehensive collection of the artist's work.

August Lederer died in 1936, so avoiding the impending catastrophe of war.
Serena fled to Budapest where she died in 1943. The two sons succeeded in going
into exile, leaving only Elisabeth. Elisabeth, who had converted to Protestantism when
she married, probably felt safe, though her husband divorced her within months of
the Anschluss. She survived precariously by making a formal declaration that her
father was not August Lederer but Gustav Klimt so making her, in Nazi parlance, a
'half-Jew'. It says much of Klimt's reputation as a womaniser that she was so easily
believed. Elisabeth Lederer, Baroness Bachofen-Echt died of natural causes in 1944.

The bulk of the Lederer collection of Klimt's work was confiscated by the Nazi's
and destroyed in the arson of Schloss Immendorf in the closing days of the war. It was
one of the greatest artistic losses of the Second World War. There was certainly no
other artist of Klimt's stature whose oeuvre suffered similar losses.

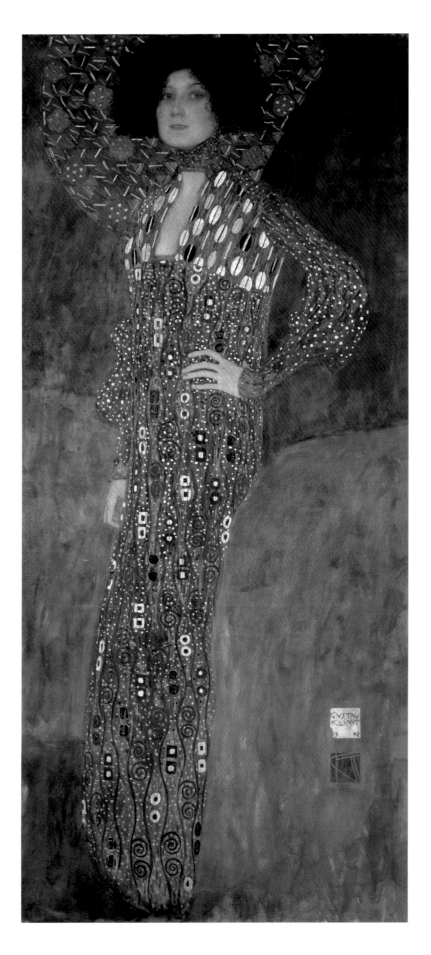

LEFT *Portrait of Emilie Flöge*, 1902, oil on canvas, 178 × 80 cm, Wien Museum, Vienna

OPPOSITE Emilie Flöge photographed by Klimt at Lake Attersee, 1906

PORTRAITS

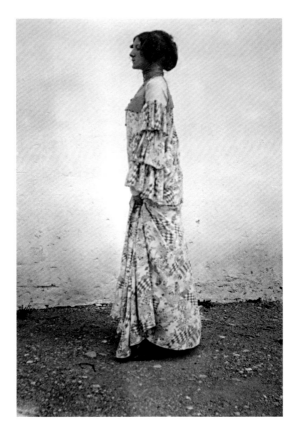

The Belle Epoque was the last great age of society portraiture and the last period in which an artist could specialise in commissioned portraits and retain critical respect. Klimt painted some of the loveliest and most celebrated portraits of this type but could not be designated as a portrait painter like his contemporaries John Singer Sargent and Giovanni Boldini. If western portrait painters can be divided into those who were more interested in Truth (Van Eyck, Holbein, Velazquez, Rembrandt and Goya) and those who were more interested in Beauty (Bronzino, Van Dyck, Ingres), Klimt belongs firmly in the latter camp. Photographs of his sitters show that he was capable of providing a likeness and his portraits are not without psychological insights but by and large he was more interested in creating a stylish and beautiful image than in making an inventory of the sitter's appearance or analysing his or her (usually her) personality.

In the first phase of Klimt's career while he was painting large-scale decorative schemes for theatres and public buildings few would have predicted that he would become so engaged with portraiture. As we have seen though, Klimt made sensitive portraits of family and friends to aid him with the murals on the staircases of the Burgtheater and the Kunsthistorisches Museum. Earlier still, while they were still students, Gustav and Ernst Klimt painted portrait miniatures from photographs in order to supplement their incomes. While this could be dismissed as potboiling, this practice enabled Klimt to develop certain skills that remained useful throughout his career.

The elaborate group portrait that Klimt painted on commission in 1888 of the audience in the old Burgtheater is unique in his oeuvre. Hardly one of his most satisfactory works from an aesthetic point of view, it is nevertheless a fascinating document offering a comprehensive cross-section of Viennese society from grand dukes to journalists and actors. A photogravure after the painting identifies many of the figures, including the composer Johannes Brahms, the future anti-Semitic mayor of Vienna Karl Lueger, the celebrated comedian and opera performer Alexander Girardi and the actress Katharina Schratt who provided solace for the aging emperor Franz Josef. It is evident that most, if not all, of the tiny portraits in this picture were painted from photographs and not from life. The effect is very much that of a collage and it seems odd that an artist as accomplished as Klimt already was at this stage in his life could not succeed in creating a more life-like sense of interaction between the figures.

The tiny portrait of the amiably ugly pianist Joseph Pembaur that Klimt painted on commission in 1890 is also evidently painted from a photograph rather than from life. It is hardly one of his more successful efforts. The disparate elements of this portrait are not yet fused with the expertise that Klimt would later develop. But we see here for the first time several features that would become characteristic of his more mature portrait style – in particular the contrast between the realism of the face and the flat pattern-making of the background, the attempt to integrate the decorated frame into the overall composition, the use of gold leaf and the borrowing of elements from a decorative object (in this case a Greek vase).

Male portraits are rare in Klimt's oeuvre and all of them date from before 1900. Perhaps the most striking is *The Blind Man* dating from around 1896. In marked contrast to the tight and smooth execution of the Pembaur portrait and other works of the early 1890s this picture is more freely painted. The sitter is posed in a dramatic raking light that accentuates his aged and care-worn appearance. Klimt was proud enough of this highly uncharacteristic work to include it in the first Secession exhibition.

A tiny portrait of a seated girl wearing a white dress dating from 1894, like the Pembauer portrait, has the look of being painted directly from a photograph but with a more satisfactory result. Klimt has conjured a miraculous transformation of a banal photograph into an exquisite and touching work of art. The cropped rendering of the carved arm of the chair in which shè sits intruding into the bottom left hand

LEFT *Portrait of Joseph Pembauer*,
1890, oil on canvas, 69 × 55 cm,
Tiroler Landesmuseum
Ferdinandeum, Innsbruck

RIGHT *Seated Young Girl*, 1894,
oil on wood, 14 × 9.5 cm,
Leopold Museum, Vienna

corner of the portrait is strikingly similar to several paintings by Vermeer which may
have been painted from photographic projections of a camera obscura. The frank
gaze of the young girl engaging the viewer and Klimt's pellucid naturalism in this
picture is also strikingly reminiscent of portraits of the Biedermeier period by artists
such as Ferdinand Georg Waldmüller (1793–1865) and Friedrich von Amerling
(1803–87). Klimt's *Schubert at the Piano*, painted for the Dumba music room in
1899, evokes the cosy domesticity of the Biedermeier and suggests that Klimt was
ahead of the game in his interest in a period that was generally despised in the late
nineteenth century as narrow and *petit bourgeois*.

The revival of interest in the Biedermeier period gathered momentum
after 1900. The sobriety of Biedermeier decorative arts appealed to designers in
reaction to the floral excesses of Art Nouveau and the psychological directness and
truthfulness of Biedermeier portraits appealed to a younger generation of artists.
A landmark exhibition of Biedermeier portraits organised by Klimt's friend and
colleague Carl Moll was held in Vienna in 1905 at the Galerie Miethke. In an article
in the *Wiener Allgemeine Zeitung*, Berta Zuckerkandl, one of Klimt's closest associates
and greatest supporters, expressed her enthusiasm for the extraordinarily modern
looking and 'profoundly penetrating' portraits of Waldmüller.

Another fascinating portrait of around 1894 that shows Klimt in a moment of transition and anticipates certain key features of his mature portrait style is the *Portrait of a Lady in Black*. Close in style to the little portrait of the girl in white, this picture is on a much larger scale (155 × 75 cm). The meticulous finish, static pose and the cropped head of a chaise longue retain a photographic air. However, the oriental carpet hanging on a wall parallel to the picture surface and the strongly demarcated contours and negative spaces look to the future.

Four years later in 1898 Klimt reached full maturity as a portrait painter with the portrait of Sonja Knips shown at the second Secession exhibition. This portrait also marks the beginning of what might be termed Klimt's Whistlerian phase. The American James McNeill Whistler (1834–1903) was the first artist to fuse all the essential ingredients of Belle Epoque society portraiture – the painterly bravura of the Old Masters, the elegance of English eighteenth-century portraits, the modern sensibility of Manet and Degas, and Japanese design. Whistler's character was too prickly and irascible for him to succeed as a society portraitist but his formula was successfully exploited by Sargent and many other portraitists of the Belle Epoque. Klimt must have been particularly attracted to Whistler's 'art for art's sake' aestheticism and his combination of Japonisme and what Degas called 'the delicate muddiness' of Velazquez. This fusion was masterfully achieved as early as the 1870s when Whistler painted *Harmony in Grey and Green: Miss Cecily Alexander*. Whistler's depiction of the little girl was inspired by that of the Infanta at the centre of Velazquez's *La Meninas,* but her pose (her Victorian parents would no doubt have been shocked to know) was directly borrowed from Manet's portrait of the Spanish dancer Lola de Valence. The utter lack of Victorian sweetness and sentimentality that elicited the hostility of British critics ('a disagreeable presentiment of a disagreeable young lady', 'an arrangement of silver and bile' were just two of the negative comments) also looks forward to the depiction of children by Klimt and his younger contemporaries in Freud's Vienna.

Whistler also anticipated Klimt in the obsessive way he supervised his sitter's appearance, down to the brushing of her hair, her clothes and even the carpet she stands on. Like Klimt in several of his portraits, Whistler designed the little girl's dress. In a letter to her mother he instructed her where to buy the kind of white Indian muslin he required and went on to describe the dress itself; 'the dress might have frills on the skirts and about it – and a fine little ruffle for the neck or else lace – also

Portrait of Hermine Gallia, 1904, oil on canvas, 170.5 × 96.5 cm, National Gallery, London

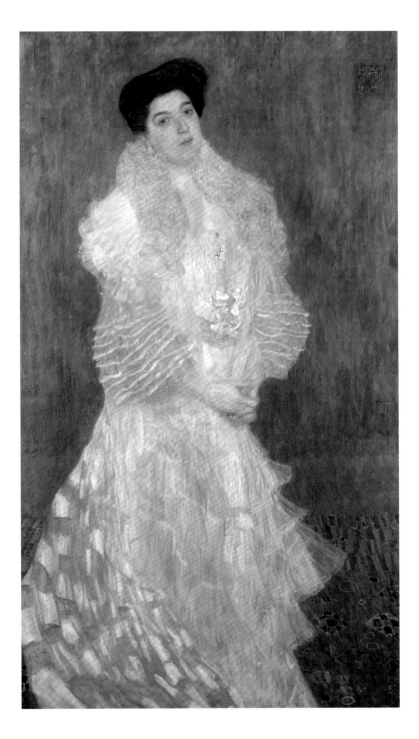

it might be looped up from time to time with bows of pale yellow ribbon ... the little dress afterwards done up by the laundress with a little starch to make the frills and skirts etc. stand out – of course not an atom of blue!'[1]

Whistler's penchant for designing rooms to create harmonious settings for his paintings would also have been of great interest to Klimt and his fashionable Viennese clientele. Whistler was one of the first foreign artists to be approached with an invitation to exhibit at the Secession and Klimt would have had plenty of opportunity to study his work. In the Whistlerian sense, the portrait of Sonja Knips could be described as a harmony in silver and pink. The exquisite paint surface, misty focus, the elision of foreground and background and the very Japanese intrusion of blossoms from the right hand side all recall Whistler.

Other portraits by Klimt that show a strong influence from Whistler include that of Serena Lederer dating from 1899 and of Hermine Gallia from as late as 1904 when Klimt was already in the process of embarking on a new phase in his work. Each could be described as a harmony in delicate shades of cream and silver. Both are full length though cropped at the bottom to create a spacial ambiguity and in the case of Serena Lederer to disguise her lack of height. Hermina Gallia is placed asymmetrically to the left and Serena Lederer to the right. They tilt their heads ingratiatingly (in opposite directions) and both wear dreamy and rather vacant expressions.

The portrait of Hermine Gallia was shown in an unfinished state in Klimt's 1903 retrospective at the Secession. A photograph was published in the magazine *Die Kunst* of the portrait hanging in that

exhibition in a simple narrow frame, very different from the heavy gilded frames customary in the nineteenth century, placed between two stylish chairs with geometrically patterned cushions and against a spacious white wall unencumbered by any other pictures. We glimpse the portrait again in the background of a photograph of the elegant apartment designed for Gallia and her husband Moritz in 1913 by Josef Hoffmann and we realise that commissioning such a portrait from Klimt was a means of buying into a lifestyle for newly wealthy, assimilated Jews such as the Gallias.

The portrait of Hermine Gallia already displays some features of the next phase of Klimt's style – the 'delicate muddiness' has given way to firmer, more sharply defined contours. Hermine's jewellery is painted with a solid impasto that stands out from the surface, creating an effect almost like collage. The portraits of Marie Henneberg (1901–2) and of Gertha Felsovanyi (1902) show Klimt's highly idiosyncratic use of the pointillist technique invented by Georges Seurat and introduced to Vienna by Seurat's disciples Theo van Rysselberghe and Paul Signac through their exhibits at the Secession. The portrait of Felsovanyi makes use of the elongated format found in Japanese prints and ultimately derived from Chinese scroll painting.

Klimt's new portrait style, and the one for which he is most celebrated, announced itself in 1902 with his full length portrait of Emilie Flöge, more than a year ahead of the completion of the portrait of Hermine Gallia. As he was painting a close friend rather than a wealthy client, Klimt presumably felt freer to experiment. Flöge's face, hands and décolleté are rendered naturalistically and surrounded by areas of ornamental abstraction with the use of gold and silver leaf. It was a formula that Klimt had tried, albeit far more crudely, as far back as his portrait of Joseph Pembauer in 1890. Not quite as elongated in its proportions as the portrait of Gertha Felsovanyi, the effect of the composition is nevertheless Japanese and after the Japanese fashion Klimt signed the picture inside a gilded square box that locks the conspicuous empty space into

Klimt's *Portrait of Marie Henneberg* hanging in the hall of the Henneberg's villa on the Hohe Warte in Vienna, c.1903

the overall picture surface. Flöge's slender and streamlined silhouette so strongly emphasised by Klimt is in striking contrast to the kind of hourglass corseted shape fashionable with women prior to reforms introduced by Paul Poiret in 1908. Nevertheless, Flöge is not wearing one of her own simple and loose-fitting 'reform' dresses, as this richly ornamented dress hugs her contours. The choker that almost seems to sever her head from her body was a feature that Klimt had borrowed from the Belgian Symbolist Fernand Khnopff and one that Klimt used frequently in his depictions of women.

Flöge apparently did not like her portrait – a hazard that every portraitist has to deal with, but a less grave one when he is not at the mercy of a rich client. It says something about Klimt's prestige that in 1908 he was able to sell this unwanted portrait to the State Museum of Lower Austria for the substantial sum of 12,000 krone. Klimt informed Flöge, 'You were "sold", or "cashed in" today'.

In the *Wiener Allgemeine Zeitung* Berta Zuckerkandl enthused about the portrait: 'The charming face, subtle and finely modelled is highlighted further by the unusual framing device. The head is surrounded by an aureole-style green blue floral corona whose background is Byzantine colour mysticism.'[2] As a close friend of the artist, Zuckerkandl was no doubt aware of his visits to Ravenna and of the new-found enthusiasm for Byzantine mosaics that was to play such an important role in the next phase of his work.

The new stylistic features in the portrait of Emilie Flöge were developed over the next few years in a series of magisterial female portraits, culminating in the 'golden' portrait of Adele Bloch-Bauer upon which much of Klimt's fame and popularity rests. These include the portraits of Margarethe Stonborough-Wittgenstein (1905) and of Fritza Riedler (1906).

Margarethe Stonborough-Wittgenstein was another of Klimt's sitters who was not satisfied with her portrait. Two years later, John Singer Sargent would give up taking on such commissions, remarking bitterly that a portrait was just a painting of someone in which 'the mouth is not quite right'.[3] It was perhaps a concession to Stonborough-Wittgenstein's intellectual personality that Klimt eschewed the ornamental excesses of other portraits of this phase in favour of a severe geometry for the background. Such severity would later characterise the modernist villa designed for Margarethe Stonborough-Wittgenstein by her brother, the philosopher Ludwig Wittgenstein.

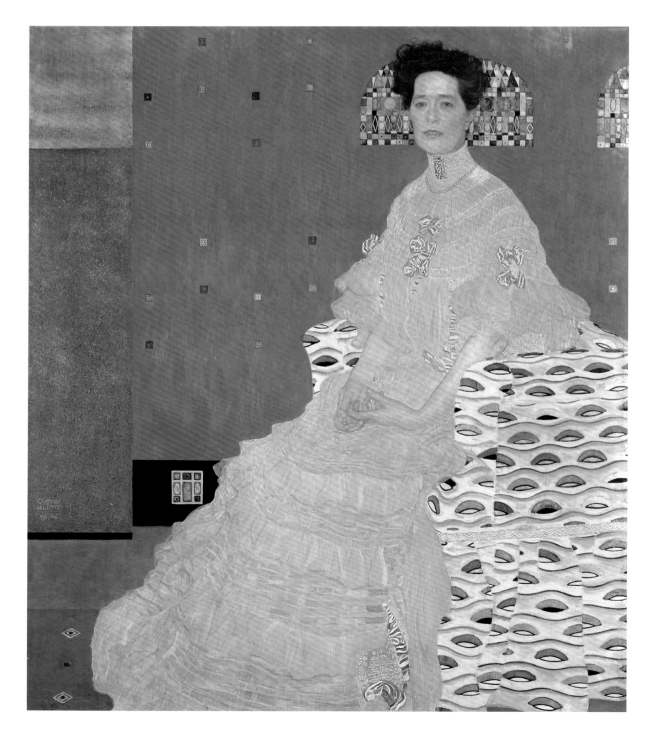

LEFT *Portrait of Fritza Riedler,* 1906, oil on canvas, 153 × 133 cm, Österreichische Galerie Belvedere, Vienna

OPPOSITE Portrait of Margaret Stonborough-Wittgenstein, 1905, oil on canvas, 179 × 90.5 cm, Neue Pinakothek, Munich

A curious feature shared by the portraits of
Margarethe Stonborough-Wittgenstein and Fritza
Riedler is the semi-circular shape on the wall behind
their heads which, because of the flattening of space,
gives the impression of being some kind of headdress
worn by the sitters. These refer to the elaborate
headdresses of similar shape worn by the Habsburg
princesses in the famous Velazquez portraits in the
collection of the Kunsthistorisches Museum.

In the portrait of Fritza Riedler Klimt's eclecticism
is displayed, with elements of Japonisme, Spanish court
portraiture, Byzantine mosaics and ancient Greek
ornament fused together to create a style that is
unmistakably that of Klimt.

This phase of Klimt's art reached a delirious climax
with the portrait of Adele Bloch-Bauer. Brilliantly
successful though this painting was, it must have been
clear to Klimt that this was a direction in which he
could not travel any further. He turned to modern
French painting to help move beyond this impasse and
on to the more free and painterly technique which
he pursued for the remaining ten years of his life. The
1903 Secession survey of French painting would have
enabled Klimt to familiarise himself with the leading
figures of Impressionism and Post-Impressionism.
Once again Klimt was strong enough to absorb these
influences while remaining entirely himself.

Two non-commissioned portraits dating from
1909 and 1910 allowed Klimt to experiment with
this new direction in his art. *Portrait of a Woman with
a Feather Boa*, executed with a painterly exuberance
entirely new to his art, depicts a modern urban femme
fatale with shifty sideways glance, a halo of fiery red
hair and a blood-red upper lip fleetingly visible above

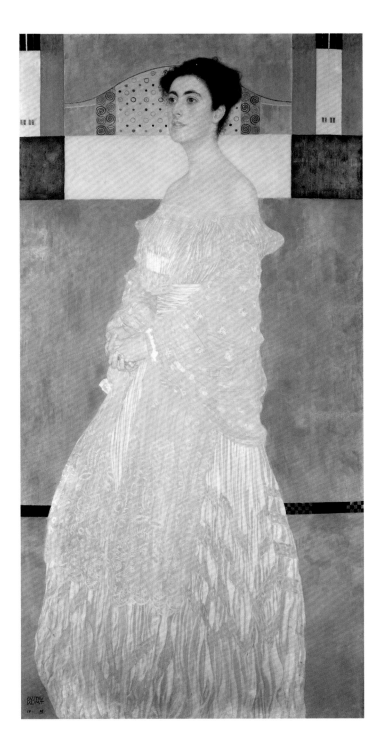

the black feather boa that masks the lower part of her face. The elusive and luminous nocturnal background is no longer flat and stylised but is so loosely painted that it is impossible to identify exactly what is represented.

The more thinly and drily painted *Woman with a Feather Hat* recalls the work of Henri de Toulouse-Lautrec in the way that Klimt draws with the brush. Such boldness would not have been possible in a commissioned portrait but in Klimt's later society portraits he found other ways to express his painterly exuberance.

The 1912 portrait of Adele Bloch-Bauer in this new manner makes a fascinating comparison with the 'golden' portrait painted just five years earlier. Klimt's characterisation of the woman herself remains remarkably consistent. We see the same heavy-lidded eyes and open mouth, the same air of world-weary languor and the same claw-like hands, now hanging limply at her sides. But the second portrait is a feast of colour. The gilded abstract ornament of the earlier portrait has been replaced by equestrian warriors borrowed from an oriental ceramic vase, whose animation contrasts with the languor of the sitter.

Klimt used the same device in his 1916 portrait of Friederike Maria Beer. The surrounding oriental warriors seem to be furiously thrusting their swords and lances into the body of the passive and placid young woman. Friederike Maria Beer was the only woman with the foresight to commission full length portraits from both Gustav Klimt and Egon Schiele, thus giving us an opportunity to make a very direct comparison between Vienna's two greatest portraitists in the early years of the twentieth century. Schiele had the young woman pose on the floor in near-foetal position. In contrast to Klimt's *horror vacui* Schiele surrounds his model with emptiness. Photographs taken of Beer at the time prove that Klimt's portrait was a much more accurate likeness of the pleasingly plump young woman, whereas Schiele has projected onto her his own twitchy neuroses and even his skinny build.

Friederike Maria Beer wearing the Wiener Werkstätte dress in which she was drawn by Egon Schiele, 1914

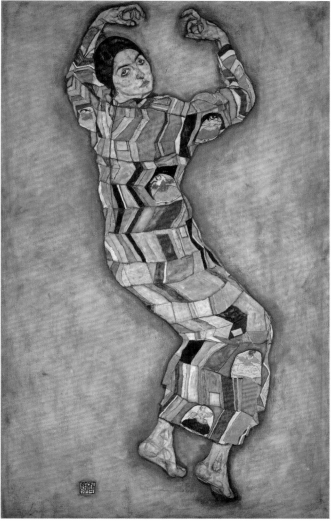

Portrait of Friederike Maria Beer, 1916, oil on canvas, 168 x 130 cm, Mizne-Blumenthal Collection, Museum of Art, Tel Aviv

Egon Schiele, *Portrait of Friederike Maria Beer*, 1914, oil on canvas, 190 x 120.5 cm, private collection

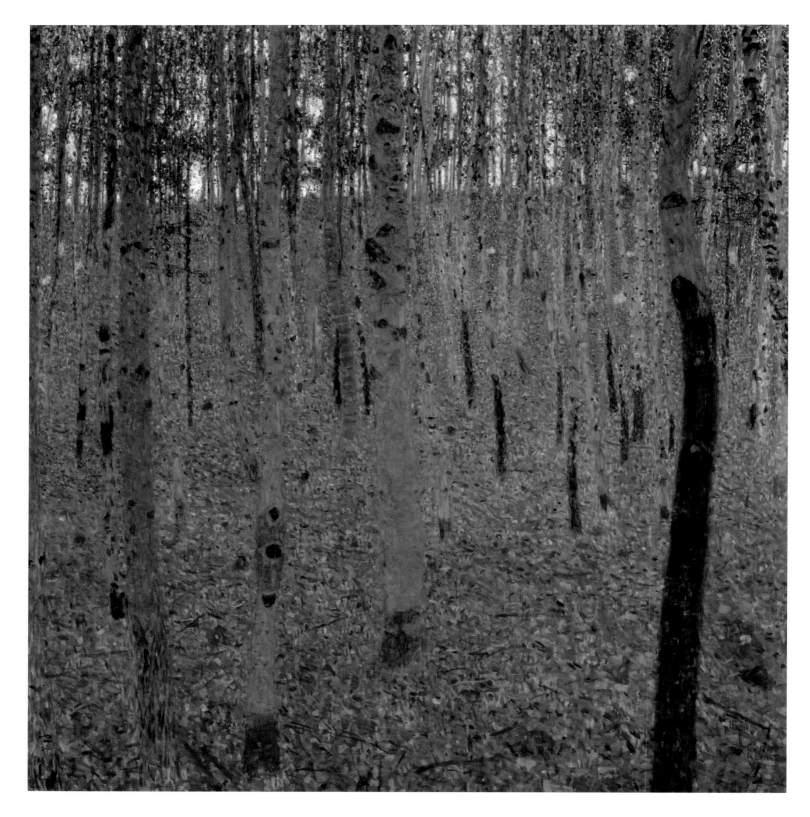

ABOVE *Beech Forest I*, c. 1902, oil on canvas,
100 × 100 cm, Galerie Neue Meister,
Staatliche Kunstsamlungen, Dresden

OPPOSITE Avenue in the park of
Schloss Kammer, Attersee

LANDSCAPES

The rapid growth and urbanisation of Vienna in the second half of the nineteenth century stimulated the desire of many Viennese to escape the city's sticky continental climate in the summer months. The annual migration was aided by the construction of the railway system. The wealthier bourgeois rented houses for up to two or three months or built comfortable villas on the shores of the many lakes with which Austria is blessed. The Attersee, one of a chain of lakes in the Salzkammergut in Upper Austria that empty into the Danube, was particularly favoured for its refreshing breezes and clean water. These features were no doubt especially enjoyed by Klimt who loved boating and swimming.

From the 1890s until his death, Klimt kept up a regular yearly output of landscape painting, usually during his summer holidays spent at the Attersee with the Flöge sisters. Nearby was the fashionable resort of Bad Ischl to which the Emperor and his inner circle retired in the summer. But the Attersee itself remained unspoilt and provided Klimt with the tranquillity that he craved. The surrounding landscape was both picturesque and spectacular with gentle hills at one end of the lake and steep mountains at the other. But Klimt ignored the more dramatic or more obviously picturesque aspects of the Attersee and the landscapes he painted there are domestic rather than Romantic, with simple block-like rural buildings providing an important element. Even the Schloss Kammer, which he painted more than once, is decidedly domestic in appearance.

A painting that exercised a profound impact on Klimt's earlier attempts at landscape was Ferdinand Khnopff's *Still Water* exhibited at the first Secession show in 1898. Khnopff's painting is more an evocation of mood – what the French would call an '*état d'âme*' – a record of a time and place in the manner of Impressionism. Klimt's friend and defender Hermann Bahr compared Khnopff's art with the writing of the 'Belgian Shakespeare' Maurice Maeterlinck. 'Khnopff paints what Maeterlinck writes. He is a painter of inner life ... Maeterlinck is fond of saying that what we say or do is unimportant; it is merely semblance, beyond which our real life lies concealed ... It is the inexpressible that Khnopff attempts to paint.'[1]

Klimt's landscapes of the late 1890s, such as *Still Pond* and *After the Rain*, are similarly more about mood than place, and adopt a muted palette close to that of Khnopff. *Still Pond* uses a compositional format close to that of Khnopff's *Still Water* with a high viewpoint, trees cropped at the top of the picture and their reflections cropped at the bottom. Compositionally, these pictures would work as well hung upside down as they do the right way up. Indeed, the Khnopff was accidentally hung upside down in the nineteenth-century section of the Kunsthistoriches Museum in the early 1980s without anyone noticing.

Many of the features that characterise Klimt's landscapes throughout his career – very high or low viewpoints, flattening of space, asymmetry and cropping of important elements – derive from Japanese woodcut prints. After 1900 the palette of Klimt's landscapes brightens under the influence of Impressionism. Both his colour and his use of a looser weave of broken brushworks show his close study of Monet, though in certain respects Klimt pursued a very different course

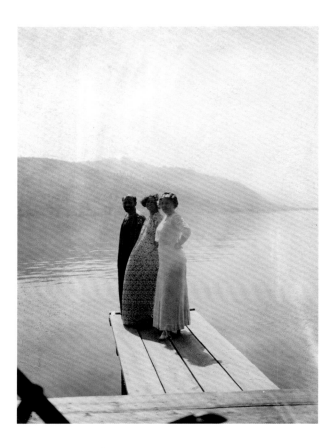

ABOVE Klimt with Emilie and Helene Flöge, Lake Attersee, c.1910

OPPOSITE *Attersee*, 1901, oil on canvas, 80 × 80 cm, Leopold Museum, Vienna

PREVIOUS PAGES View over the Attersee Lake and village in the Austrian Alps

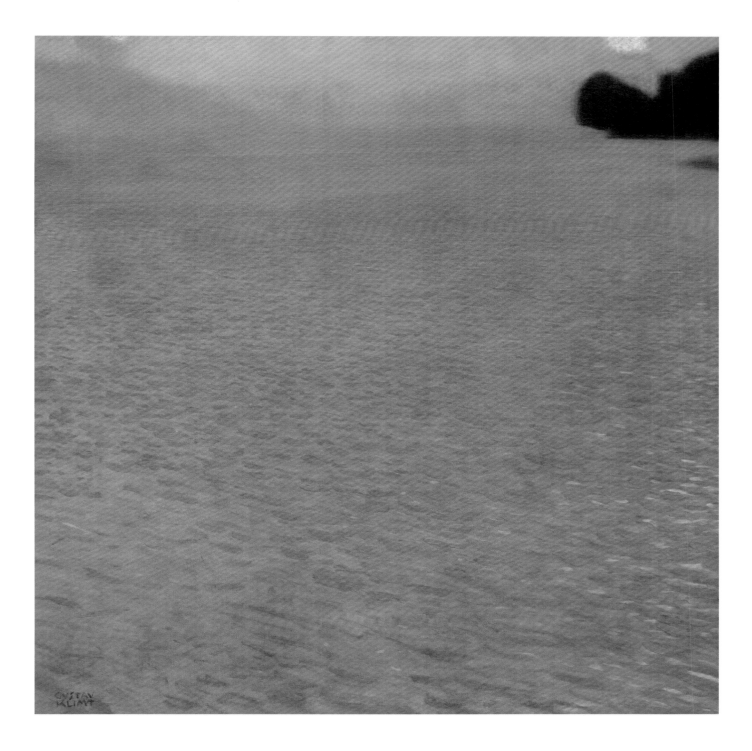

OPPOSITE *The Avenue in the Schloss Kammer Park*, 1912, oil on canvas, 110 x 110 cm, Österreichische Galerie Belvedere, Vienna

RIGHT View of Schloss Kammer at Attersee, c.1930

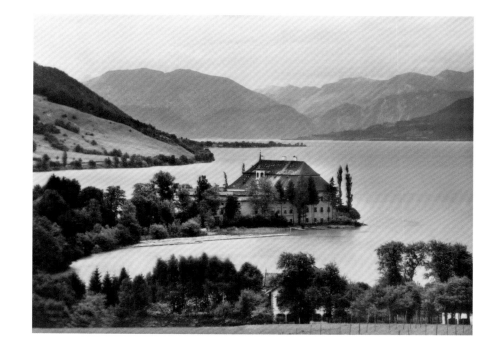

from that of Monet and the Impressionists. At first glance a painting like *Island in the Attersee* of 1901 looks remarkably like Monet in its luminosity and the way Klimt has recorded the shimmering surface of the water with separate horizontal strokes of the brush. Though Monet too uses compositional devices borrowed from the Japanese such as high viewpoints and cropping, his paintings are never as flat as those of Klimt, nor as concerned with surface pattern. Unlike the landscapes and waterscapes of the Impressionists, Klimt's landscapes show no evidence of human habitation and activity even when they include buildings. And for all the sunlit luminosity of certain works, Klimt was never particularly interested in recording specific weather conditions or time of day. The more forceful and expressive brushwork strongly emphasised contours of later landscapes such as *The Avenue in the Schloss Kammer Park*, Klimt looking beyond Monet to the Post-Impressionism of Van Gogh, though Klimt's landscapes of this period tend to be joyous and exuberant rather than angst-ridden.

It is typical of the compartmentalisation of Klimt's life that the most detailed information we have about Klimt's painting activities when he was on holiday with

The Schloss Kammer on the Attersee III, 1910, oil on canvas, 110 x 110 cm, private collection

the Flöge sisters comes from his furtive correspondence with Mizzi Zimmermann, his long-term model and mistress and mother of two of his children: 'I get up early in the morning usually at six, a little earlier, a little later – if the weather is fine, I go into the forest nearby – I paint beech wood there (when it's sunny) with a few pines mixed in, that goes on till eight, then there's breakfast, after that a swim in the lake, as cautiously as possible – after this a bit of painting again, if it's sunny a painting of the lake, if it's dull a landscape from the window of my room – sometimes there's no morning painting, instead I study my Japanese books – outdoors. So it goes on till noon, after lunch I have a little doze or do some reading – until snack time – before or after the snack I go for a second swim, not every day but most. After the snack there is more painting – a big poplar in the twilight in a gathering storm – now and then instead of the evening painting we have a little bowls match in a village nearby – but rarely – twilight comes – supper – then early to bed and up again early next morning. Now and then there is some boating added to this timetable to shake up the muscles a bit.'[2]

Klimt's landscapes are more directly linked to the preoccupations of his other work than might be imagined. In the later landscapes it is the rampant fecundity of nature that fascinates him and depictions of parks and gardens can be as charged with erotic symbolism as his portraits and allegories. His attitude to nature is summed up in a little poem he wrote down on 10 July 1917.

The water-lily grows by the lake
It is in bloom
The yearning for a handsome man
Is in her soul.

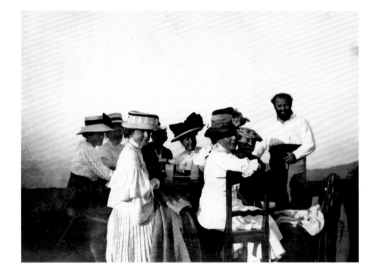

LEFT Gustav Klimt sitting at a table
with friends on a trip to the Gahberg,
Attersee, 1908

RIGHT Klimt and Emilie Flöge with
Hermann and Barbara Flöge in front of
the Oleander villa in Kammer, 1908

BELOW Klimt in his pinafore and Emilie
Flöge in front of the boathouse in
Litzlberg at the Attersee Lake, with Fritz
Paulick in a canoe, 1904

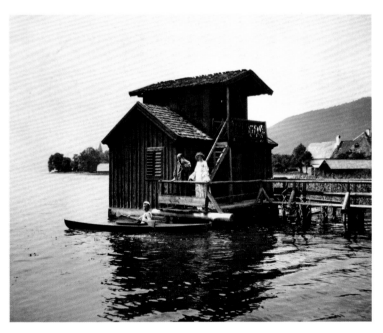

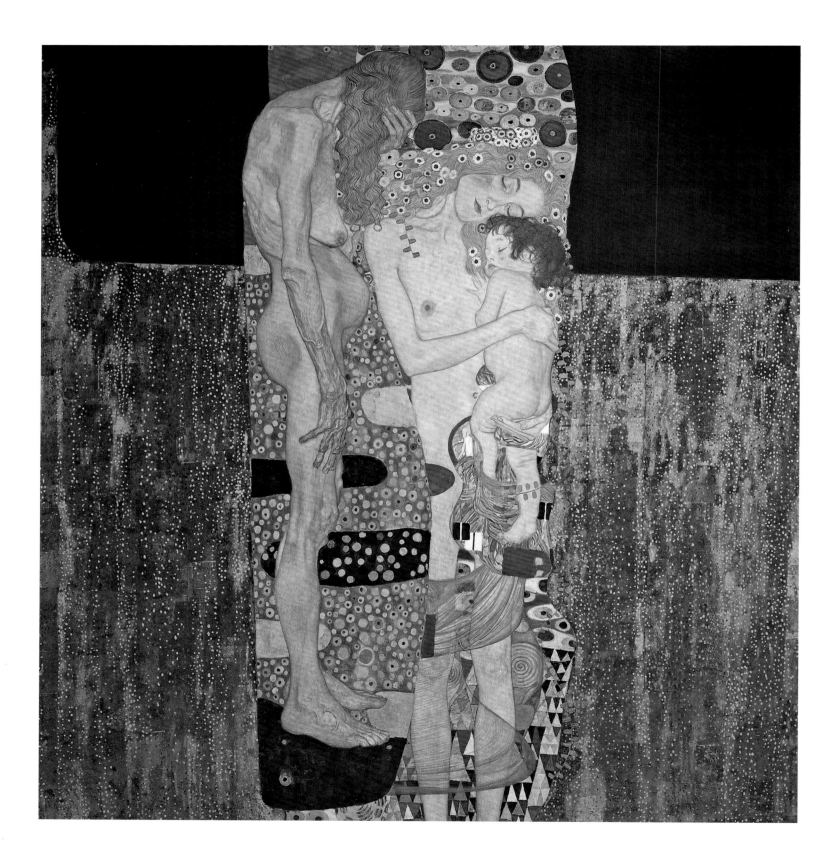

ALLEGORIES & SYMBOLS

· ·

The Three Ages of Woman, 1905,
oil on canvas, 180 x 180 cm,
Galleria Nazionale d'Arte
Moderna, Rome

Time, taste and the misfortunes of war have all tended to deflect attention away from Klimt's more ambitious and philosophical works and towards his portraits and landscapes. It is unlikely, though, that he thought of himself primarily as a painter of portraits and landscapes. Stylistically Klimt can be linked to Art Nouveau, Jugendstil or the Secession style (in this context the three terms being almost interchangeable) but if one wishes to place him in a broader art movement, it is with the Symbolists that he belongs, alongside Edvard Munch, Ferdinand Hodler, Franz von Stuck and Fernand Khnopff.

The Symbolist movement in literature and the visual arts gained momentum in the 1880s and 90s in reaction to the materialist and positivist philosophies that had dominated the mid-century with their unquestioning belief in progress. In the visual arts there was a reaction against the Realist and Impressionist movements and their commitment to the sensory perception of the real world. The change of attitudes is evidenced by contrasting comments by the arch-Realist Gustave Courbet and the Symbolist Gustave Moreau. When asked why he painted ugly people and never an angel, Courbet answered that he would willing paint an angel if someone would bring one to his studio. Whereas Moreau insisted he was only interested in depicting what he could not see around him in the material world.

In 1892 a Symbolist salon was launched by the decadent writer Joséphin Péladan under the name Salon de la Rose+Croix. According to Péladan, they

favoured 'Legend, Myth, Allegory and the Dream and the Paraphrase of great poetry and finally all lyricism; the order prefers work that has a mural-like character as being of superior essence.' It was an agenda that would have suited Klimt nicely and it is significant that the most important artist attracted to exhibit with the Salon de la Rose+Croix was Ferdinand Hodler, with whom Klimt felt a great affinity.

In a famous letter from the Swedish playwright August Strindberg to Paul Gauguin, written in 1895, which the artist used in the catalogue of an exhibition, Strindberg noted the sea change in cultural attitudes in Paris in the mid-1880s and in particular the change in allegiance amongst the avant-garde from Manet to Puvis de Chavannes. The key date would seem to have been 1884. In that year the previously ignored and misunderstood Puvis de Chavannes was acclaimed for his mural *Le Bois Sacré* exhibited at the Salon. This image of muse-like figures, wrapped in sheets and relaxing in what looks like an idealised municipal park became one of the most influential and widely imitated of the late nineteenth century. Also in that year, the publication of the novel that Oscar Wilde declared to be the 'encyclopaedia of decadence', Joris-Karl Huysmans' *Against Nature*, signalled the defection of its author from the Realist camp. *Against Nature* launched the fame and notoriety of another artist central to the Symbolist movement, Gustave Moreau. Huysmans' astonishing verbal evocations of Moreau's Salome paintings highlight the artist's fin-de-siècle decadence but also seem to anticipate Klimt's depictions of Judith/Salome in the early years of the new century.

'In Gustave Moreau's work, which in conception went far beyond the data supplied by the New Testament, Des Esseintes [the protagonist of the novel] saw realised at long last the weird and superhuman Salome of his dreams. Here she was no longer just the dancing girl who extorts a cry of lust and lechery from an old man by the lascivious movements of her loins; who saps the morale and breaks the will of a king with the heaving of her breasts, the twitching of her belly, the quivering of her thighs. She had become, as it were, the symbolic incarnation of undying Lust, the Goddess of immortal Hysteria, the accursed Beauty exalted above all other beauties by the catalepsy that hardens her flesh and steels her muscles, the monstrous Beast, indifferent, irresponsible, insensible, poisoning, like the Helen of ancient myth, everything that approaches her, everything that see her, everything she touches.'[1]

The two qualities which Moreau himself identified as essential to his art – '*la richesse necessaire*' and '*la belle inertie*' (literally 'necessary richness' and 'beautiful

inertia or indolence') could be used to define the very notion of fin-de-siècle. 'Beautiful inertia' is that languorous and slightly unhealthy lethargy present in the paintings of so many artists of this period, from Burne-Jones to Klimt himself. 'Necessary richness' means that the image should have a gorgeous and decorative surface quite separate from what is represented. The paintings of Moreau have been compared to jewellery, and certain works by Burne-Jones look as though they had been painted over expensive embossed wallpaper. In words that could have come from the mouth of Klimt, Burne-Jones said, 'I love my pictures as a goldsmith does his jewels. I should like every inch of surface to be so fine that if all but a scrap from one of them were burned or lost, the one who found it might say, whatever this may have represented it is a work of art beautiful in surface and quality of colour.'[2] Certainly no other painting has ever taken the twin qualities of 'beautiful inertia' and 'necessary richness' to greater extremes than Klimt's portrait of Adele Bloch-Bauer.

The trivial anecdotalism of the Burgtheater murals represented everything that Péladan most despised and it was not until well into the 1890s that Klimt began to develop a new approach to his subject matter. We see a moment of transition in the tiny panel entitled *Liebe* (love) dating from 1895. The title itself suggests a desire to move away from the specific and anecdotal towards something more universal. The influence of Japonisme is evident in the elongated format and the asymmetrical placing of roses on the plain gold frame. The sinister and erotic figures floating mistily at the top of the picture anticipate the imagery of the University ceilings, but the literal and rather banal depiction of the lovers themselves is closer to the academic style of Francesco Hayez's immensely popular *Il Bacio* (The Kiss) than it is to Klimt's later depictions of similar subjects.

In the still smaller *Music I* (measuring only 37 x 44 cm), also painted in 1895, the disparate elements of Klimt's mature style coalesce far more successfully. But there are significant differences between this and the larger version *Music II*, painted three years later for Baron Dumba's music room. In the earlier version the girl is seen in strict profile, with her hair tied up behind her head and seems completely absorbed in her music-making. In *Music II*, the formerly chaste young girl has quite literally let her hair down and has been transformed into a fully-fledged femme fatale who swings round slightly menacingly towards the viewer while still strumming the harp with her left hand. The sly erotic symbolism that was to play such an important role in Klimt's later work makes an early appearance in *Music I*, with the libidinously

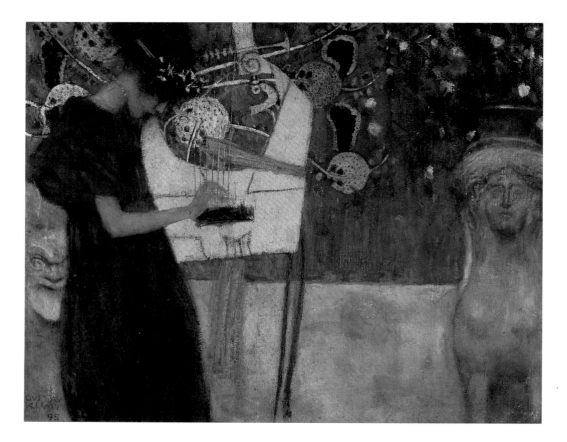

Music, study for the *Stoclet Frieze*,
1895, oil on canvas, 37 × 44 cm,
Neue Pinakothek, Munich

grinning Greek mask nestling suggestively into the small of the girls back. The same mask reappears in *Music II*, no less suggestively placed to the front of the girl's figure.

The nude femme fatale appears for the first time in Klimt's art in the same year, miniaturised and standing in the hand of *Pallas Athene* and causing consternation at the second Secession exhibition. This relatively small work with its unusual square format (75 × 75 cm) is important as perhaps the first entirely successful expression of Klimt's mature art but also for its fusion of the classical and the fin-de-siècle. Art Nouveau and the art of the fin-de-siècle in most of its forms is strongly anti-classical, but Klimt, like his Bavarian colleague Franz von Stuck, was deeply engaged with certain aspects – one might say the Freudian aspects – of the classical world and its mythology. Both Klimt and Stuck succeeded in creating a version of classicism that was very much of their time. The link with Freud is underlined by the ex-libris that Freud chose for his library, depicting Oedipus

and the Sphynx, which is very much in the style of the Secession clearly influenced by Klimt's Theseus poster.

The tiny red-headed nude in *Pallas Athene* was enlarged to life-size for the painting *Nuda Veritas* exhibited at the fourth Secession exhibition in 1899. The image of a nude woman was a traditional symbol of truth, and used as such by the academic artist Gérôme in his painting *Truth Rising from her Well to Shame Mankind*, exhibited at the Salon in 1896. Klimt explains the meaning of his picture with a quotation from Schiller effectively exhorting the artist to be true to himself, inscribed onto a gold ground at the top of the picture. According to Klimt's friend Berta Zuckerkandl, the painting also referred to the Dreyfus case then at its height in France. All of this would make *Nuda Veritas* into a fairly traditional allegorical painting were it not for some confusing and disturbing elements such as the snake at the feet of the nude woman. The snake could be borrowed from Stuck's notorious painting *Sin,* or from Old Master representations of the Immaculate Conception in which the snake representing heresy is trampled at the Virgin's feet.

The use of symbols and allegory was traditional in Western art. What made the Symbolists work different was that they might not be so specific or easily read. The meaning was conveyed more by suggestion and association or by purely visual means. For the professors of Vienna University it was less the exposure of pubic hair and the explicit sexuality of the University ceilings that troubled them than Klimt's departure from traditional easily comprehensible allegory into vaguer realms of Symbolism. Speaking on the behalf of the bewildered professors, Karl Krauss wrote sarcastically about *Philosophy*: 'Klimt's original sketch I am told, showed a naked boy, standing deep in thought; his long hair falling over his face, concealing the deep blush that may have shot into the immature lad's cheeks as he looks at the two figures lying in a loving embrace in the picture above … When the sketch was presented to the commission, the current rector of the University declared that it wasn't a painting of philosophy but a boy wondering prematurely where babies come from.'[3]

Klimt heeded Schiller's exhortation to be true to himself and refused to compromise with the University professors, confusing and enraging them further with the complex and disturbing imagery of his ceilings for the law and medicine faculties. The one thing that the professors could be sure of was they were not the kind of uplifting homilies on the progress of mankind that they had in mind when they gave Klimt the commission.

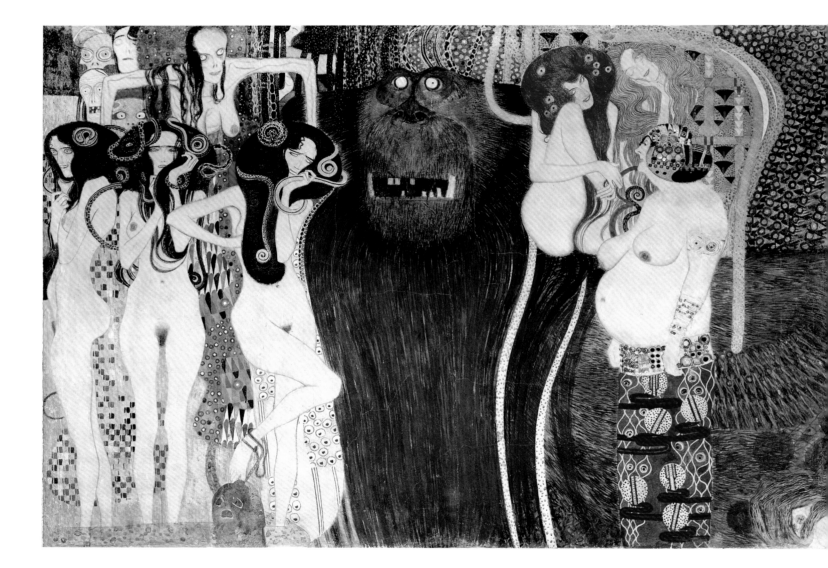

Similarly, Klimt offered something of a counter-commentary on the strident optimism of Beethoven's setting of Schiller, with his *Beethoven Frieze* exhibited at the Secession in 1902. The explanatory entry in the catalogue of the exhibition reads as follows: 'Decorative principle: regard for the disposition of the room, ornamented plaster surfaces. The three painted walls form a coherent sequence. First long wall opposite the entrance: longing for happiness. The sufferings of

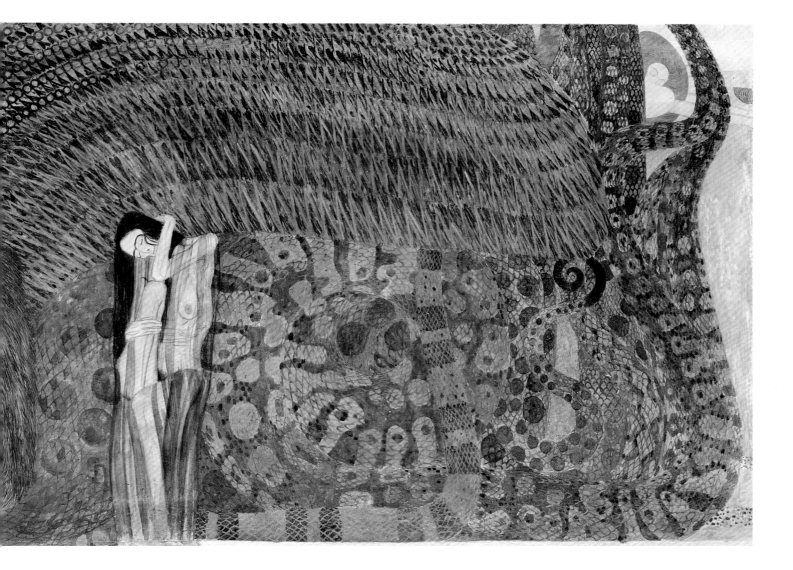

The Forces of Evil, detail from the *Beethoven Frieze*, 1902, casein colour, gold leaf, semi-precious stones, plaster, charcoal, pastel and pencil on stucco ground, 215 × 3414 cm (long walls 1392 cm each, short wall 630 cm), Österreichische Galerie Belvedere, Vienna

Weak Humanity, who beseech the Knight in Armour as external, Pity and Ambition as internal, driving powers, who move the former to undertake the struggle for happiness. Narrow wall: the Hostile Powers. The giant Typhon, against whom even the gods battle in vain; his daughters, three Gorgons, Sickness, Mania, Death. Desire and Impurity, Excess. Nagging care. The longings and desires of mankind fly above and beyond them. The second long wall: longing for happiness finds repose in Poetry. The Arts lead us into the kingdom of the Ideal, where alone we can find pure joy, pure happiness, pure love. Choir of Heavenly Angels.' It is a programme that would seem to be a recipe for pretentious kitsch, but in the hands of Klimt results in compelling imagery. As usual, Klimt's visual thefts are blatant – from Margaret MacDonald's gesso panels for the Wärndorfer music room, from Aubrey Beardsley for the obese figure of Excess, and from Hodler for the stylised and repetitive chorus line behind the climactic figures of the Kiss. Hodler acknowledged and appreciated the compliment of Klimt's imitation, commenting in an interview in 1905, 'Of the moderns, I have an especially high opinion of Klimt. In particular, I love his frescoes: in them everything is fluent and still, and he too likes using repetition, which is the source of his splendid decorative effects …'[4]

It is deeply ironic that thanks to the vicissitudes of war and the interminable litigation of the Stoclet family that ensures that Klimt's murals in the Palais Stoclet remain inaccessible to the public, work executed in the improvisatory medium of casein on the fragile ground of stucco and not intended to outlast the duration of the 1902 exhibition is the only major decorative work of Klimt's maturity that is currently viewable.

Between the 1890s and his death in 1918 Klimt also painted a large number of independent canvases and panels of allegorical subjects. A group including *Moving Water* of 1898, *Gold Fish* of 1901–2, *Water Snakes I* and *Water Snakes II* of 1904–7, depict the Freudian subject of naked women floating ecstatically in the depths of the sea. The laughing trio of girls in *Gold Fish*, clearly relate to the teasing and flirtatious Rhine Maidens in Wagner's Ring Cycle. The enormous gilded fish with the lustful eye of a voyeur represents not only the Rhine gold of Wagner's opera but also Klimt/Alberich.

The phallic connotations of the snakes in the two versions of *Water Snakes* are obvious to modern eyes but would have been perhaps only to the more knowing of Klimt's contemporaries. The Freudian combination of women with predatory

LEFT *Water Snakes I*, 1904–07, mixed media on parchment, 50 × 20 cm, Österreichische Galerie Belvedere, Vienna

RIGHT *Gold Fish*, 1901–02, oil on canvas, 181 × 67 cm, private collection

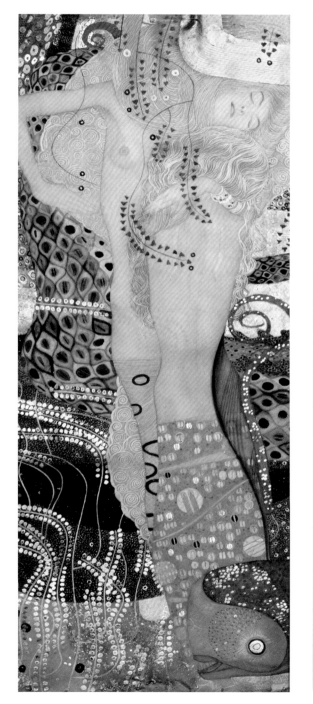

animals, reptiles and in particular with snakes became a cliché of fin-de-siècle art. The most notorious examples were a series of paintings of nude women entwined in various poses with big, black slimy snakes by Franz von Stuck. Stuck seems to have used a lexicon to come up with the titles of the variant paintings in the series – *Sensuality*, *Lasciviousness*, *Lust* and so on. In his magnificently appointed Munich studio, Stuck erected a blasphemous altar to Sin, with one of the multiple versions of the painting at its centre. The respect with which these absurd pictures were regarded at the time now strikes us as astonishing. When it was first exhibited rows of seats were arranged in front of it so that admirers could sit in awed contemplation.

The fact that both versions of Klimt's *Water Snakes* were completed in 1907, the year that Picasso painted *Les Demoiselles d'Avignon*, is a reminder that in an international context he was not and indeed never had been what might be described as 'cutting edge'.

Another small but important group of paintings depicts Biblical or mythological heroines as femmes fatales. The striking facial resemblance between *Judith I* and Adele Bloch-Bauer, the only society hostess Klimt painted twice, has led to the supposition that not only did she pose for Judith but that there was a long-standing sexual relationship between Bloch-Bauer and the artist. Both versions of *Judith* have frequently been mistaken for Salome even though the name of Judith appears on the frame of the first version. The mistake is understandable as Judith and Salome appear to be interchangeable in Klimt's imagination as castrating femmes fatales. It may be that Klimt felt by the early 1900s Salome had outstayed her welcome and become over-familiar.

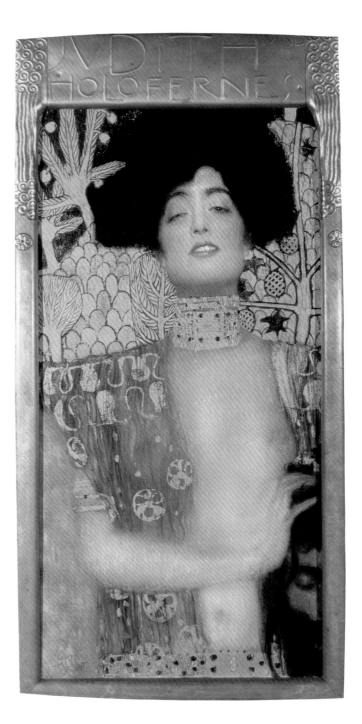

The beautiful Old Testament heroine Judith, who saved the Jewish people by seducing and murdering the enemy general Holofernes, was frequently depicted in the fifteenth and sixteenth centuries as an example of female courage and virtue. Baroque images of Judith and Holofernes in the seventeenth century, such as those of Caravaggio and Cristofano Allori, already carry some erotic connotations, but it was not till the late nineteenth century that Judith was enlisted into the evil sisterhood of femmes fatales. Among the other artists of Klimt's time who depicted Judith in this way were Stuck and the French illustrator Gustave Mossa. Mossa shows her as a modern woman dressed in the latest fashion. Klimt's *Judith I* also has a decidedly modern air as pointed out by the Viennese critic Felix Salten (the author somewhat incongruously not only of *Bambi* but of the notorious erotic novel *Josephine Mutzenbacher: the Life Story of a Viennese Whore as Told by Herself*): 'The modern element of Klimt's work can be seen in detail in his Judith: he takes a present-day figure, a lively, vivid person the warmth of whose blood can intoxicate him, so that she seems enhanced and transfigured in all her realness. One sees this Judith dressed in a sequined robe in a studio on Vienna's Ringstrasse, she is the kind of beautiful hostess one meets everywhere, whom men's eyes follow at every première as she rustles by in her silk petticoats. A slim, supple, pliant female, with a sultry fire in her dark glances, cruelty in the lines of her mouth, and nostrils trembling with passion. Mysterious forces seem to be slumbering within this enticing female, energies and ferocities that would be unquenchable if what is stifled by bourgeois life were ever to burst into flame. An artist strips the fashionable dresses from their bodies, and takes one of them and places her before us decked in her timeless nudity.'[5]

Judith I owes an obvious debt to Rossetti's *Beata Beatrix*, one of the most potent and influential images of the second half of the nineteenth century. Both pictures present a Wagnerian *Liebestod*, a powerful fusion of Eros and Thanatos. *Beata Beatrix* represents the death of Dante's beloved Beatrice as a moment of ecstasy as her soul leaves her body. It was also a private homage to his wife Lizzie Siddal who died of a drug overdose in 1862. An unhealthy narcotic aura suffuses both *Beata Beatrix* and *Judith I*. From Rossetti, Klimt has adopted the head thrown back with half-closed eyes, the parted lips and the halo of hair. Klimt was not alone in making use of *Beata Beatrix*. Munch's *Madonna* and Mucha's advertisement of Job cigarettes are amongst the multiple descendants from Rossetti's image and therefore cousins of Klimt's Judith.

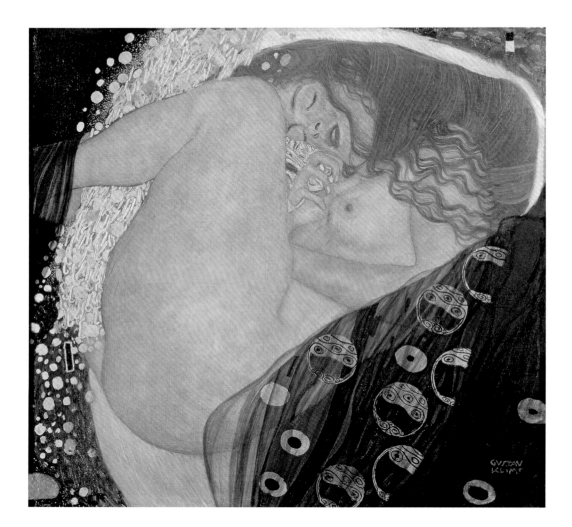

LEFT *Danaë*, 1907–08, oil on canvas, 77 × 83 cm, Galerie Wurthle, Vienna

OPPOSITE *Hope I*, 1903, oil on canvas, 181 × 65 cm, National Gallery of Canada, Ottawa

Entwined in a beautiful transparent patterned scarf of a kind a fashionable Belle Epoque lady might wear to the opera, Klimt's *Danaë* is hardly more ancient Greek than *Judith I* was Biblical. Like so many of Klimt's female subjects, she seems to be in the grip of sexual ecstasy as if impregnated by Zeus's golden shower. Klimt would have been familiar with Correggio's more discreetly erotic version of the subject in the Galleria Borghese, though it was the same artist's *Jupiter and Io*, one of the greatest treasures of the Kunsthistorisches Museum, that provided the more immediate model for Klimt's *Danaë*.

It was Klimt's own impregnations of one of his models, Mizzi Zimmermann, that seems to have inspired his three painted depictions of pregnancy, though it was a subject he drew on a number of occasions. Pregnancy was a subject almost as rare in Western art as pubic hair. There was, of course, Van Eyck's celebrated *Marriage of Arnolfini,* though whether the bride in this picture is actually represented as pregnant or not has been the subject of some controversy, and Vermeer's tender representation of a pregnant woman in blue (presumed to be his wife) that so moved Vincent van Gogh. Perhaps inspired by Klimt's ground-breaking depictions of pregnancy, his disciple Egon Schiele gained access to a woman's maternity ward in Vienna where he was able to make many studies of pregnant women.

Mizzi Zimmermann became pregnant by Klimt for the first time in 1899 while he was working on *Medicine* for the Vienna University ceilings and it seems likely that the highly controversial representation of pregnancy was introduced into the final version of that picture as a result. Klimt's most arresting image of pregnancy, *Hope I,* dating from 1903, seems likely to have been inspired by Mizzi Zimmermann's second pregnancy the year before. Klimt most probably painted the pregnant body of his mistress, though out of discretion perhaps, he did not depict her facial features. The background of *Hope I* underwent considerable transformation before the picture's completion. It is likely that the sinister death-like masks along the top, borrowed from his own *Beethoven Frieze,* were introduced in response to the premature death of the child whose conception had inspired the picture.

The birth and death of his second child with Mizzi Zimmermann affected Klimt deeply and correspond with another important theme of Klimt's allegories – that of the life cycle. One of Klimt's most poignant expressions of this theme is *The Three Ages of Woman.* This canvas was presented at the 1908 Kunstschau with the golden portrait of Adele Bloch-Bauer and *The Kiss.* All three canvases were a slightly unusual square format. *The Three Ages of Woman* and *The Kiss*

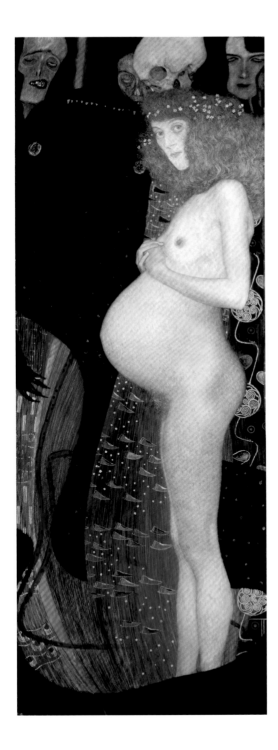

are identical in size (180 x 180 cm) and could almost be considered as pendants. All three must have looked slightly old-fashioned compared to the work of young artists such as Egon Schiele, Oskar Kokoschka and Richard Gerstl, whose talents were emerging around this time.

The Three Ages of Woman was a modern reworking of a very famous Old Master picture by the sixteenth-century German artist Hans Baldung Grien. The special arrangement with the figures apparently floating in space and the flat collage-like effect hark back to *Jurisprudence* from the University ceilings. The tender depiction of the young mother and child locked in an embrace and lost in their dreams is affecting. But perhaps the most striking element in the picture is the truthful and sensitive rendering of the withered body of the old woman. For this, Klimt surely took inspiration from Rodin's *She Who was the Helmet Maker's Once Beautiful Wife* created originally for a pilaster of *The Gates of Hell*.

The portentously titled *Death and Life* begun before 1911 and re-painted in 1915 marks the transition between Klimt's flat golden phase and his subsequent more colourful and painterly style. The original gold background was painted over with a veil of dark greenish blue. The representation of death as a skeleton wrapped in a robe decorated with black crosses seems uncharacteristically banal and obvious. In the tower of massed embracing figures on the right, Klimt follows the nineteenth-century academic convention (much derided by Renoir) of painting the male a darker hue than that of the female. Klimt's formula of creating a mass of embracing figures with colourful ornamental infill is developed more successfully in the joyous *The Virgin* of 1913.

Klimt's final works, *Baby, Adam and Eve,* and *The Bride,* all left unfinished at his death in 1918, announce what should have been an entirely new phase in his work with more abstract and geometrical compositional structures perhaps inspired by the younger Egon Schiele. Created in the depths of the most terrible and destructive war the world had ever seen and in what would prove to be the death throes of the Habsburg Empire, these are amongst the most joyous and life affirming works that Klimt ever painted, with the powers of darkness that had so often invaded Klimt's work now entirely banished.

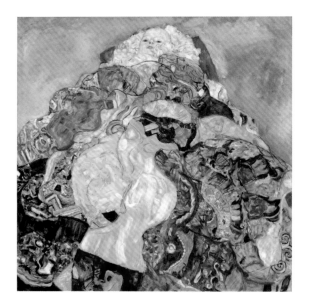

ABOVE *Baby (Cradle)*, 1917–18, oil on canvas, 110 x 110 cm, National Gallery of Art, Washington

OPPOSITE *Death and Life*, 1910–11, oil on canvas, 178 x 198 cm, Leopold Museum, Vienna

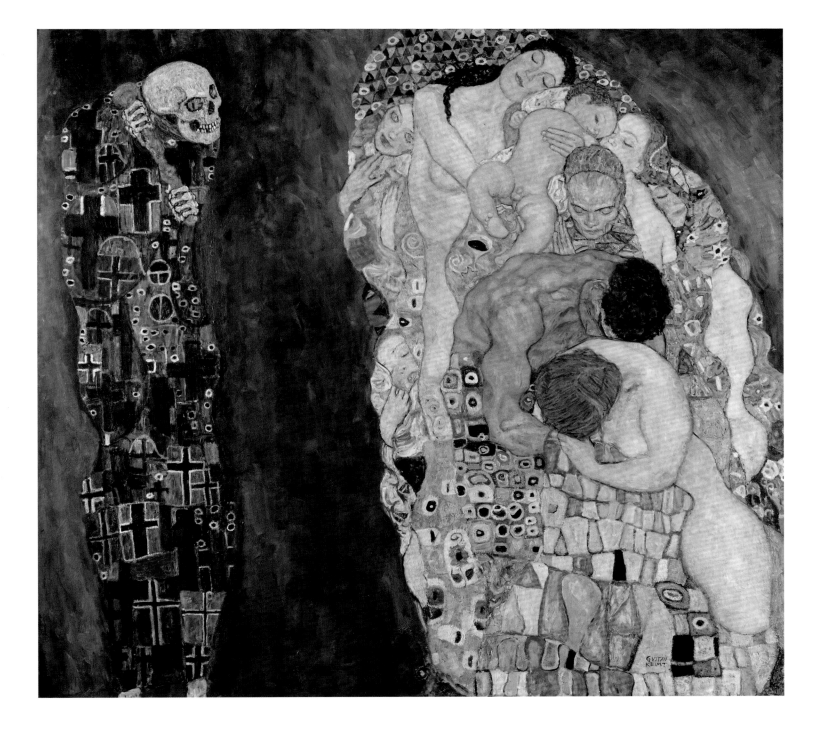

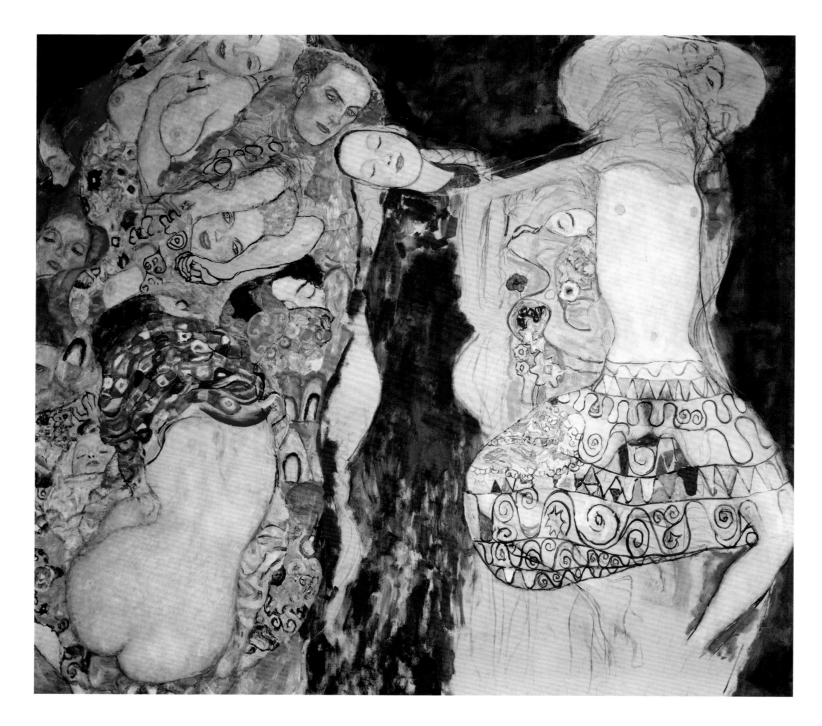

The Bride, 1917–18, oil on canvas,
165 x 191 cm, private collection

KLIMT, FREUD & SEX

On the opening page of her brilliant introduction to the art of Klimt published in 1975, the American art historian Alessandra Comini imagines the astonishment of the burglars who broke into Klimt's studio after he had been hospitalised with stroke and found the unfinished painting *The Bride* standing on the easel with pubic hair partially revealed between the splayed legs of a female figure whose patterned garment Klimt had not yet completed. 'The knees were bent and the legs spread apart to expose a carefully detailed pubic area upon which the artist had leisurely begun to paint an overlay of "dress" of suggestive and symbolic ornamental shapes . . . the unknown ransackers of the studio had, sheerly by accident, caught the artist in the secret and revelatory act of flagrant voyeurism.'[1]

Female pubic hair was one of the great unmentionables of the nineteenth century. We assume that it was a secret known to women but even that was not necessarily so, as many women from respectable backgrounds were forced to wear modesty clothing when bathing. According to Stefan Zweig, 'Young girls in boarding schools and convents even had to take baths in long white robes, forgetting that they had bodies at all.'[2] And of course bathing might not be the regular occurrence we expect today. Hygiene, health and cleanliness were issues that were only beginning to be discussed in more advanced circles.

For male libertines, female pubic hair was an exciting taboo to be explored. Nineteenth-century manuals of prostitutes such as *The Pretty Women of Paris*,

published in 1883 for English-speaking sex tourists in Paris, described the pubic hair of Parisian prostitutes in the most excitable and lubricious detail. But for more innocent and less experienced men familiar with the female body only from paintings they saw in museums and exhibitions, and from the sculptures that adorned public buildings and monuments throughout Europe, female pubic hair could come as a shocking discovery.

The most notorious nineteenth-century depiction of female pubic hair, Courbet's *L'Origine du Monde*, was painted for the private delectation of the Turkish voluptuary and collector of erotica Khalil Bey and was not seen in public until the late twentieth century. Closer to Klimt's time, the visible pubic hair in Gauguin's painting *Annah the Javanaise* painted in 1894 may have been deemed more acceptable because of the 'exotic' character of the model. Sadly, the Victorian art historian John Ruskin saw neither of these pictures or indeed any work of art that depicted female pubic hair. He claimed that his inability to consummate his marriage resulted from the unwelcome discovery of pubic hair on his wedding night. Had he lived a generation later in Vienna he would not have been able to make such an excuse. Not only would he have been able to consult Dr Freud about his fears of adult female sexuality but he would have been faced with images of female pubic hair on the walls of the Secession and if Klimt had had his way even on the ceiling of the University Aula. But Vienna had not always been so open about such matters and Freud and Klimt had a mighty battle on their hands.

There is no evidence that Klimt ever read the works of Freud or that the artist and the doctor ever socialised. They must have had many friends and acquaintances in common. In particular the Zuckerkandl brothers Emil, Victor and Otto, who belonged to Klimt's closest circle of friends, and as important members of Vienna's medical establishment would have been familiar with both Freud the man and his work. Gustav Mahler, who also met Klimt on many occasions, as we know from Alma Mahler's diaries, famously consulted Freud after a crisis in their marriage. What is more important though is that Freud and Klimt's attempts to explore human sexuality more honestly free from the shibboleths of the Judeo-Christian belief system stem from the same impulse, an impulse shared by many of the artists and intellectuals of their time.

In *The World of Yesterday* Stefan Zweig paints a gruesome picture of sexual repression and hypocrisy in nineteenth-century Vienna: '. . . great care was taken

to leave them [girls] ignorant of all natural things, in a way unimaginable to us today. A young girl of good family was not allowed to have any idea of how the male body was formed, she must not know how children come into the world, for since she was an angel she was not just to remain physically untouched, she must also enter marriage entirely "pure" in mind.' Young men were kept in an equal state of ignorance: 'A woman's figure was to be so entirely concealed ... that even at the wedding breakfast her bridegroom had not the faintest idea whether his future companion for life was straight or crooked, plump or thin, had short legs or long legs ...The more a woman was expected to look like a lady, the less her natural shape might be shown; in reality the guiding principle behind this fashion was only to obey the moral tendency of the time, which was chiefly concerned with concealment and covering up.' The consequence of all this prudery was paradoxically a greater preoccupation with sex. 'So ultimately the generation that was prudishly denied any sexual enlightenment, any form of easy social encounter with the opposite sex, was a thousand times more erotically obsessed than young people today ... the air of Vienna in particular was full of dangerously infectious eroticism.'[3]

Just how over-heated the erotic imagination of young Viennese girls could become can be seen from the diaries of Alma Schindler, shortly to become Alma Mahler. While an interest in sex amongst the young might be universal, the exalted and explicit expression of it to be found in Alma's diaries would seem to be particular to the time and place. During the agonisingly drawn out but eventually unconsummated affair with the ugly and apparently unwashed composer Alexander Zemlinsky, Alma repeatedly addressed her diary in a state of near hysterical fervour: 'I've just been watching two flies copulating. They were so still, imperturbable. Now and then a shiver ran through their wings. I blew at them – and they flew off lethargically, the one with the other, and resumed their activity a little further away. How I envied them. The breath of the world caressed me. How could anyone find that offensive? The flow of the one into the other – I find it beautiful, *wondrously* beautiful. How I long for it. Alex, my Alex, let me be your font. Fill me with your holy water.'[4]

There was certainly a lot of sex about in turn-of-the-century Vienna, and not only in Vienna but also in Paris and even in London. Gustav Klimt belonged to a sexual revolution that was more courageous and heroic than that of the 1960s.

Kitagawa Utamaro, *Lovers* from the 'Poem of the Pillow', eighteenth century, colour woodblock print, Victoria & Albert Museum, London

Other artists of his era for whom sexual liberation of one kind or another was a major preoccupation included August Rodin, Félicien Rops, Aubrey Beardsley and the somewhat younger Egon Schiele.

A liberating factor for all of them was the discovery of Japanese erotic prints. Unencumbered by Judeo-Christian inhibitions, Japanese print-makers made images of the sex act with a directness, but also a lack of prurience, that was simply revelatory to Western artists in the late nineteenth century. To those inured to the Western tradition of coyly idealised and depilated nudity, Japanese erotic prints, with their minute examination of all the folds and wrinkles of pubic flesh and curly hair, were often so startling as to be incomprehensible at first glance. Aubrey Beardsley was first introduced to such images by his friend William Rothenstein. Rothenstein later recalled how he had 'picked up a Japanese book in Paris, with pictures so outrageous that its possession was an embarrassment. It pleased Beardsley, however, so I gave it to him. The next time I went to see him, he had taken out the most indecent prints from the book and hung them around his bedroom.'[5] The German critic Julius Meier-Graefe, who curated the French retrospective at the Secession in 1903, remembered seeing these prints on display in Beardsley's house. 'At Beardsley's house one used to see the finest and most

ABOVE *Lovers Turned to the Right*, 1914–16, pencil on paper, private collection

BELOW *Nude Lying on her Stomach Facing to the Right*, 1910, pencil, blue and red pen, heightened with white, 37 × 56 cm, private collection

explicitly erotic Japanese prints in London. They hung in plain frames against delicately-coloured backgrounds, the wildest fantasies of Utamaro, and when seen from a distance delicate, proper and harmless enough. There are but few collectors of these things because they cannot be exhibited.'⁶ Throughout his career Klimt was a passionate admirer of and an enthusiastic borrower from Japanese visual culture. He subscribed to Siegfried Bing's journal *Le Japon Artistique* and would no doubt have been introduced to Japanese erotic prints by the kind of collectors who enthused about his own work.

As already mentioned, Klimt ceased to depict the male sex almost altogether after 1900, apart from the occasional figure in his allegorical works and a few drawings. In this he was not so unusual in this period and he also shared with many of his contemporaries a preoccupation with the femme fatale – the seductive and dangerous woman. How much of this with Klimt was personal and how much cultural we could only know if Klimt had submitted to Freud's couch. The collective male hysteria in the late nineteenth and early twentieth centuries in reaction to the relatively modest political and cultural gains of the female sex in Western society is still a matter of mystery. Salome, Judith, Delilah and innumerable variants on these biblical prototypes proliferated in the literature, opera and the visual arts of the period and there was a pervasive misogyny amongst male artists and intellectuals.

Two artists of an older generation determined the character and the appearance of the fin-de-siècle femme fatale – the French Symbolist Gustave Moreau and the British Pre-Raphaelite Dante Gabriel Rossetti. It was Moreau who established the cult of Salome, who became the most commonly represented woman in the nineteenth century (rivalled in Britain only by Queen Victoria). For Moreau, Salome was an obsession and the Gustave Moreau Museum in Paris contains over 90 representations by him of the biblical anti-heroine. Moreau's coruscating depictions of Salome and Joris-Karl Huysmans' equally dazzling verbal descriptions of them

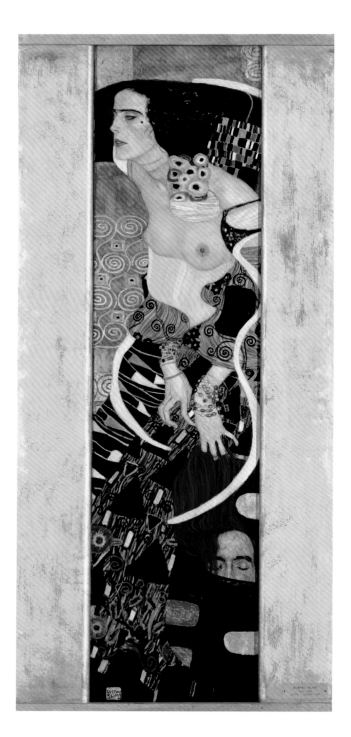

Judith II (Salome), 1909, oil on canvas, 178 x 46 cm, Museo d'Arte Moderna, Venice

in his 1884 novel *Against Nature,* spawned Oscar Wilde's 1891 play *Salome* which in turn inspired Richard Strauss's incandescent operatic masterpiece of 1905. Despite the somewhat condescending attitude of Strauss's later collaborator Hugo von Hofmannsthal towards the art of Klimt, which he regarded as inferior to that of Franz von Stuck, Strauss was the first to recognise the similarity between the glittering textures of his opera and the paintings of Klimt's golden period. The personal and indeed deeply Freudian meaning of Moreau's many depictions of Salome is evidenced by a letter in which he attempted to explain the meaning of his watercolour *Salome in the Garden*: 'This bored and fantastic woman, with her animal nature, giving herself the pleasure of seeing her enemy struck down, not a particularly keen one for her because she is so weary of having all her desires satisfied. This woman, walking nonchalantly in a vegetal, bestial manner, through the gardens that have just been stained by a horrible murder, which has frightened the executioner himself and made him flee distracted . . . when I want to render these fine nuances, I do not find them in the subject, but in the nature of women in real life who seek unhealthy emotions and are too stupid even to understand the horror in the most appalling situations.'[7]

But it was above all Rossetti who gave the femme fatale her physical appearance. The powerful shoulders, columnar neck, strong chin, the menacing smile, languorous, heavy-lidded eyes and the aureole of dark or fiery hair were features taken up by Klimt and many other artists of the period. Though Klimt was certainly familiar with the work of Rossetti in reproduction, and with that of his disciples such as Edward Burne-Jones and Walter Crane, many of the Pre-Raphaelite features in his work may have been picked up second-hand through Fernand Khnopff, who exhibited several times at the Secession and visited Vienna.

Another Belgian much admired in Klimt's circle, who certainly played a role in the development of Klimt's concept of the femme fatale, was the graphic artist Félicien Rops. When the art of Rops was celebrated in a special edition of the magazine *La Plume* in 1896, poets and intellectuals fell over themselves to stress his profound understanding of the evil nature of modern woman. According to the Belgian novelist Eugène Demolder, Rops, 'like an implacable Darwin, has discovered under the white wings of the Woman, so celebrated by poets, the hideous membranes of pterodactyl fossils and evil flying reptiles, demonstrating that Woman is their natural and diabolical zoological descendent.' And according to

Huysmans, 'In a period when materialistic art cannot see beyond hysterical women consumed by their ovaries or nymphomaniacs whose brains function in their guts, he has celebrated, not contemporary woman nor the Parisian woman with her affected charms and dubious finery, but the essential woman outside of time, the naked, venereal beast, the mercenary from the Shadow, the abject slave of the devil.'

Though Klimt, like many other artists of this period, including Rops, Munch, Khnopff and Stuck, frequently presents a sinister image of women, there is no reason to believe that he would have concurred with such misogynistic excesses. We do not have from Klimt the kind of hostile comments about women that typified Degas, nor even the demeaning comments of Renoir, an artist who claimed to love women. The evidence of Klimt's relationship with the Flöge sisters is that he liked and respected intelligent and capable women and enjoyed their company.

Perhaps the most Freudian aspect of Klimt's art is his use of symbolic and erotically charged ornament – vertical, straight, elongated and rectangular ornament representing the male and horizontal, rounded and elliptical, the female. Such use of ornament can be found in subject pictures, portraits and even landscapes but is to be seen at its most blatant in the most celebrated of all Klimt's paintings, *The Kiss*. The man and the woman, each wearing their characteristic ornament, merge to form a phallic shape that penetrates a womb-like space. At the moment of orgasm, shining threads of highly decorative and stylised gold stream down to the bottom of the picture.

To conclude with the words, once again, of Alessandra Comini: 'It is not strange, in a neurotic, self-indulgent metropolis like Vienna – already titillated to the point of spontaneous combustion by the "erotic pollution" of Arthur Schnitzler's plays and Richard Strauss's operas – that both Klimt and Freud should have focused upon sex as the primary spectacle and motivating factor of life. What is surprising is that time and the sheer beauty of Klimt's sensuous facades have obscured the blunt urgency of that artist's close and unremitting fixation upon sexuality.'[8]

The Kiss, 1907–08, oil on canvas, 180 × 180 cm, Österreichische Galerie Belvedere, Vienna

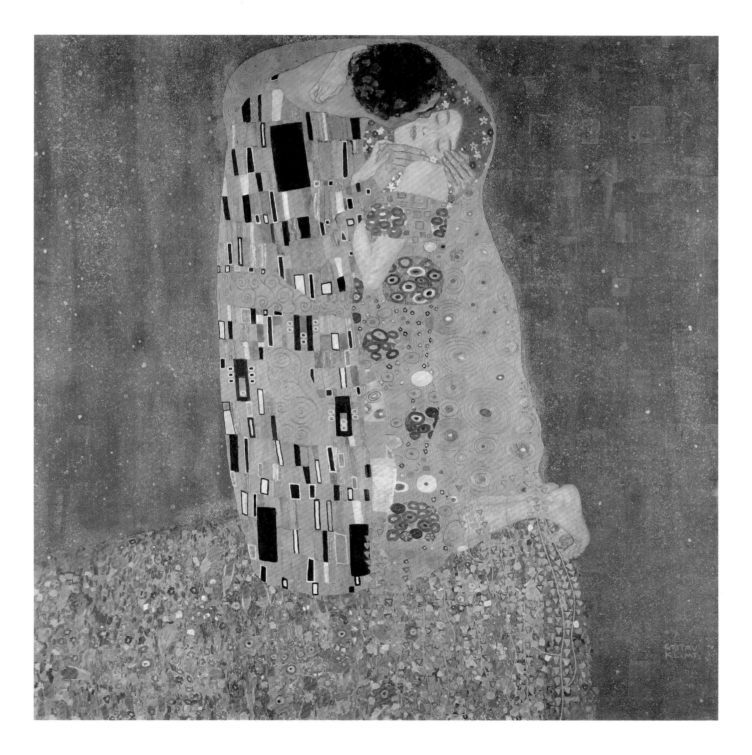

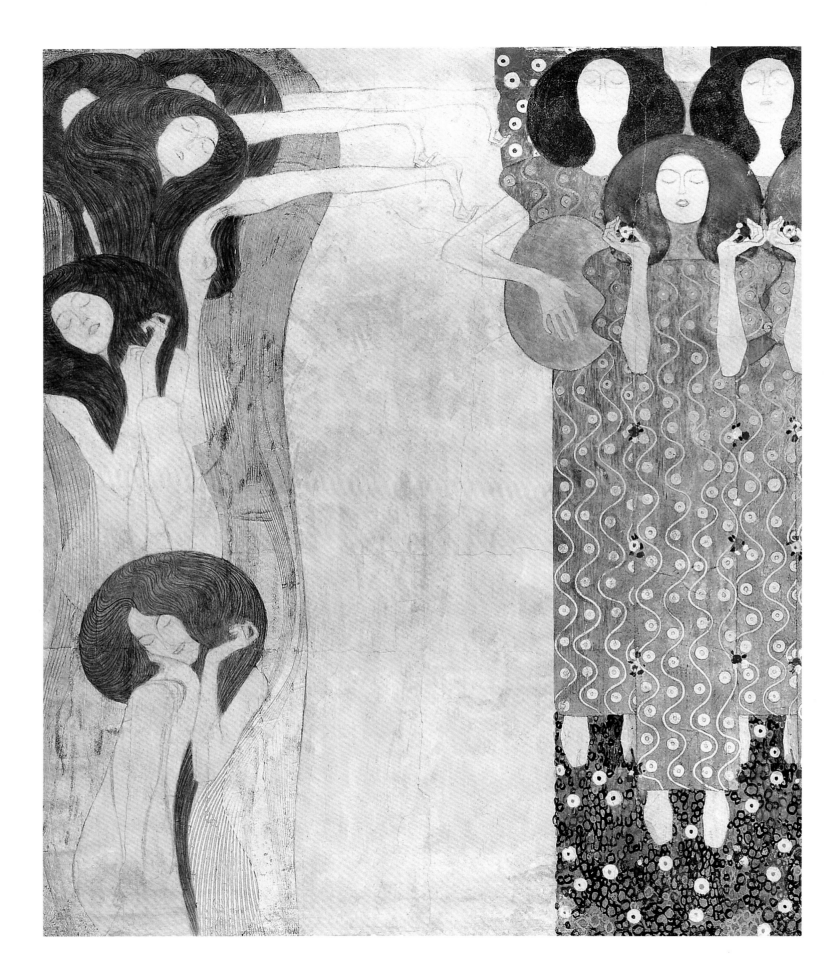

KLIMT, MAHLER & MUSIC

The Longing for Happiness,
detail from the *Beethoven
Frieze*, 1902, casein colour,
gold leaf, semi-precious stones,
mother of pearl, plaster, pencil
and pastel on stucco primer,
215 x 3414 cm (long walls
1392 cm each, short wall
630 cm), Österreichische
Galerie Belvedere, Vienna

Klimt was very much involved in musical life in Vienna. His passion for the music of Schubert could have been satisfied in the two auditoriums of the Vienna Musikverein inaugurated in 1870, with the larger 'Golden Hall' for symphonic music and the smaller Brahmssaal devoted to chamber music. The practice of giving public concerts of chamber music developed in the second half of the nineteenth century and concerts devoted entirely to Lieder only became common after the turn of the century. The first permanent professional String Quartet in Vienna was the Hellmesberger Quartet, established in 1849. In Klimt's day the most important quartet in Vienna was the Rosé Quartet, founded by the leader of the Vienna Philharmonic Orchestra, Arnold Rosé, in 1882 and continuing until its enforced disbanding in 1938 after the Anschluss. The Rosé Quartet performed the premieres of many important works, including late Brahms and early Schoenberg.

Arnold Rosé was very much part of Klimt's social set. He was the brother-in-law of Mahler twice over. Arnold married Mahler's sister, Justine, and his cellist brother Eduard married Emma. Like Klimt's sisters, Justine had assumed the role of house-keeper for her bachelor brother and delayed her marriage to Rosé till the day after Mahler's to Alma. Arnold and Justine's daughter, Alma Rosé, was named after Mahler's wife. After a distinguished career as a violinist and leader of women's orchestras she led the woman's orchestra in Auschwitz-Birkenau, where she died in 1944.

The Rosé Quartet made recordings by the electrical process in the 1920s affording us a fascinating glimpse of the musical styles and practices of Klimt's day. The use of gut strings, and the liberal use of *rubato* (literally 'robbed time') or flexible rhythm, and of *portamento* (sliding from one note to the next) are unfamiliar and disconcerting to modern ears.

On 31 December 1905 as Klimt was entering his 'golden' period, the so-called 'Silver Age' of Viennese operetta was launched with the first performance of Franz Lehar's *Die lustige Witwe* (Merry Widow) at the Theater an der Wien. Three years earlier what eventually became one of Lehar's most popular concert works, the shimmering and melodious *Gold and Silver Waltz*, was commissioned by Princess Metternich for a ball in which all the guests wore gold and silver.

Operetta was a Parisian invention of the 1850s. Exported to Vienna in the 1860s with Offenbach's wildly popular *La Belle Hélène* it soon established itself as a thriving and peculiarly Viennese genre. The greatest masterpiece of the genre was Johann Strauss's *Die Fledermaus* premiered at the Theater an der Wien, followed by *Der Zigeunerbaron* in 1885. After Strauss's death he left no obvious successor. In 1898 Richard Heuberger enjoyed a great success with *Der Opernball*. The enduringly popular song *Im Chambre Separée* encapsulated the transgressive sensuality of Klimt's Vienna better than any other music, with the possible exception of the *Merry Widow Waltz* itself. But the success of *Der Opernball* proved to be a flash in the pan. When Heuberger was invited to write the score for the *Merry Widow*, he discovered that the worst thing that could happen to an operetta composer had happened to him. He had run out of tunes. With a slot in their programme needing to be filled with some urgency, the management of the Theater an der Wien turned in desperation to their Kapellmeister Franz Lehar. Up to this point Lehar had achieved only modest successes as a composer and the commission was only awarded to him after he had been set the task of creating a tune for the duet *Dummer, dummer Reitersmann,* which he sang to the management over the telephone. Even then, the management lacked confidence in Lehar. At one point they tried in vain to persuade him to give up the commission and they economised on the production by re-using some of the songs from Sidney Jones's operetta *The Geisha* for a piece that was set in a Balkan embassy in Paris.

The Merry Widow was a slow burner. On opening night its success was modest. But the *Viljalied,* the *Merry Widow Waltz,* and Danilo's *Da geh' ich zu Maxim* proved to be earworms and audiences came flocking back for more. Rapidly, *The Merry Widow*

Interior view of the Theater
an der Wien, Vienna

conquered the world and became the most popular and widely performed operetta of all time. By 1907 it was playing simultaneously in five theatres in Buenos Aires in five different languages.

In April 1902, Gustav Mahler brought members of the brass section of the Vienna Philharmonic orchestra to perform his arrangement of the climactic *Ode to Joy* from Beethoven's Ninth Symphony at the opening of the fourteenth exhibition of the Secession. Beethoven's celebrated setting of the words of Schiller had been hailed by Wagner as a forerunner of his own ideas about the *Gesamtkunstwerk* or the fusion and unity of the arts. The exhibition centred on the recently completed statue of Beethoven by the German artist Max Klinger widely regarded at the time as one of the supreme masterpieces of Western art.

The polychrome monument was itself a kind of *Gesamtkunstwerk*, with its fusion of varied materials and techniques. Over ten foot high, it was made from Greek marble, Pyrenees marble, alabaster, amber, bronze, ivory, mosaic strips of antique tesserae, agate, jasper, mother of pearl and gold leaf. Whether Klimt really liked this rather monstrous piece or not, it must certainly have encouraged his own use of precious materials in the next few years.

Josef Hoffmann transformed the interior of the Secession into a temple for the worship of the twin geniuses of Beethoven and Klinger. The artists of the Secession, led by Klimt, Roller and Moser, offered to provide backdrops that, in a gesture of self-effacing homage to Klinger, were intended to last only for the duration of the exhibition. Luckily, after a campaign led by Ludwig Hevesi, Klimt's *Beethoven Frieze* was saved from its intended destruction and preserved for posterity.

The figure of the knight in golden armour, in the first panel of the *Beethoven Frieze*, was assumed by friends of Klimt and Mahler to be an idealised representation of the composer/conductor. Klimt and Mahler shared not only a love of the beautiful Alma Schindler but some of their artistic ideals, including that of the 'Total Work of Art' and for a number of years their careers seemed to run in tandem and their lives followed a similar rhythm. When in Vienna, each would follow a rigid and almost unvarying work routine. As neither was much given to small talk, socialising was kept to a minimum. Mahler's boredom with the numerous administrative meetings he was forced to attend expressed itself with doodling on odd scraps of paper, several of which were preserved by Alfred Roller, the mutual friend and colleague of Mahler and Klimt. They look remarkably like the symbolic ornamental infill of Klimt's portraits and would lend themselves to psychoanalysis. In the summer months, each would escape the intrigues and controversies that dogged them in Vienna to refresh their inspiration on the shores of Austrian lakes. Klimt went to the Attersee to paint his landscapes and Mahler went to Maiernigg on the Worthersee to compose his symphonies.

The year 1897 was a fateful turning point in both their lives. In that year Mahler converted to Catholicism in order to take up the most prestigious position of his career as director of the Vienna Court Opera. The timing could not have been more fortuitous. The old order in Vienna's musical life, like that in its visual arts, was on the point of dissolution. The symphonists Anton Bruckner and Johannes Brahms died in 1896 and 1897 respectively, followed by the 'Waltz King' Johann Strauss in 1899. Though not everyone appreciated it at

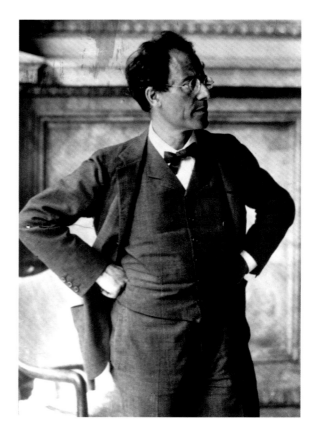

Conductor Gustav Mahler, during his directorship of the Court Opera in Vienna

The Knight, detail from the *Beethoven Frieze*, 1902, casein colour, gold leaf, semi-precious stones, mother of pearl, plaster, pencil and pastel on stucco primer, 215 × 3414 cm (long walls 1392 cm each, short wall 630 cm), Österreichische Galerie Belvedere, Vienna

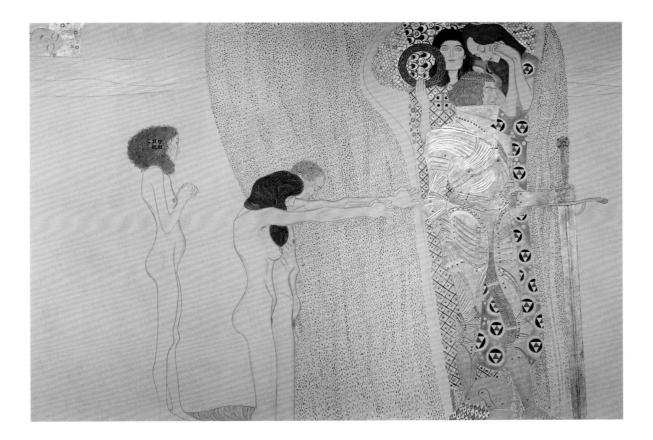

the time, Mahler stepped into Brahms's shoes as Vienna's greatest composer. There would be a short interregnum after the death of Johann Strauss before Franz Lehar took up the role of operetta king of Vienna in 1905.

Strangely in a city as incestuous as Vienna, Johann Strauss and Johannes Brahms first met towards the end of their lives. The occasion was recorded with a photograph in which the two genial and elderly composers pose together slightly awkwardly. Humbly, the 'Waltz King' asked the great symphonic composer for his autograph. Brahms wrote out the first bars of the *Blue Danube* waltz and added the inscription, '*Nicht von Johannes Brahms, leider*' (Not by Johannes Brahms, unfortunately). The characteristically Viennese sighing cadence of a sentence ending with the word 'leider' shows that after many years of residence in Vienna, the north German Brahms had gone native.

Between 1897 and 1907, as director of the Vienna Court Opera (Kaiserliche und Königliche Hofoper), Mahler presented a succession of opera productions, the excellence of which set a standard for every opera house in the world for the next century. Pursuing the Wagnerian ideal of the *Gesamtkunstwerk*, Mahler ensured that every aspect of the performance, whether musical, dramatic or visual, worked in harmony towards a

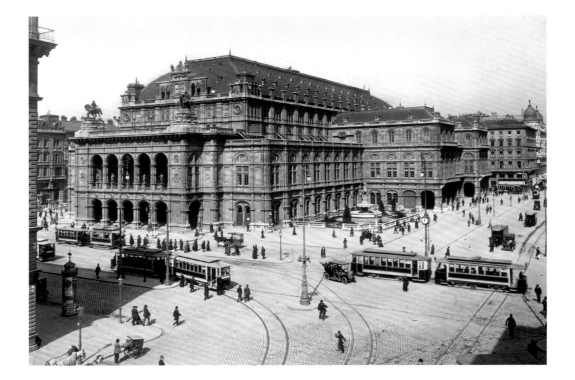

Hand-coloured lantern slide
showing the Vienna Court
Opera, c.1910

common goal of fulfilling the composer's intentions. From 1903 Mahler's collaborator in visual
matters was his close friend and fellow Secessionist, Alfred Roller. Amongst their benchmark
productions were *Tristan und Isolde* in 1903, which a few years later made an indelible impression
on the teenage Adolf Hitler, and *Don Giovanni* in 1906. The cluttered historicism of nineteenth-
century productions gave way to the leaner and more economical style of the Secession.

Like Paganini and Liszt before him Mahler was one of those musicians with an aura of the demonic.
In the words of the soprano Anna Bahr-Mildenburg, 'People found him demonic, wild, grotesque,
bizarre, strange and original and weird when he was conducting. They felt his monstrous power and
would cower as though before something threatening and were astonished and curious.'

Mahler was not only an innovator but a rigid disciplinarian. With his mottos of '*Tradition ist
Schlamperei*' (tradition is sloppiness) and '*Korrektheit ist die Seele der Kunstleitung*' (correctness is
the soul of creativity), Mahler waged a war of attrition against the whims and excesses of his star
performers. Once again, according to Bahr-Mildenburg, there was no one who rehearsed with
him who did not come away 'complaining, cursing, weeping and desperate'. Mahler was equally

draconian with audiences, rigorously excluding late-comers and putting an end to the time-honoured institution of the claque.

Many of the singers who worked with Mahler, and who would have been heard by Klimt on a regular basis, made recordings. These sound documents make fascinating and informative listening to modern ears. As recorded on the primitive equipment of the time, that listening is not always a comfortable experience. The records of Erik Schmedes for example, a favourite tenor of Mahler in Vienna and later in New York, display the most disagreeable features of the Germanic heroic tenor with strangulated and effortful emission of tone. Though he was a great favourite in Vienna, Schmedes failed to please in New York, where vocal beauty tended to take precedence over the projection of text. One New York critic described his voice as sounding like 'bits of Swiss cheese fired from a canon'. The records of another popular Viennese tenor who worked with Mahler over many years, Leo Slezak, are also variable but sometimes mellifluous with an exquisite quality surprising in a tenor celebrated for such heavy roles as Otello and Siegmund. With these two tenors Mahler maintained an uneasy relationship that involved some pretty brutal humour and cruel and bizarre practical jokes on both sides. Knowing how much he longed to have his compositions rather than just his conducting skills appreciated, Schmedes bribed and trained a boy to follow Mahler in the streets of Vienna whistling the main melody of Mahler's symphonic song *Um Mitternacht*, and hid to watch Mahler's reactions.

With Slezak, Mahler had a less cordial and more tempestuous relationship, probably because of Slezak's greater international renown and star appeal. Irritated by Slezak's notorious jocularity, Mahler once interrupted him saying, 'I'm breaking off the rehearsal in the hope that the next time you will arrive in the right mood.' For next rehearsal with Mahler, Slezak arrived dressed in deep mourning and announced to the astonished conductor that he was 'just trying to get in the mood'. Despite his many run-ins with Mahler, Slezak recognised his inspirational qualities as a conductor and even claimed that it was easier for him to reach his top notes when Mahler conducted.

The records of the soprano Selma Kurz demonstrate exactly why Mahler needed to discipline his more self-indulgent stars. Selma Kurz was world-famous for her trill — known as the 'kurz trill' — a joke in German as 'kurz' means short and her trills were exceedingly long. Mahler apparently helped her gain this remarkable skill

by training her with the aid of a stopwatch. To the delight of audiences but the exasperation of conductors and fellow singers, Kurz would trill until her breath ran out. On her record of the song *Der Vogel im Walde*, Kurz's trill lasts a full twenty-one seconds, leaving most modern listeners quite literally breathless.

Kurz started her career singing mezzo and lyric soprano roles. Her freakish coloratura skills were discovered by Mahler during a rehearsal during which he urged her to sing higher and higher. With Mahler's help she transformed herself into one of the most celebrated coloratura sopranos of her age. Their relationship began with a flirtation and perhaps with an affair but soon soured. In 1906 she attempted to break her contract with the Vienna opera on grounds of her incompatibility with Mahler.

Alma Mahler later complained that her husband was unable to fulfil her sexual needs. Their wedding night was apparently something of a fiasco. But the prospect of taking the virginity of the formidable Alma might well have struck fear into the heart of the most sexually confident man. Later Mahler succeeded in fathering two daughters with Alma and in the years before his marriage to her, Mahler seems to have regarded his female singers rather as Klimt regarded his models and exercised a kind of *droit de seigneur*. Between 1895 and 1897 Mahler had an affair with the noted dramatic soprano Anna von Mildenburg (later known as Anna Bahr-Mildenburg after she married Klimt's great supporter Hermann Bahr). Mahler broke off the affair with Bahr-Mildenburg in 1897 when he moved from Hamburg to Vienna, only to discover to his alarm that she had also received an invitation to become a member of the Vienna company. He wrote to her brutally that if she accepted the offer, 'we should then restrict our personal intercourse to the minimum … If we were to provide the slightest grounds for suspicion etc., *my own position* would become *impossible* in no time.' In fact, Bahr-Mildenburg remained one of the chief ornaments of the Vienna company throughout Mahler's decade there and beyond. Her voice survives in a single test recording of the opening recitative of the Ocean aria from Weber's *Oberon* in an interpretation of awesome grandeur.

ABOVE Tenor Leo Slezak

BELOW Tenor Erik Schmedes

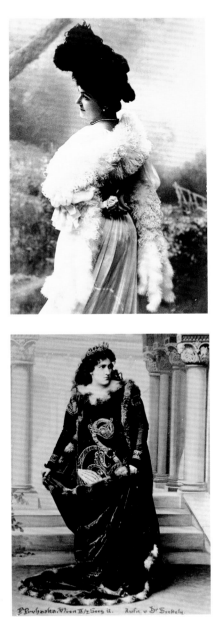

ABOVE Soprano Selma Kurz

BELOW Soprano Anna Bahr-Mildenburg

From the first, Mahler had a difficult relationship with the anti-Semitic press in Vienna. 'In our edition of 10 April we printed a note on the person of the newly appointed Opera Conductor, Mahler. At the time we already had an inkling of this celebrity and we therefore avoided publishing anything other than the bare facts about this unadulterated – Jew. The fact that he was acclaimed by the press in Budapest of course confirms our suspicion. We shall refrain from any overhasty judgment. The Jew's press will see whether the panegyrics with which they plaster their idol at present do not become washed away by the rain of reality as soon as Herr Mahler starts his Jew-boy antics at the podium.'[1]

In this city so notorious for its factionalism and intrigue, both Mahler and Klimt, as conspicuous leaders of the avant-garde, came under increasing attack in the early years of the new century. Hermann Bahr pointed out the parallels between the two. 'And once again Mahler is being hounded, hounded, hounded! Why do they hate him so? Well, why do they hate Klimt so? They hate everyone who tries to be true to himself.'[2] Overwhelmed by the viciousness of the attacks, Mahler resigned from his position at the Court Opera in 1907 and set off for a new one in New York. Amongst the crowd who saw him off at the station were the singers Erik Schmedes and Marie Gutheil-Schoder, the violinist Arnold Rosé, the composers Arnold Schönberg, Alexander Zemlinsky and Alban Berg and the artists Alfred Roller and Gustav Klimt. As the train pulled out of the station, Berg heard Klimt say 'Vorbei!' (It's over!)

In more ways than one, Klimt was right. The following year proved to be another great watershed in Viennese cultural life. Though Mahler and Klimt were still at the height of their creative powers, between 1908 and 1909 a new generation of composers and artists emerged that relegated them to history. The savage dissonance of Schönberg's Second String Quartet premiered in December 1908 and the edgy expressionism of the paintings of Kokoschka and Schiele shown in the Kunstschau exhibition of 1908 and 1909 suddenly made Mahler and Klimt seem like old masters.

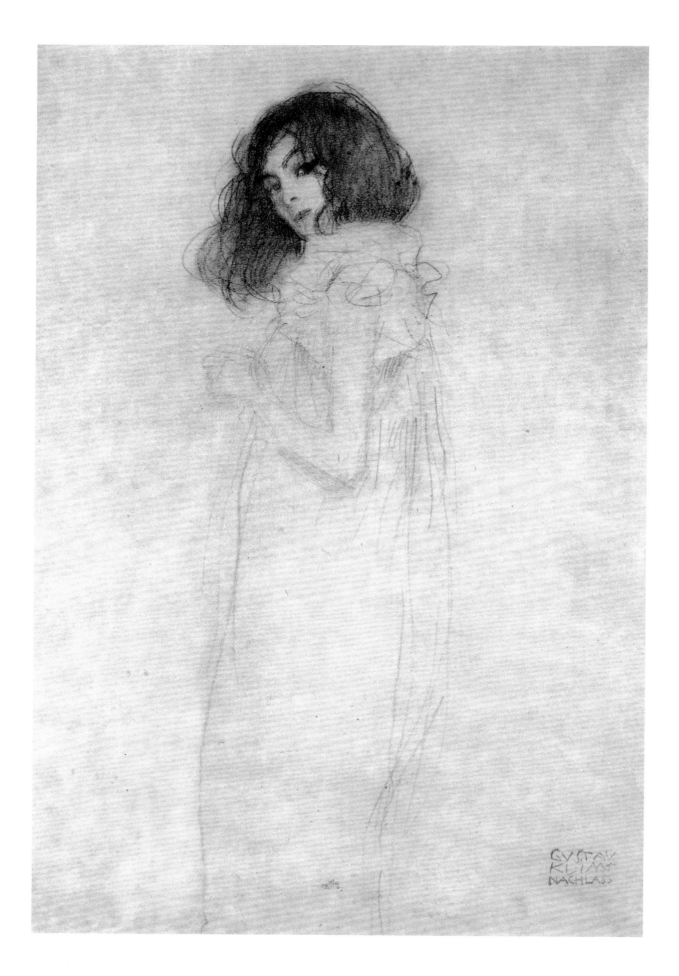

DRAWINGS

· ·

Portrait of a Young Woman,
1896–97, charcoal on paper,
private collection

Throughout his career Klimt made countless drawings. A slow and meticulous worker in oils, Klimt made barely more than two hundred paintings over his entire career but the number of drawings ran into many thousands, only a proportion of which have been preserved. Egon Schiele recalled visiting Klimt in his final studio in the Feldmühlgasse and finding 'hundreds of drawings lying around . . . of which one surely saw only occasional sheets in exhibitions.'[1] Another friend and biographer, Emil Pirchan, claimed that Klimt's friends had to secretly cull the numerous cats that roamed his Josefstädterstrasse garden and studio in order to save his drawings from destruction. If this suggests that Klimt did not lay value on the drawings in themselves, drawing was certainly central to his creative process. Numerous preparatory drawings would be made before he embarked upon a painting and unfinished paintings show the structure of drawing that underlay even the most sumptuous and painterly of his works.

Unlike Schiele, Klimt rarely made a drawing as an end in itself or to sell, and few were signed or dated unless given or sold to friends. Nevertheless, as Schiele indicated, drawings were occasionally exhibited in Klimt's lifetime. Some were published in the pages of *Ver Sacrum* and some were issued as facsimiles of such quality that they have often been passed off by unscrupulous dealers as originals. Many sketches were made in small red-bound books like the one that Sonja Knips holds in her portrait by Klimt. Many of these were acquired by the Lederer family

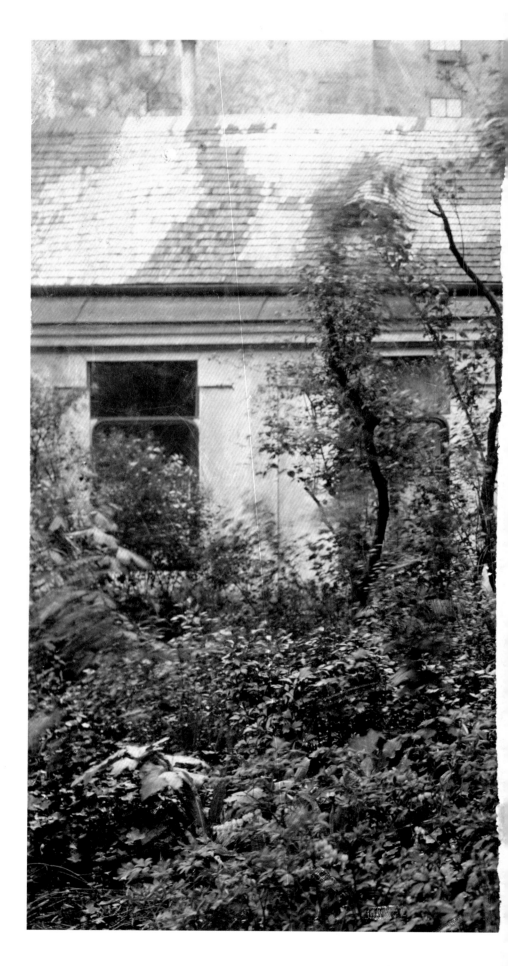

Gustav Klimt in the garden in front
of his studio at Josefstädterstrasse 21
in Vienna's 8th district, c.1910

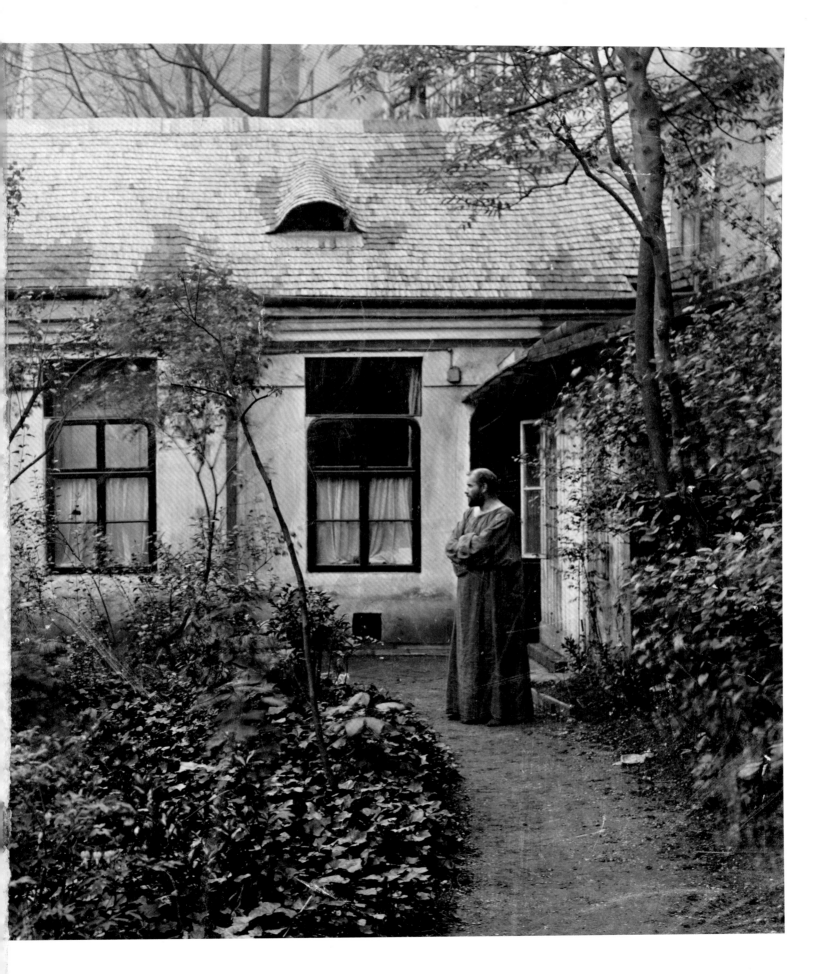

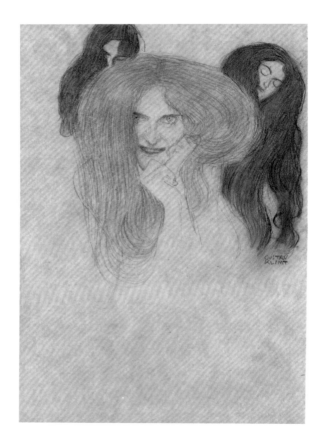

Study for the Three Gorgons in
Enemy Powers, Beethoven Frieze,
1902, black pencil and chalk on
paper, 43.8 × 31.4 cm, Wien
Museum, Vienna

and, sadly, destroyed with much of their collection in the Schloss
Immendorf conflagration in 1945.

Over his career Klimt's draughtsmanship underwent a
transformation as radical as anything else in his oeuvre. He used
charcoal, black and white chalk and coloured crayons, occasionally
mixing media. Very rarely he would use pen and ink and on a couple
of occasions watercolour. But his preferred medium was the graphite
pencil. For many years Klimt liked to work on simple packing paper
but later liked to use fine Japanese paper.

The carefully shaded studies of nude models that Klimt made
as a student could have been made by any moderately gifted and
well-trained young artist in the late nineteenth century nor are the
portrait studies he made of friends and siblings a little later very
much more individual, lovely and sensitive though they are. Studies
made in the late 1870s and into the 1880s on tinted paper in
black chalk and heightened with white chalk have a strongly three-
dimensional character. Klimt relied increasingly on contour and less
on internal shading, eventually eliminating it altogether.

The great projects of the Burgtheater and Kunsthistorisches
Museum staircases, the University ceilings and the *Beethoven
Frieze* and the Palais Stoclet dining room mural generated the
largest number of preparatory studies. There are also magnificent
preparatory drawings for allegorical paintings such as *Hope I* and
Hope II. The brilliantly observed studies of the withered body of an
old woman made for *The Three Ages of Woman* are especially tender
and moving and show that Klimt was not always motivated by lust to
produce his best work.

Curiously, Klimt does not seem to have made preparatory
drawings for his landscapes eventhough these was largely completed
in the studio using photographs or even picture postcards as
aide-memoires. For his portraits, however, Klimt made a great deal
of studies, restlessly searching for the right pose for the sitter. The
collection of the Wien Museum contains half a dozen studies for the
portrait of Sonja Knips in which she twists and turns in her armchair.

Study for *Hope I*, 1903–04,
blue chalk on paper,
Graphische Sammlung
Albertina, Vienna

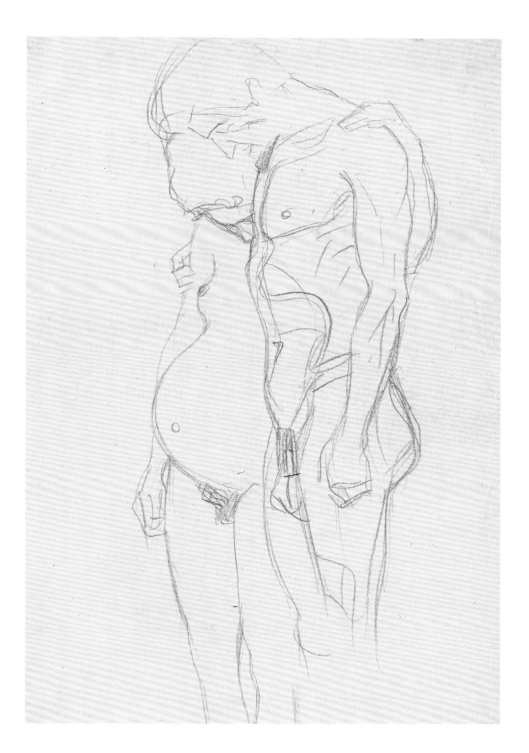

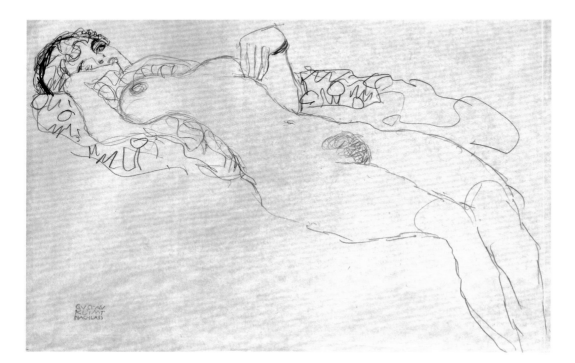

ABOVE *Semi-nude Girl Lying Left*, 1914–15, pencil on paper, 37.4 × 56.9 cm, private collection

BELOW *Two Women Friends Reclining*, graphite on paper, 34.9 × 55.2 cm, Metropolitan Museum of Art, New York

The final drawing in which Klimt captured precisely the contours of the pose he wanted is gridded for transfer to the canvas. For the famous golden portrait of Adele Bloch-Bauer, Klimt made around one hundred studies that were acquired by her family along with the portrait itself. These show her in a variety of poses, several of which would seem to have presented brilliant though unused solutions for the portrait.

Klimt's greatest achievement as a draughtsman, and even perhaps altogether as an artist, are the countless pencil studies he made in later years in his studio of women in various states of undress. Following the example of Rodin, Klimt allowed these women, often more than one at a time, to range freely around his studio, while he made his rapid studies, catching them in natural and unselfconscious poses while they dressed, undressed, relaxed, masturbated and behaved in ways that suggest they were unaware of being observed.

It is not surprising Egon Schiele commented on these drawings and particularly admired them amongst Klimt's works, even exchanging some of his own drawings with the older artist. In his densely worked paintings Klimt always remained an artist of the Belle Epoque and of an older generation. But in these late drawings Klimt approached the freedom and expressiveness of the younger generation of artists that emerged in the years before the First World War, such as Schiele and Kokoschka.

After Klimt's death the remaining drawings in his studio were divided between his siblings and his life-long companion Emile Flöge. Many of those in the possession of the Flöge sisters were destroyed in the bombing of their apartment in the Second World War. Those inherited by his younger brother Georg bear the stamp of the artist's estate 'Gustav Klimt Nachlass', whilst those belonging to his sisters, Hermine and Johanna, bare various stamps or inscriptions.

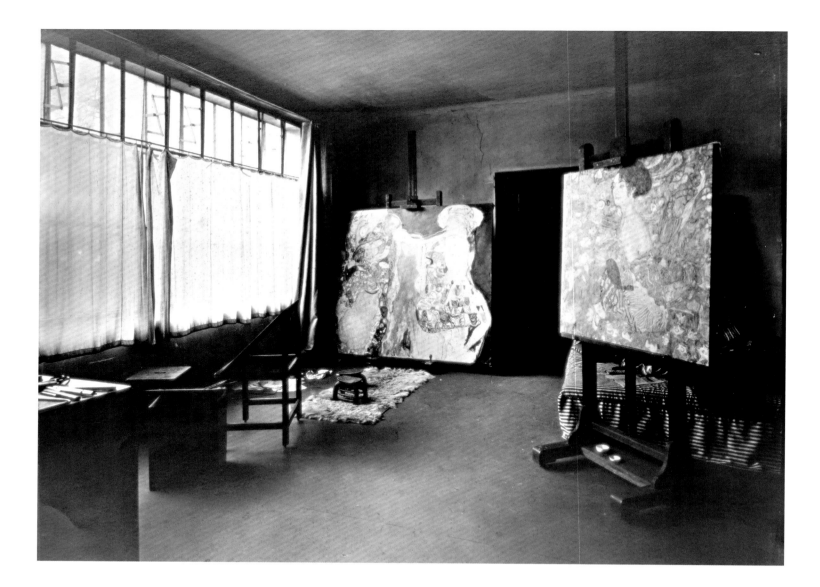

ABOVE Klimt's studio at Feldmühlgasse 11, with two
unfinished paintings, *Woman with Fan* and *The Bride*, 1918

OPPOSITE The grave of Gustav Klimt at the cemetery
of Hietzing in Vienna, photographed c.1925

END OF AN ERA

On 11 January 1918 at the age of fifty-five, Klimt was felled by a stroke. The first words he managed to utter were, 'Send for Emilie', indicating the important role that Emilie Flöge played in his life. Just under a month later in his weakened state he contracted the Spanish flu that was sweeping through Europe and died on 6 February. The young Egon Schiele came to the hospital to make portrait drawings of his former mentor on his deathbed, with his facial appearance transformed by the removal of his beard during his final treatment.

In October of the same year a second more virulent wave of influenza that was particularly deadly for young adults and pregnant women attacked the city. Egon Schiele's pregnant wife died on 28 October and Schiele himself succumbed to the disease three days later on 31 October at the age of twenty-eight. Other luminaries of Vienna's golden age who died in this terrible year included Kolomon Moser and Otto Wagner. In the aftermath of the First World War hunger and misery stalked the city. The Treaty of Versailles reduced the once proud capital of a vast multi-ethnic empire to a provincial capital of a small landlocked German-speaking state. Talent fled the city – much of it drawn to Berlin. The Vienna of Klimt was 'vorbei' – over.

NOTES

KLIMT'S VIENNA

1. Zweig, Stefan, *The World of Yesterday,* London, 2009, p.34
2. Ibid, pp.35–6
3. Ibid, pp.61–2
4. Godowsky, Dagmar, *First Person Plural: The Lives of Dagmar Godowsky,* New York, 1958, p.17
5. Zweig, p.36
6. Hare, Franz, *Die Moderne in Jahrhundertwende 1900, Untergangsstummung und Fortschrittsglauben,* Stuttgart, 1998, p.190
7. Bahr, Hermann, *Die Uberwindung des Naturalismus (Studien zur Kritik der Moderne, zweite Reihe),* Dresden, 1891, pp.3–4
8. Zweig, p.80

REVOLUTION AND RINGSTRASSE

1. Zweig, Stefan, *The World of Yesterday,* London, 2009

CHARACTER AND PERSONAL LIFE

1. Partsch, Susanna, *Gustav Klimt Painter of Women,* Munich, 1976, pp.73–4
2. Husslein-Arco, Agnes and Weidinger, Alfred, *Gustav Klimt und Emilie Flöge,* Munich, 2012, p.47
3. Comini, Alessandra, *Gustav Klimt,* London, 1975, p.11
4. Husslein-Arco, Weidinger, p.79
5. Ibid., p.230
6. Ibid., p.228

SECESSION

1. Vergo, Peter, *Art in Vienna 1898–1918,* London, 1975, p.23
2. Ibid., p.26
3. Ibid., p.27
4. Nebehay, Christian M, *Gustav Klimt,* Munich, 1976, p.102
5. Puvis de Chavannes, Henri, *La Renaissance de l'Art Français et des Industries de Luxe,* February 1926, pp.87–90
6. Vergo, pp.31–2
7. Shapira, Elana, *Style and Seduction: Jewish Patrons, Architecture and Design in Fin de Siècle Vienna,* Brandeis University, 2016, p.70

SCANDAL

1. Nebehay, Christian M, *Gustav Klimt,* Munich, 1976, p.145
2. *Deutches Volksblatt,* May 1900
3. Nebehay, pp.159–60

DECORATIVE ARTS

1. Vergo, Peter, *Art in Vienna 1898–1918,* London, 1975, p.180
2. Ibid., p.132
3. Ibid., p.134

JEWISH VIENNA

1. Gombrich, Ernst, *The Visual Arts in Vienna circa 1900,* London, 1997
2. Ibid.
3. Zweig, Stefan, *The World of Yesterday,* London, 2009, p.41
4. Ibid., p.43
5. Ibid., p.34
6. Magee, Bryan, *Aspects of Wagner,* London, 1972, p.40
7. Shapira, Elana, *Style and Seduction: Jewish Patrons, Architecture and Design in Fin de Siècle Vienna,* Brandeis University, 2016, p.5

PATRONS AND COLLECTORS

1. Natter, Tobias, *Die Welt von Klimt, Schiele und Kokoschka, Sammler und Mäzenne,* Cologne, 2003, p.24
2. Natter, p.88
3. Natter, p.126

PORTRAITS

1. Excerpt from letter dated 26 August 1872 from Anna Matilda Whistler to Rachel Agnes Alexander, *Correspondence of James MacNeill Whistler,* University of Glasgow
2. Wien Museum, *100 x Vienna, Highlights from the Wien Museum Karlsplatz,* 2013, p.178
3. Excerpt from letter quoted in Stanley Olson, *John Singer-Sargent: His Portrait,* London, 1986, p.237

LANDSCAPES

1. Vergo, Peter, *Art in Vienna 1898–1918,* London, 1975, p.148

2. Partsch, Susanna, *Gustav Klimt Painter of Women,* Munich, 2006, pp.59, 60

ALLEGORIES AND SYMBOLS

1. Huysmans, Joris-Karl, *Against Nature,* London, 1959, pp.65–6
2. Harrison, Martin and Waters, Bill, *Burne-Jones,* New York, 1973, p.153
3. Vergo, Peter, *Art in Vienna 1898–1918,* London, 1975, pp.55–6
4. Ibid., p.75
5. Salten, Felix, *Gelegentliche Anmerkungen,* Vienna, 1903

KLIMT, FREUD AND SEX

1. Comini, Alessandra, *Gustav Klimt,* London, 1975, p.6
2. Zweig, Stefan, *The World of Yesterday,* London, 2009, p.96
3. Ibid., p.94
4. Mahler-Werfel, Alma, diary entry from 24 September 1901 in *Diaries, 1898–1902,* London, 1997
5. Colligan, Colette, *The Traffic in Obscenity from Byron to Beardsley,* 2006, New York, p.128
6. Bade, Patrick, *Aubrey Beardsley,* 2001, University of Virginia, p.57
7. Bade, Patrick, *Femme Fatale, Images of Evil and Fascinating Women,* 1979, Pennsylvania State University, p.17
8. Comini, Alessandra, *Gustav Klimt,* London, 1975, p.6

KLIMT, MAHLER AND MUSIC

1. Blaukopf, Kurt and Blaukopf, Herta, *Mahler, His Life, Work and World,* Thames and Hudson, 2012, p.125
2. Ibid., p.190

DRAWINGS

1. Husslein-Arco, Agnes and Weidinger, Alfred, *Gustav Klimt und Emilie Flöge,* Munich, 2012, p.230

SELECT BIBLIOGRAPHY

Beaumont, Antony, *Zemlinsky,* London, 2000

Blackshaw, Gemma, *Facing the Modern, The Portrait in Vienna 1900,* London, 2013

Comini, Alessandra, *Gustav Klimt,* London, 1975

Blaukopf, Kurt and Blaukopf, Herta, *Mahler, His Life, Work and World,* Thames and Hudson, 2012

Constantino, Maria, *Klimt,* London, 2004

Fahr-Becker, Gabriele, *Wiener Werkstätte,* Cologne, 2015

Friedländer, Otto, *Letzter Glanz der Märchenstadt,* Vienna, 1996

Godowsky, Dagmar, *First Person Plural, The Lives of Dagmar Godowsky,* New York, 1958

Hamburger Kunsthalle, *Experiment Weltuntergang Wien um 1900,* Hamburg, 1981

Hare, Franz, *Jahrhundertwende 1900, Untergangsstummung und Fortschrittsglauben,* Stuttgart, 1998

Huysmans, Joris-Karl, *Against Nature,* London, 1959

Husslein-Arco, Agnes and Weidinger, Alfred, *Gustav Klimt und Emilie Flöge,* Munich, 2012

Horvat Pintoric, Vera, *Vienna 1900, The Architecture of Otto Wagner,* London, 1989

Kennedy, Michael, *Mahler,* London, 1977

La Grange, Henri-Louis de, *Gustav Mahler, Vienna: Triumph and Disillusion,* Oxford, 1999

Moskovitz, Marc D, *Alexander Zemlinsky, a Lyric Symphony,* Woodbridge, 2010

Mahler, Gustav, *Letters to his Wife,* New York, 1995

Mahler-Werfel, Alma, *Diaries, 1898–1902,* London, 1997

Mahler, Alma, *Gustav Mahler, memories and letters,* New York, 1971

Mahler-Werfel, Alma, *And the Bridge is Love,* New York, 1958

Natter, Tobias, *Die Welt von Klimt, Schiele und Kokoschka, Sammler und Mäzene,* Cologne, 2003

Nebehay, Christian M, *Gustav Klimt,* Munich, 1976

Neue Galerie, *Josef Hoffmann, interiors 1902–1913,* New York, 2006

Partsch, Susanna, *Gustav Klimt, Painter of Women,* Munich, 2006

Rogoyska, Jane and Bade, Patrick, *Gustav Klimt,* New York, 2012

Shapira, Elana, *Style and Seduction: Jewish Patrons, Architects and Design in Fin de Siècle Vienna,* Brandeis University, 2016

Schorske, Carl E, *Fin-de-Siècle Vienna, Politics and Culture,* Cambridge, 1981

Vergo, Peter, *Art in Vienna 1898-1918,* London, 1975

Werner, Alfred, *Klimt, 100 drawings,* New York, 1972

Wien Museum, *Klimt, Collection of the Wien Museum,* Ostfildern, 2012

Zweig, Stefan, *The World of Yesterday,* London, 2009

PICTURE CREDITS

INDEX

· ·

ACKNOWLEDGEMENTS

I would like to express my gratitude to two academics who inspired my interest in the Vienna of 1900: Alessandra Comini, whose lecture on the portraits of Klimt and Schiele was the most brilliant I heard during my years as a student; and Peter Vergo, who offered generous hospitality and advice on my second visit to Vienna in 1975. The publications of both were important references for this book. PB